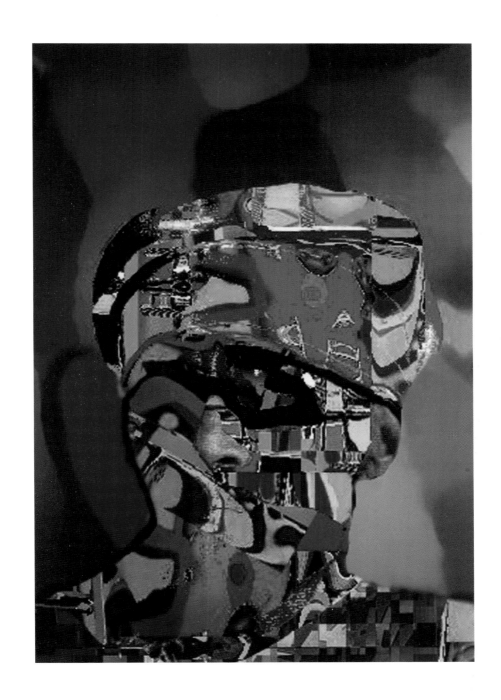

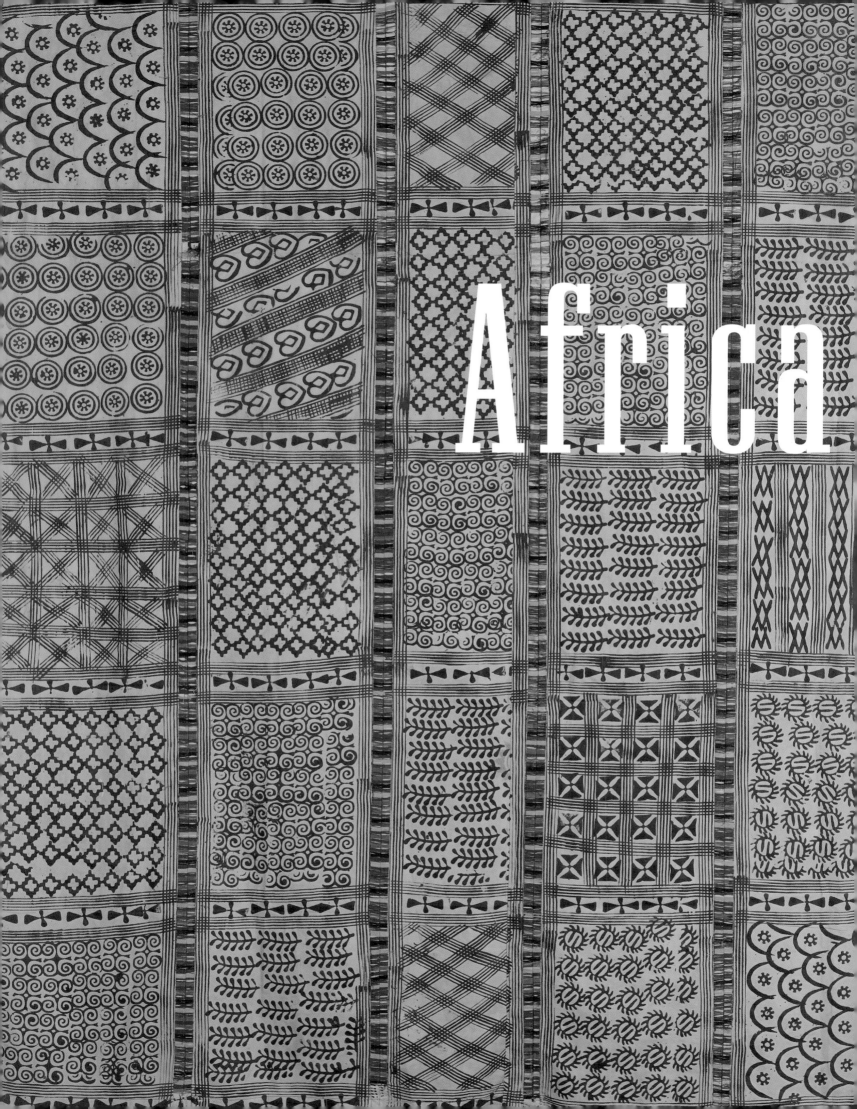

Africa

Interweave

TEXTILE DIASPORAS

Susan Cooksey

with essays by

Cynthia Becker

Sarah Fee

Jordan A. Fenton

Suzanne Gott

Courtnay Micots

Robin Poynor

Christopher Richards

Victoria L. Rovine

MacKenzie Moon Ryan

Samuel P. Harn Museum of Art
University of Florida, Gainesville

CONTENTS

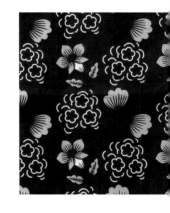

front cover: (detail) Fulani People, Goundam, Mali,
Wall Covering (*arkilla kereka*), 20th century

back cover: Ekpenyong Bassey Nsa, Nigerian, b. 1973
Ebonko Masquerade Ensemble, 2010

page one: Achamyeleh Debela, American, b. Ethiopia,
1947, *The Priest*, 1990–91

across from title page: (detail) Akan People, Ghana,
Aðinkra Cloth, late 20th century

Rebecca Martin Nagy
Director, Harn Museum of Art

FOREWORD

As a great admirer of beautiful textiles, I am personally delighted that the Harn Museum is presenting *Africa Interweave: Textile Diasporas*, the end result of years of exhaustive research and committed collection-building by Curator of African Art Dr. Susan Cooksey. And I am equally pleased that the impact of the exhibition will live on and be extended through the insightful essays and rich illustrations of this fine accompanying publication.

In developing a major collection of African textiles for the Harn, Dr. Cooksey has assembled a marvelous variety of pieces ranging in technique and style from traditional to contemporary and including textiles used for ritual, ceremonial, prestige, and domestic purposes. Complete ensembles of clothing for a range of occasions are represented, as well as high-fashion attire and elaborate masquerade costumes for various performances. The textiles represent all regions of the continent, from Tunisia to South Africa and Ghana to Tanzania. They come from many diverse cultural traditions and display stunning achievements of weaving, dyeing, embroidery, appliqué, and beadwork in a dazzling array of colors and designs. In addition, the exhibition includes works by contemporary African artists who employ textiles or have been inspired by textile traditions in their work—El Anatsui, Viyé Diba, Skunder Boghossian, Seydou Keïta, Achamyeleh Debela, and Yinka Shonibare.

We are committed at the Harn Museum to exploring ideas and topics of global significance in our exhibitions, publications, and programming. This exhibition clearly demonstrates the continuity of African artists' fascination with textiles. It shows the interrelationships of textiles across cultures on the continent, and also reveals how global market, fashion, and other trends affect the production, meanings, and uses of textiles. We learn how the mobility of textiles across chronological, spatial, and ideological boundaries influences their corresponding visual, technical, and aesthetic aspects.

In keeping with the Harn's mission to weave the work of the museum into the academic fabric of the university, this exhibition and catalogue have been a collaborative effort in which Dr. Cooksey has engaged University of Florida faculty and graduate students as well as scholars from other institutions.

University of Florida art history professors Dr. Robin Poynor and Dr. Victoria Rovine contributed essays to the catalogue, as did textile scholars Dr. Cynthia Becker, Dr. Sarah Fee, and Dr. Suzanne Gott. Ph.D. candidates Jordan Fenton, Christopher Richards, and MacKenzie Moon Ryan, and (now Dr.) Courtnay Micots conducted field research in Nigeria, Ghana, and Tanzania; purchased textiles, garments, and a masquerade costume for the exhibition; and wrote entries for this catalogue. They will also join our faculty colleagues as presenters in the educational programming accompanying the exhibition.

Every aspect of *Africa Interweave* — the exhibition, the publication, and the educational programming for visitors of all ages — has been made possible by the contributions of many people. In her acknowledgments Dr. Cooksey recognizes the generous friends of the Harn who have donated textiles to the collection, as well as those whose financial contributions have supported the project. She thanks the dedicated and hard-working members of the Harn Museum staff who joined her in making the exhibition a reality and those whose talents produced the handsome catalogue. I add my sincere appreciation to hers, and close with heartfelt thanks to Susan herself for her great gift to the Harn and the University of Florida in organizing this remarkable exhibition.

Susan Cooksey

Curator of African Art, Harn Museum of Art

ACKNOWLEDGMENTS

he planning and implementation of this exhibition and catalogue have rewarded me in ways I could not have predicted, but being the beneficiary of such an outpouring of support from so many generous and talented people has been the most deeply gratifying part of this project.

I must begin by thanking the students and faculty of the University of Florida who contributed their expertise to shaping the concept and organization of the exhibition in many ways. Dr. Robin Poynor, my longtime mentor from the University of Florida's School of Art and Art History, built the foundation for the textile collection at the Harn Museum and donated four textiles that appear in the exhibition. He also wrote an essay on his research in Owo and contributed contextual images for several works that appear in the exhibition and the catalogue. His suggestions about acquisitions and scholarly contacts were much appreciated as well. Dr. Victoria Rovine generously contributed her advice on the concept and organization of the exhibition and the catalogue, and traveled to Mali twice to research textile artists and acquire objects for the exhibition. Her essay on embroidery includes discussion of a woman's robe from Timbuktu she commissioned for the Harn, as well as an object loaned from her personal collection. I am also grateful to her for introducing me to several scholars in the field of African textiles and fashion, including Dr. Sarah Fee and Dr. Suzanne Gott who contributed essays to the catalogue.

Drs. Rovine and Poynor also suggested that I involve doctoral students with textile-related field research. Thanks to their recommendations, Jordan Fenton, Dr. Courtnay Micots, MacKenzie Moon Ryan, and Christopher Richards contributed essays based on their latest research (in Nigeria, Ghana, Tanzania, and Ghana, respectively), and assisted with acquiring objects for the Harn's collection and for the exhibition. Jordan Fenton, who conducted research in Calabar, commissioned a dazzling Ebonko masquerade costume and collected an entire ensemble of chiefly ceremonial attire. Dr. Courtnay Micots did research on Fante *asafo* flags in Ghana and collected the cloth commemorating President Obama's visit there. She also helped me with commissions of cloth from Samuel Cophie. MacKenzie Moon Ryan assisted with the translation of Swahili on *kanga* cloths in the collection and acquired cloths in Tanzania, including the eye-catching *kanga* cloth in the exhibition. MacKenzie and Courtnay also assisted with additional interpretive texts for the exhibition. Christopher Richards, who studied textiles and fashion in Ghana, kindly agreed to meet with Samuel Cophie to retrieve two commissioned works for the Harn. In addition, I am truly appreciative of the efforts of Eugenia Martinez, who assisted with many tasks, including research, translations, technology, and contacts in Senegal and Mali. The new works brought from various locations in Africa, and the insights of these scholars, have infused the exhibition and catalogue with a fresh and timely perspective on the role of textiles in Africa today.

I am deeply grateful to each of them for their unique contributions to this exhibition.

Many of the textiles on view in the exhibition were newly acquired or loaned with the help of private collectors. Norma and William D. Roth generously donated a beaded Ngwane bridal cape that is featured in the exhibition, and recently gave several more textiles to the Museum. Barbara and William McCann guided me through the long process of choosing textiles from their cherished collection, gathered during their travels in Africa, that were acquired for the Harn. Thanks to these collectors' appreciation for textiles and their generosity of time, energy, and expertise, the Museum has fulfilled its goal of building a strong collection of textiles that spans the continent. Many thanks also go to the Richardson family, whose endowment supported the purchase of several textiles for the exhibition, including five commissioned works. Ambassador Kenneth Brown and Bonnie Brown kindly loaned two delightful *asafo* flags from their collection. I also would like to express my gratitude to the staff of the Norton Museum of Art, who generously agreed to lend their wonderful example of Yinka Shonibare's work, *Victorian Couple*.

The installation of this exhibition presented many challenges, but the Harn registration and preparation staff worked together to find creative solutions. My thanks go to Laura Nemmers, registrar, and Jessica Uelsmann, associate registrar, for their patience and attention to the slightest details in preparing art works for this exhibition. Their ability to handle a myriad of tasks simultaneously is essential, but also astonishing. I am particularly grateful to them, and to Elizabeth Bemis and Dushanthi Jayawardena, for organizing the textiles and preparing them for photography. Michael Peyton, chief preparator, devised innovative and elegant methods for mounting textiles. Tim Joiner, assistant preparator, and Nathan Ahern were meticulous in preparing the gallery and hanging the art. They have been responsible for maximizing the aesthetic impact of the work in the space of the gallery. Many thanks to textile conservators Muffie Austin, for going above and beyond all expectations to restore the beauty of two of our textiles, and Stephanie Hornbeck, who ably assisted us in mounting the textiles.

The production of this catalogue has involved a host of contributors. I've had the pleasure of working with three scholars who contributed essays and contextual images—Dr. Sarah Fee, Dr. Suzanne Gott, and Dr. Cynthia Becker. I thank them for their enthusiasm in embracing this project, and for the insights they have shared about their subject areas and the overall theme of the exhibition. I am particularly grateful to Dr. Gott, who kindly agreed to meet with weaver Samuel Cophie in Kumasi and transport his gift of a *kente* cloth to the Harn.

I would also like to thank Dr. Sarah Worden, curator of Africa collections at the National Museum of Scotland, Edinburgh, who shared her research on Hausa textiles. Dr. Sally-Anne Coupar, curator of archaeology at the

Hunterian Museum, University of Glasgow, and Tracey Hawkins, curatorial assistant, and Dr. Patricia Allan, curator of world cultures, both at the City Museum Resource Center, Glasgow, helped me to select and view textiles in their collections. I am grateful as well to Dr. Maxine Downs, a UF alumna whose doctoral research on women dyers in Mali inspired the section of the exhibition on *bazin*. She and her colleague Maureen Gosling have produced a stunning film on the women dyers that is featured in the exhibition. Dr. Jean Borgatti sparked my interest in the Okakagbe masquerade and the mask-maker Lawrence Ajanaku, and the Museum now owns an Ajanaku mask she commissioned. She was kind enough to give us photographs and videos that are on view in the exhibition. Thanks also to Dr. John Pemberton, who contributed two photographs for the exhibition. My friend and colleague Barbara Thompson provided information on *kanga* cloth use and meaning, and shared her photographs for the exhibition and the catalogue. Thanks to the following scholars for their assistance with imperative materials: Doran Ross, Dr. Patricia Darish, Dr. David Binkley, and Venny Nakazibwe. I am grateful to Achamyeleh Debela and Viyé Diba for allowing me to interview them.

Dr. Courtnay Micots was responsible for locating and securing contextual photographs for the catalogue and the exhibition. I greatly appreciate her dedication and discernment in seeking out these images. I had exceptional interns during the course of preparing for this exhibition, whose work has been invaluable: Christopher Richards, Courtnay Hammer, MacKenzie Moon Ryan, Dushanthi Jayawardena, Kerri Duffield, and Michael Pagan. Each assisted eagerly and efficiently with research, organization, design, and a plethora of other tasks — many thanks to all of them. Tami Wroath, director of marketing and public relations at the Harn, oversaw the production of the catalogue, and I am truly grateful for her time and positive energy. The visual appeal of this publication can be attributed to designer Ron Shore, and I thank him for his unflagging enthusiasm in working closely with me and my colleagues to help shape the vision for this catalogue. Thanks also to Randy Batista, who photographed all the textiles in this catalogue. I am grateful to Victoria Scott for her patient and careful editing of all text.

Several individuals and institutions offered funding to support the exhibition and the catalogue. I am grateful to the University of Florida's Center for African Studies, Michael and Donna Singer, and Mary Ann and Richard Green for helping to fund the exhibition, and to Robert and Joelen Merkel, and Storter Childs Printing, for their support of the catalogue. The exhibition and catalogue also received generous support from the John Early Publications Endowment, the Harn 20th Anniversary Fund, the 1923 Fund, the Dr. Madelyn M. Lockhart Endowment for Focus Exhibitions at the Harn Museum of Art, and the Harn Program Endowment.

Finally, I would like to express my thanks to the many colleagues, friends, and family who offered their support. To the Harn's director, Dr. Rebecca Nagy, who encouraged me to pursue this exhibition from the beginning; Phyllis Delaney, who worked tirelessly to find support for the catalogue and the exhibition; Brandi Breslin, curatorial secretary, who spent endless hours organizing my materials, contacting contributors, and processing paperwork; to Mary Yawn, who worked through all budgetary issues so effectively (and even cheerfully); and to my fellow curators Dulce Roman, Kerry Oliver-Smith, Jason Steuber, and former colleague Tom Southall, who gave me insight, guidance, and many other forms of assistance in the last few years — you have all proven the meaning of cooperation. To my sister Melanie Cooksey, my husband Scot Smith, and my friends Ann Lindell and Madeleine Traoré, thank you for your moral support. I credit all of you and those named above with the realization of the exhibition and this publication.

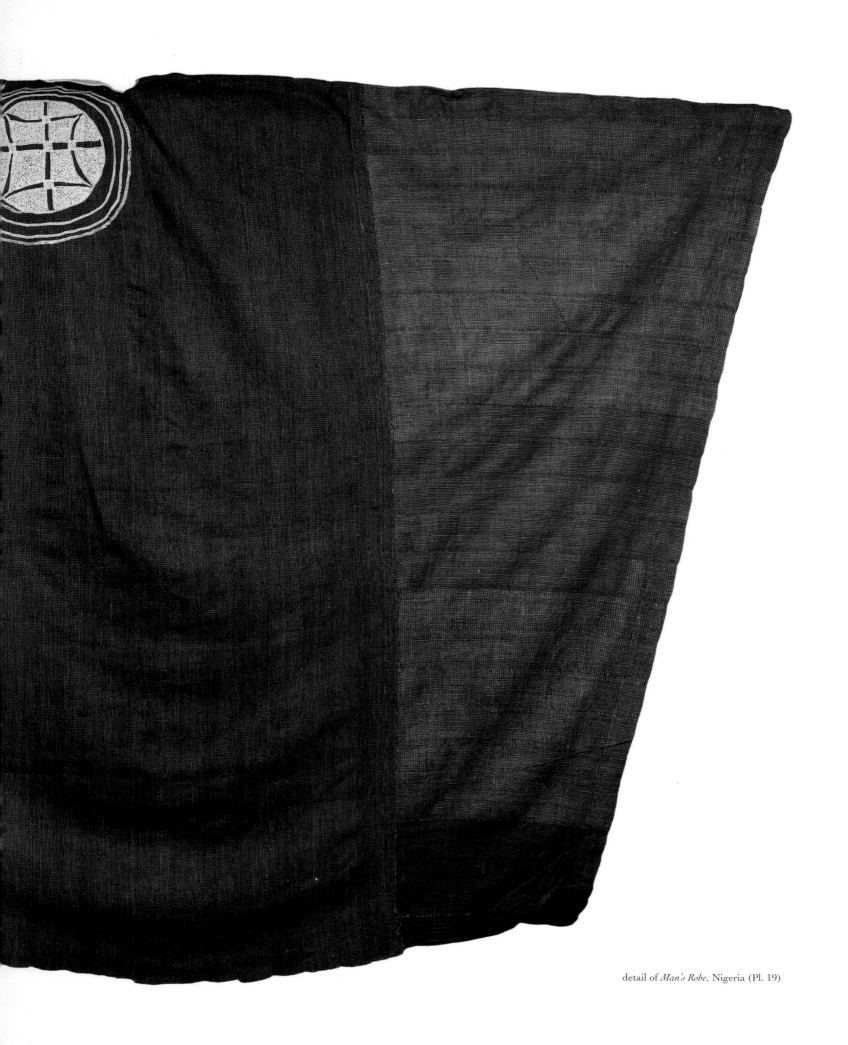

detail of *Man's Robe*, Nigeria (Pl. 19)

Susan Cooksey

INTRODUCTION
AFRICA INTERWEAVE: TEXTILE DIASPORAS

The intersecting trajectories and the forces that have propelled the ceaseless flow of textiles on the African continent and beyond its boundaries for centuries are focal points of the exhibition *Africa Interweave: Textile Diasporas*. Aesthetically charged with vivid palettes, complex patterns, and an enticing array of textures to engage our senses while they animate the spaces we occupy, textiles have long captured the imagination of both local artists and "others"—those living outside the local sites of production. Through these artists' and enthusiasts' eyes and hands, the aesthetics and functionality of textiles have been and continue to be transformed, either subtly or radically. Design elements, materials, and methods of fabrication are appropriated, synthesized, and altered as they are assimilated by individuals and groups. Inevitably, as traders, consumers, and artists contribute their own interpretations, culturally associated meanings are shifted and refashioned.

In the last half century, numerous exhibitions have celebrated the aesthetic qualities and technological skill of textile production. The pivotal 1972 exhibition *African Textiles and Decorative Arts*, at the Museum of Modern Art in New York, foregrounded the study of textiles within the discipline of African art history and also situated it squarely within the context of contemporary art. *Africa Interweave* similarly celebrates textile aesthetics but also illuminates the complexities of the cultural interactions that shape cloth—and that are in many ways shaped by cloth. Cloth has long been used to influence perceptions of political power, religious belief, and economic status that have had far-reaching effects both transculturally and transnationally.

Such interactivity is also relevant to the work of contemporary artists from Africa. The works on display in *Africa Interweave* serve as a representation of the historical and conceptual continuum of artistic exploration of textiles from the mid-twentieth century to the twenty-first century. Through the works of nine contemporary artists in the exhibition—Yinka Shonibare, El Anatsui, Achamyeleh Debela, Skunder Boghossian, Seydou Keïta, Viyé Diba, Aboubakar Fofana, Maimouna Diallo, and Nike Davies Okundaye—we see a variety of differing approaches to incorporating textiles into their work, whether materially, visually, or conceptually. Each has a unique insight into some aspect of the historical, social, or other context of textiles in Africa that leads us to a new interpretation of them within the global framework of contemporary art and culture.

In the Harn exhibition, historical and contemporary works are purposely juxtaposed to illuminate their affinities. For example, Yinka Shonibare's sculpture *Victorian Couple* (Pl. 53), a pair of figures dressed in Victorian-era-styled garments made of West African wax-print cloth, is seen next to an Egungun masquerade of the Yoruba people of Nigeria (Pl. 48) with layers of handwoven local cloth and early twentieth-century imported wax-print cloth. Although Shonibare and the mask-maker each recognized the status attached to imported wax-print cloth, they approached it from divergent cultural and historical perspectives that engage the viewer in a dialogue about what constitutes local and global identities vis-à-vis ideas about authenticity and modernity. Adjacent to these works are others that demonstrate the explosion of new art forms or revisions of preexisting forms that were inspired by imported cloth, including two appliquéd flags of the Fante people of Ghana, one by renowned artist Kweku Kakanu (Pl. 46) and the other in the

13

style of Kakanu (Pl. 47), which Courtnay Micots discusses in her essay entitled "Griffins, Crocodiles, and the British Ensign." The exhibit also showcases masquerade and masquerade-related ensembles made of imported cloth from the Igbo and Northern Edo people of Nigeria (Pls. 49–52), including two works from Calabar, Nigeria—an Ebonko masquerade ensemble and a complete ensemble for the chief of a powerful men's society, Ekpe (Pls. 49 and 50). My essay "Transfigured Textiles: Masquerades and Imported Cloth" highlights the pivotal role of the artist in linking Igbo maiden-spirit masquerades (Pl. 51) and the Northern Edo Okakagbe masquerade (Pl. 52), both of which use imported cloth costumes and depict female characters. In his essay "Displaying the Ostentatious," Jordan Fenton illuminates the long history of trade and cultural interactions of the Calabari peoples with Cameroon, Europe, and India, and their impact on textiles used in Ekpe. Fenton's research was informed by his intensive work with the mask-maker Ekpenyong Bassey Nsa, and his own initiation into Ekpe.

Emmanuel (El) Anatsui's *Old Man's Cloth*, a relief work made of linked pieces of metal bottle-tops (Pl. 23), formally suggests a patched and worn strip-woven cloth commonly produced throughout southern Ghana and much of West Africa. Anatsui's work is displayed beside an Asante *kente* cloth (Pl. 26) named after former U.S. President Bill Clinton that was created by the workshop of master weaver Samuel Cophie. An adjacent strip-woven cloth (Pl. 25) by an Ewe weaver is closely related historically and visually to the Asante *kente*, and also signifies

wealth and status. The proximity in the exhibition of these three works highlights the visual rapport of cloth with Anatsui's work, and also the role of cloth as a marker of economic and political status in Ghana, which Suzanne Gott discusses in her essay, "Ghanaian *Kente* and African-Print Commemorative Cloth." Elaborating on the significance of cloth in Africa, Anatsui has said, in reference to a comment by artist Sonya Clark, that "cloth is to the African what monuments are to Westerners. Indeed their capacity and application to commemorate events, issues, persons and objects outside of themselves are so immense and fluid it even rubs off on other practices" (Polly Savage 2006, no pagination). Anatsui's comment on the effects of cloth on "other practices" can be applied both to his work and other art media as well.

Also in the Harn exhibition, *Time Cycle III*, a relief construction (Pl. 33) made of bark cloth by the Ethiopian artist Alexander (Skunder) Boghossian, is seen in the context of examples of indigenous fibers, including raffia cloth of the Kuba people of Democratic Republic of Congo (Pls. 36 and 37), woven raffia textiles of the Dida people of Côte d'Ivoire (Pl. 35), and bark-cloth garments of the Mbuti of the Ituri rainforest (Pls. 38 and 39). Boghossian's use of bark cloth from Uganda, where the Bagandan people have revered bark cloth for centuries as a garment suitable for both secular and religious ceremonial use (Nakazibwe 2005, 3), alludes to its somber role as burial cloth (Harney 2003, 37; Nagy 2007, 56). *Time Cycle III* is but one example of the work of many African artists who acknowledge the historical and iconic value of this textile (Nakazibwe 2005, 325).

Sarah Fee's essay, "*Futa Benadir*: A Somali Tradition within the Folds of the Western Indian Ocean," gives us insight into the complex exchanges between the Benadiri and India, Arabia, the Swahili Coast, Europe, and America that affected the aesthetics and production of the cloth. The three Somali textiles on view (Pls. 41–43) date from the late twentieth century and are, as Fee notes, evidence of the cloth's hybridity and its resilience, since they have retained features comparable to those found in nineteenth-century examples of *futa benadir* but have adapted to new social and economic conditions.

MacKenzie Moon Ryan's essay, "The Emergence of the *Kanga*: A Distinctly East African Textile," examines cultural blending in the history of the *kanga*, a widely popular cloth of Tanzania. She traces its development through trans–Indian Ocean trade as well as exchanges with Europe and America. The exhibition features a cloth Moon Ryan recently acquired in Tanzania that is typically inscribed with a Swahili proverb (Pl. 40).

Achamyeleh Debela's chromogenic color print *The Priest* (Pl. 44) is adjacent to textiles from the East African coast, *kanga* cloth from Tanzania, and Somali *futa benadir*. The vibrant hues of Debela's priest recall colorful Ethiopian Orthodox Christian liturgical vestments, which are both celebratory and sacred. While the patterns and colors of the secular cloths—*kanga* and *futa*—delight the eye, they, too, draw attention to inscribed or embedded cultural or spiritual meanings. Debela's image also illuminates the central role of textiles in sacred performance. The work *Traces* (Pl. 45), by Senegalese artist Viyé Diba, references another

type of performance—dance—that he associates both with his dynamic engagement with the materials he uses (paint, cloth, and found objects) and with the rhythm of dance reflected in his composition. (My essay "Cloth and Performance" further discusses these two pieces.)

Two strip-woven textiles from the Owo Yoruba of Nigeria, a colorful sampler (Pl. 5) and a head-tie (Pl. 6), reiterate the role of cloth in performance. Robin Poynor's essay, "A Noble Multimedia/Intermedia Event," describes an Owo second burial ceremony, *ako*, in which various locally made textiles are not only worn and displayed but transformed into percussive instruments that are beaten during a procession. The transformation of the textiles from visual displays to musical instruments entails a transference of medium, aesthetics, and meaning. Poynor's examination of *ako* shows us how extensively the aesthetics and social functions of textiles can be reinterpreted within the context of a specific performance.

A photograph by Malian artist Seydou Keïta of a woman dressed in a locally made tailored garment, posed against an imported-cloth backdrop (Pl. 32), is juxtaposed in *Africa Interweave* with an example of an imported damask (known locally as *bazin*) dyed in Bamako (Pl. 29), and with a chic *bazin* garment designed by Malian artist Maimouna Diallo in 2010, using South African–inspired beadwork (Pl. 30). Together these three pieces show the many interpretations of this textile in the hands of African artists. To complement Diallo's ensemble, the exhibition includes a Ngwane wedding cape from South Africa, circa 1960 (Pl. 31), with intricate beadwork motifs depicting

cars, tall buildings, and a woman in a minidress. Both the *bazin* garment by Diallo and the beaded cape express high regard for an historic style of dress combined with receptivity to modernity and a globalized fashion sense.

Victoria Rovine's essay, "West African Embroidery: History, Continuity, and Innovation," traces the history of embroidery in West African textiles, showing the interrelated techniques and motifs in garments from a widespread geographic area and diverse cultures in Mali, Nigeria, Niger, and Cameroon (Pls. 14–16, 18–21, and 30). She discusses an embroidered woman's robe, or *tilbi*, by Baba Djitteye, an embroiderer from Timbuktu, with motifs derived from sacred calligraphic inscriptions (Pl. 20). Rovine compares them to embroidered motifs on Hausa and Yoruba garments (Pls. 14 and 19), and contrasts them with the secular motifs of a tunic inspired by late twentieth-century visual culture in West Africa that is associated with a style known locally as "Ghana Boy" (Pl. 21). She concludes with a discussion of a contemporary garment (Pl. 30) incorporating embroidery by Maimouna Diallo, a Malian designer.

Many of the works in the exhibition reflect the influence of Islam, including the embroidered robes from northern Nigeria, Mali, and Niger, and the weavings from Mali, Tunisia, and Morocco (Pls. 7–9, 11–13). Cynthia Becker's "Trans-Saharan Aesthetics" explores the aesthetic, material, and iconographic legacy of various textiles from North Africa—a legacy that extended across the Saharan desert to Mali and Niger, focusing on the indigenous inhabitants of northern Africa, the Imazighen (Berbers). Becker

addresses the significance of textiles as conveyers of social, religious ideas that occurred on the desert fringe and have continued from the era preceding European presence until the present, defying the constructed boundaries of North and sub-Saharan Africa.

Indigo-dyed textiles abound in Africa and have a long, complex history of cultural exchanges through intercontinental trade routes. The Harn exhibition focuses on indigo dyeing in Nigeria and Mali from the late twentieth century to the present, showing how each draws on the past but also represents innovation. A strip-woven cloth of the late twentieth century, made with yarns dyed with a resist technique known as *ikat* (Pl. 4), was produced by the Yoruba people of Nigeria, but the technique and dyestuffs circulated throughout West Africa for centuries. A Yoruba hand-painted resist-dyed cloth named after Olokun, the Goddess of the Sea (Pl. 2), illustrates how textile artists of the mid-twentieth century subtly expanded the canonical repertory of motifs. A work by Nike Davies Okundaye (Pl. 1) demonstrates the artist's effort to revive the declining art of indigo dyeing while introducing her personal aesthetic and content. An indigo resist-dyed scarf by Aboubakar Fofana (Pl. 3) can be described as revivalist, but also reflects his transnational aesthetic and technical training. Other examples of indigo-dyed garments in *Africa Interweave* that demonstrate the vast range of indigo dyeing are Hausa men's robes, a head-covering from Tunisia, a cape from Morocco, and a tunic of the Wodaabe people of Niger (Pls. 19, 12, 10, and 17).

The presentation of textiles in this exhibition is intended to generate

appreciation for the aesthetic qualities of the work as well as the scope of their interwoven histories. The exhibition also attempts to promote a dialogue about the many ways that the skill, creativity, and tastes of artists, patrons, and those who use various cloths in their everyday lives have always impelled the course of African textiles. To this end, many recently produced textiles, along with information about the artists who have made them, are included in the exhibition. The presentation of these works in the gallery in conjunction with the sculpture, paintings, and photographs of contemporary artists illuminates artistic agency as their common denominator, and as the impetus that continues to drive African textiles to new destinations. ◆

References

Harney, Elizabeth. 2003. *Ethiopian Passages: Contemporary Art from the Diaspora*. Washington, D.C.: National Museum of African Art.

Rebecca Nagy. 2007. *Continuity and Change: Three Generations of Ethiopian Artists*. Gainesville: Samuel. P. Harn Museum of Art, University of Florida.

Nakazibwe, Venny. 2005. "Bark-cloth of the Baganda People of Southern Uganda: A Record of Continuity and Change from the Late Eighteenth Century to the Early Twenty First Century." Ph.D. dissertation, Middlesex University.

Savage, Polly. 2006. "El Anatsui: Contexts, Textiles and Gin." In Polly Savage and Chili Hawes, *El Anatsui 2006*. Parkwood, South Africa: David Krut Publishing.

Susan Cooksey

Tracing the Routes of Indigo:

FOUR TEXTILES FROM WEST AFRICA

Indigo-dyed textiles are among the most highly prized on the continent of Africa, ascribed with aesthetic, spiritual, and monetary value. The history of indigo in Africa is replete with its transport via complex trading routes and cultural exchanges across continents and oceans. Indigo dyeing is widely acknowledged to have begun in India, which has the greatest number of native species of the plant *Indigofera*. From there, indigo-dyeing technology was transported to the Arab world and suffused the Middle East and Mediterranean world, including the north of Africa. Indigo cloth in Egypt dates to the eighteenth dynasty of the New Kingdom era. Between the seventh and the twelfth century, indigo dyeing had taken root in southern Tunisia, and spread from there to Morocco and all of the Sudan.

Tangible proof of the earliest indigo use in sub-Saharan West Africa can be seen in indigo-dyed cotton cloth and garments of the Tellem people, who inhabited the Bandiagara Escarpment of eastern Mali from the eleventh to the fourteenth century. By the sixteenth century, Portuguese traders had brought the first European indigo dye to West Africa. They developed the production of indigo-dyed cotton textiles on Cape Verde, using slaves from Senegal and other coastal areas. This production had some influence on Fulani, Senegalese, and Yoruba peoples (Boser-Sarivaxévanis 1972, 58). Later transatlantic trade

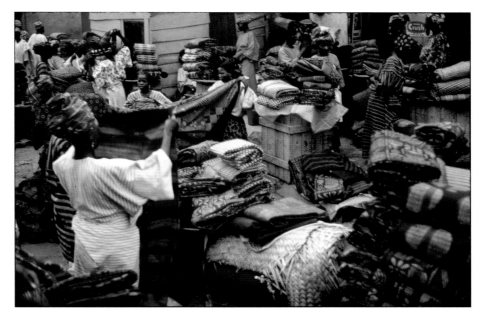

brought an American species of indigo (*Indigofera suffructiosa*) to West Africa, and it soon flourished. By the nineteenth century, indigo was well established in the Sahel, and demand for dyed goods propelled trade routes from northern Africa to Cameroon. To complete the global trade circuit, a species of African indigo, *Indigofera arrecta*, was introduced to Asia around 1860, and was widely cultivated in India, where it was known as "Java Indigo" (Musée du Tapis 2001).

Trans-Saharan traders, the Berber north of the Sahara and the Tuareg south of the desert, were known as "the blue men" because of their blue-black turbans, *turkudi*, produced by Hausa dyers. The Hausa, who had

Fig. 1. (above) *Adire* vendors in Oje market, Ibadan, Nigeria, 1971. Photograph by John Pemberton III.

17

established themselves in northern Nigeria in 500–700 CE, commanded some of the most important early centers of indigo dyeing in West Africa. The Hausa towns of Kano and Rano were the most renowned, and by the nineteenth century, the Hausa indigo industry extended from the Atlantic coast to Timbuktu to Tripoli, as noted by Heinrich Barth ([1857] 1965, 358) There were two thousand active dye-vats in Kano alone. Kano's commercially viable indigo-dyeing industry has lasted for centuries and is still active today, albeit greatly modified. In southern Nigeria, Yoruba textile artists became known in the nineteenth century for production of indigo-dyed textiles, including woven textiles and resist-dyed cloth known as *adire* (Fig. 1). When synthetic indigo was developed in Europe in 1897, it rapidly supplanted the use of natural indigo. The textiles in the Harn exhibition demonstrate a pivotal time in the history of indigo dyeing in Nigeria, from the mid-twentieth century up to the 1970s, when the production of local indigo-dyed cloth and handmade textiles in general underwent dramatic changes.

Indigo and *Ikat* in Yoruba Ceremonial Cloths

Ikat, dervived from the Malaysian word *mengika*, meaning "to bind," refers to the technique of dyeing that involves the wrapping of a section of gathered yarns to form an area resistant to dye. When incorporated into weavings, the attenuation of color created during the dyeing process creates a soft-edged pattern that forms a pleasing contrast to the hard-edged patterns of evenly dyed yarns. The process originated in Indonesia but has appeared throughout Asia, the Middle East, and Africa. Although *ikat* is used widely in West Africa, the weavers of Côte d'Ivoire and Nigeria are well known for exploiting this technique. In Nigeria, Yoruba dyers may have learned techniques through Hausa traders who traversed

the great textile centers in the Jula area of Kong (now in central Côte d'Ivoire), where Hausa textile artists were living in the nineteenth century and where indigo-dye *ikat* was well developed (Holmes and Lamb 1980). Yoruba weavers produced *ikat* using both cotton and silk for a diverse array of elaborate garments.

Cloths incorporating *ikat* patterns are considered to be of such beauty and prestige that the Yoruba place them in the category of *aso alaro*, that is, a cloth appropriate for rites and ceremonies. The Harn example combines the richest dyestuffs, indigo and magenta (Pl. 4). Magenta can be derived from two sources. One type, derived from camwood (*Pterocarpus tinctorius*), was often used as a dye for Yoruba and Hausa prestige wear, and the other, *alhari*, a brilliant red dye, was used widely in Nigeria. *Alhari* originated in the Tunisian silk industry, as early as the sixth century, and by the eleventh century was transported via caravans across the Sahara, from Tripoli and Ghadmes to Kano. (Al Bakri, an Andalusian geographer and historian, recorded the use of the dye in Africa in the eleventh century.) In West Africa, it became popular due to the scarcity of vibrant-red dyeing agents. Later, European magenta waste silk—primarily from Lyon, France—was exported to Africa. By the 1970s, a Senegalese company produced an imitation dye, called *alharini* (Holmes and Lamb 1980, 41).

The cloth is further enhanced by the use of silk, which appears as a tan color that is gradually blended into both magenta and indigo *ikat* stripes, meaning that it is the area that was blocked to resist those dyes. The silk can be either natural or synthetic. Natural silk occurs in two forms in Nigerian textiles, either in weaving or in embroidered patterns, and comes from the species *Anaphe infracta* or *Anaphe molneyiare*. The Bororo Fulani herders collect the cocoons as they

traverse the savanna, and sell them in the markets in the Hausa towns of Kano, Zaria and Bida. Wild silk was rarely used in the later twentieth century, so it is possible that this cloth (see Pl. 14) was produced before 1980 in Ilorin (see Homes and Lamb 1980, 38, fig. 47 for a similar example), where in the 1970s elder spinners still remembered buying silk cocoons from Kano (1980, 39). Indigo and magenta *ikat* strips are juxtaposed with other striped patterns in dark blue, green, white, and light blue. The men's weave cloth consists of fourteen strips, each approximately 4 inches wide and woven on a double-heddle loom. Each strip has a distinctive pattern, demonstrating the great skill and versatility of the weaver, who has managed to harmonize the entire composition by the repetition of stripes and the strategic placement of the visually arresting *ikat* sections.

Oparo eleto can be classified as an *aso alaro*, a cloth appropriate for rites and ceremonies. *Oparo* cloth is one of at least three types of cloth made of *aso alaro* patterns that are presented to a fiancée from her future husband. An *oparo eleto* cloth must have the following six patterns in this order: *okun* (a dark blue with thin white stripes), *alikinla*, *jija*, *magie*, *eleku*, and *patugie*. The bride will wear the *oparo eleto* cloth a month after her marriage (Holmes and Lamb 1980, 46).

A cloth with a similar use of women's strip-weave—blue, red, and green colorants combined with *ikat* (Fig. 2), but for an entirely different purpose—was documented by Robin Poynor in *igogo* ceremonies in Owo, Nigeria:

> This was part of a seventeen-day festival known as *igogo*, the most important ritual observance in Owo in honor of a queen who was deified as an *orisha*. These men are the *ugbamas*, sort of a middle grade from a specific part of Owo, that part where the original

band from Ife live. In the *igogo* festival they march each day at a certain point, all dressed alike in trousers of a given imported print. On this particular day, they march single file through the city, dressed in what are referred to as *ipanmeta*. The *ipanmeta* is a large fabric made of several pieces of women's weave sewn side by side to produce a large toga-like wrap. All the *ipanmeta* are locally woven by women. Most are patterns of indigo and white stripes, although a few included *ikat*, and in this procession there was one *sheghoshen ipanmeta*. *Sheghoshen* is a very expensive weave of brilliant red with green inlay pattern. (Poynor, personal email, 11/18/10)

The two examples cited above of *ikat* used for *aso alaro—oparo eleto* and *ipanmeta*—hint at the endless variations generated by the most basic elements of construction, color, and pattern, and the shift in interpretation and cultural value as they are subtly reconfigured.

Adire Past and Re-Presented: "Olokun" Cloth and the Work of Nike Davies Okundaye

The Yoruba passion for indigo-dyed textiles is best illustrated by the proliferation of resist-dyed textiles, or *adire* (a Yoruba word meaning "to tie and to dye"). Although there are many methods of creating resist, such as tying (*adire oniko*) and sewing (*adire alabere*), the technique known as *adire eleko* uses a painted substance, originally cassava starch, as a resist to the dye. When dyed with indigo, the resist areas range from the light color of the cloth to pale blue, which is thought to form a pleasing contrast to the deeper indigo. For the most prestigious and costly cloths, the contrast is intensified because the dyer dips the cloth in the dyebath several times to achieve a metallic sheen, which lends the cloth both beauty and value.

Fig. 2. A procession of men (*ugbamas*) in the *igogo* ceremony wearing wrappers (*ipanmeta*) with *ikat* patterns. Owo, Nigeria, 1973. Photograph by Robin Poynor.

19

Adire was originally made with handwoven local cloth, but in the late nineteenth century, the British imposed taxes on locally produced cloth to increase the market for imported cloth from England (Wolff 2001, 52). Imported cotton sheeting provided a smoother surface that allowed the *adire* artists to create finer lines and shapes with crisply defined edges. With this new canvas, *adire* artists were inspired to create more elaborate and finely detailed designs. The art of *adire eleko*, using cassava starch, was introduced sometime between 1880 and 1925. By the mid-twentieth century, *adire* production reached its peak as *adire* artists produced a standard repertoire of recognized designs but also competed to create innovative variations that would attract greater attention to their wares. Abeokuta was a great center of *adire* production, and it is possible that the Saros or Sierra Leoneans descended from liberated slaves who had been relocated to Africa brought the art of *adire* there from the Mende people of Sierra Leone (Byfield 2002, 89, quoting Badejogbin 1983). Once established in Abeokuta, *adire* spread to other Nigerian cities, including Oshogbo and Ibadan, which also became important centers of *adire* production. Of the West African traders who came to the Yoruba towns for *adire*, Senegalese merchants were the most avid buyers of *adire* from Abeokuta. By the time *adire* production reached its peak in the 1930s, *adire* had become a symbol of wealth and prestige not only for the women who purchased and wore it, but for the artists who produced it (Wolff 2001, 52; Byfield 1993, 149).

The 1930s brought innovations in technology, including the sewing machine and metal stencils, that streamlined production and brought men into the former exclusive domain of women *adire* artists. However, handmade *adire* was still popular enough that European factories reproduced *adire* designs. During World War II,

cloth was scarce and *adire* production declined. After the war, cheap factory-printed cloth from Nigeria, Europe, and Asia, including imitation *adire* from Japan, flooded the market, and by the 1950s, there was a marked decrease in demand for *adire*. By the 1960s, though local people had little interest in producing such a labor-intensive cloth for use as women's wrappers, momentum was building for new applications of *adire*. Instead of confining their output to the two yard-lengths used for women's wrappers, the cloth could be sold by the yard. Bold new colors from synthetic dyes were used, and attracted a different clientele, mainly expatriates. It became known as the "new *adire*." The ease of using synthetic dyes, and the banning of imported cloth during the civil war of 1966–70, inspired many Nigerians to produce their own cloth using candle wax as a resist. By means of crumpling and folding waxed designs or freer applications of dripping or splashing the wax, a new *adire* aesthetic was created. Wax *adire* became so popular that, by the time of the Kampala Peace Conference during the civil war, it became known as Kampala cloth (Wolff 2001, 54).

Despite the fluctuations in the production of *adire* throughout the mid-twentieth century, *adire eleko*—with its powerful combination of indigo, the most desirable color, and finely painted and elaborately detailed patterns—remains as an icon of the Yoruba textile artistry (Fig. 3). An indigo resist-dyed textile collected in 1973 in Oshogbo, Nigeria, is named after Olokun, a sea goddess venerated by the Yoruba people (Pl. 2). Olokun has the power to bring wealth, and the cloth bearing her name was one of the most popular patterns among *adire eleko*. As Joanne Eicher has noted, *adire* patterns are an expression of the Yoruba worldview, and "seeking the good life is also a part of the Yoruba worldview. . . . The Olokun pattern calls attention to the Goddess of the Ocean who gives wealth and

Fig. 3. (above) A woman wearing *adire eleko* cloth collected by Joanne Eicher in 1974 outside Oshogbo, Nigeria. The cloth was uniquely modified by machine-stitching over the painted pattern, known as Ibadandun. Photograph by Joanne Eicher. From Susan Torntore, ed., *Cloth Is the Center of the World: Nigerian Textiles, Global Perspectives* (Saint Paul: Goldstein Museum of Design, University of Minnesota, 2001), p. 63.

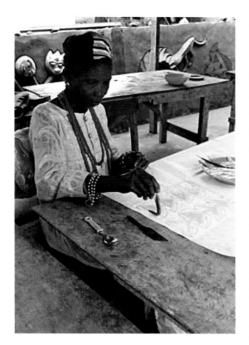

happiness to those who worship her" (Eicher 2001, 60).

The Olokun pattern is one of the richest and most intricate of the many *adire eleko* designs. No two *adire eleko* cloths are the same because they include endless compositional variations of old and new motifs, such as leaves, and different numerical configurations of the blocked-out designs. Olokun cloth has a conventional composition of two panels, divided into squares, bordered by rectangles. Each square has a different pattern that is duplicated on both panels to form a mirror image. The two panels are then sewn together. Signature motifs of the Olokun cloths are the floral design situated in the center, known as "leaves" or "stool," and those with birds, turtles, fish, and other fauna and flora associated with the aquatic realm of Olokun. These organic forms are rendered as highly abstract geometric forms, whereas other designs are purely geometric shapes. An example of the former, among this cloth's twenty-two motifs, is an image of a swimming turtle with concentric circles around it representing rippled water.

Production of *adire eleko* has dropped off since the 1970s, due to the labor-intensive hand-painting technique and the decline in the use of indigo dye, as noted by Robin Poynor, who collected the cloth. Poynor has noted that the Oshogbo market was brimming with every type of *adire* in 1973, but that today one would be hard pressed to find similar examples (Poynor, personal communication, 6/30/2007).

In a 2004 publication, Ulli Beier lamented the loss of Yoruba social and cultural values due to civil war in the 1960s, ensuing governmental corruption, and the devastating effects of globalization (Abiodun, Beier, and Pemberton 2004). But Beier's tone shifts as he describes those who are currently striving to revive what he perceives as a deep and rich cultural legacy. Among those he names is the artist Nike Davies Okundaye, whom he

credits with reviving "the ancient craft of indigo dyeing by forbidding her students to use an imported alternative" (2004, 61). Nike grew up in Ogidi, Nigeria, and learned *adire* from her aunt in Oshogbo (Picton, 1995, 17). She experimented with both early twentieth-century *adire* materials and techniques—indigo and cassava—as well as with making new *adire* with synthetic dyes and Kampala cloth with wax. Nike's latest venture is a Cultural Center established in 1990 in Oshogbo, with satellite workshops in Lagos, Abuja, and Ogidi that focus on batik production with indigo (Fig. 4).

The Harn example of a cloth collected from Nike in the 1980s, is an example of *adire alabere* (Pl. 1). The interplay of the light blue resist areas and the deeper indigo with the subtle texture of the perforated surface recalls early needle-resist techniques, but Nike's images and content—playful, nebulous forms that resemble elephants and are derived from her imagination and local lore—are the products of her own vision. While *adire* was most often created for wear as women's wrappers, this cloth with identical panels sewn at the selvedges, so that the resist areas form an abstract mirror image, can function equally well as garment or two-dimensional hanging. The amorphous resist shapes recall the organic and uncontrolled effect of Kampala wax-resist patterning, despite the fact that they were created with such meticulous hand-stitching. These are the qualities that distinguish this cloth as representing a new direction in the use of *adire*, fully grounded in the two earlier practices of Kampala and adire but animated by new subject matter and a new regard for the object quality of the textile, which allows it to move freely among the categories of "garment," garment as art, and simply art.

Fig. 4. (above) Ms. Eleha demonstrating resist technique onto a cloth at the workshop of Nike Art & Culture Foundation, Oshogbo, Nigeria, 1997. Photograph courtesy of the Nike Art & Culture Foundation.

Indigo Resist-Dyed Scarf by Aboubakar Fofana

Another recent effort to revive indigo-dyeing techniques can be seen in the work of Aboubakar Fofana, a Malian-French textile designer and calligrapher. Fofana's approach to indigo dyeing is informed by his multi-cultural and transnational experience. As a native Malian who was born in Bamako in 1967, he knew of Mali's long history as a center for indigo-dyed textiles. He has lived in France most of his life, and studied and worked in Britain in 2009. He obtained much of his practical knowledge of the craft of indigo dyeing when he was apprenticed to the master dyer Akiyama Masakazu in Japan in 2005. Fofana opened a textile workshop in Bamako in 2003, with the intention of reintroducing organic indigo-dyeing techniques, which have all but vanished due to the influx of synthetic dyes. His efforts address not only the aesthetics of natural indigo dyeing but its ecological advantages, since the use of synthetic dyes, in Bamako in particular, is responsible for the severe pollution of the Niger River. The indigo vats in his workshop contain only vegetal substances—both indigo and the ingredients necessary to maintain the longevity and color quality of the dyebath through a fermentation process comparable to earlier methods of dyeing (Fig. 5). His strip-woven textiles are made with only organically grown cotton and silk that is hands-pun and handwoven (Fofana, website).

The indigo-dyed scarf in the Harn collection created by Fofana clearly reflects his knowledge of technique and design from African sources (Pl. 3). The rich blue color of the cloth, the result of multiple immersions in the dye bath, recalls the textiles from West Africa of the late nineteenth century, and up to the late twentieth century, that reflected the value placed on the dark blue hues. The monochromatic tie-dyed pattern of small circles on handwoven cotton cloth is reminiscent of textiles originating with the Soninke people. This pattern extends from Guinea to Burkina Faso, and farther south into Côte d'Ivoire. Although such handwoven tie-dyed textiles are still made, they are seldom made with purely natural dyes. Fofana's attention to environmental concerns connects him to a growing number of contemporary designers in the world who seek sustainable processes for textile production, including many Africans who draw on earlier modes of dyeing, weaving, and designing from diverse locations on the continent (Christopher Richards, personal communication, 11/30/10). ◆

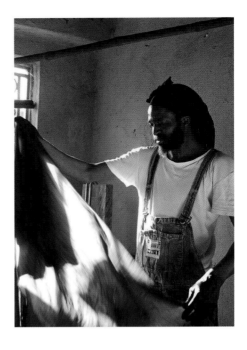

References

Abiodun, Roland, Ulli Beier, and John Pemberton. 2004. *Cloth Only Wears to Shreds: Yoruba Textiles and Photographs from the Beier Collection*. Amherst, Mass.: Mead Art Museum, Amherst College.

Badejogbin, O. A. 1983. "The Relation ship between Environment and Culture: Adire Industry in Southern Nigeria, A Case Study." B.A. honors essay, University of Ibadan.

Barth, Heinrich. (1857) 1965. *Travels and Discoveries in North and Central Africa in the years 1849–1855*. Vol. III. London: Frank Cass and Co. Ltd.

Boser-Sarivaxévanis, Renée. 1972. *Les Tissus de l'Afrique Occidentale*. Vol. 1. Bale: Pharos-Verlag Hansrudolf Schwabe AB.

Byfield, Judith. 2002. *The Bluest Hands: A Social and Economic History of Women Dyers in Abeokuta, Nigeria, 1890–1940*. Portsmouth, N.H.: Heinemann.

———. 1993. "Pawns and Politics: The Pawnship Debate in Western Nigeria." In Toyin Falola and Paul Lovejoy, eds., *Pawnship in Africa: Debt Bondage in Historical Perspective*, 187–216. Boulder, Colo.: Westview Press.

Eicher, Joanne. 2001. "Cloth Is the Center of My World." In Susan Torntore, ed., *Cloth Is the Center of the World: Nigerian Textiles, Global Perspectives*. Saint Paul: Goldstein Museum of Design, University of Minnesota.

Fofana, Aboubakar. Website: http://www.aboubakar-fofana.com.

Gardi, Bernhard. 2009. *Woven Beauty: The Art of West African Textiles*. Basel: Museum der Kulturen Basel / Christophe Merian Verlag.

Holmes, Judy, and Venice Lamb. 1980. *Nigerian Weaving*. Roxford: Hertingford-bury.

Musée du Tapis et des Arts Textiles de Clermont-Ferrand. 2000. *Afrique Bleue: Les routes de l'indigo*. Aix-en-Provence: Édisud.

Nike Davies Okundaye. Website: http://nikeart.com.

Torntore, Susan, ed. 2001. *Cloth Is the Center of the World: Nigerian Textiles, Global Perspectives*. Saint Paul: Goldstein Museum of Design, University of Minnesota.

Picton, John. 1995. *The Art of African Textiles: Technology, Tradition, and Lurex*. London: Lund Humphries in association with Barbicon Art Gallery.

Wolff, Norma. 2001. "Leave Velvet Alone." In Susan J. Torntore, ed., *Cloth Is the Center of the World: Nigerian Textiles, Global Perspectives*. Saint Paul: Goldstein Museum of Design, University of Minnesota.

Fig. 5. (above) Aboubakar Fofana in his Bamako-Mali studio. Photograph by François Goudier.

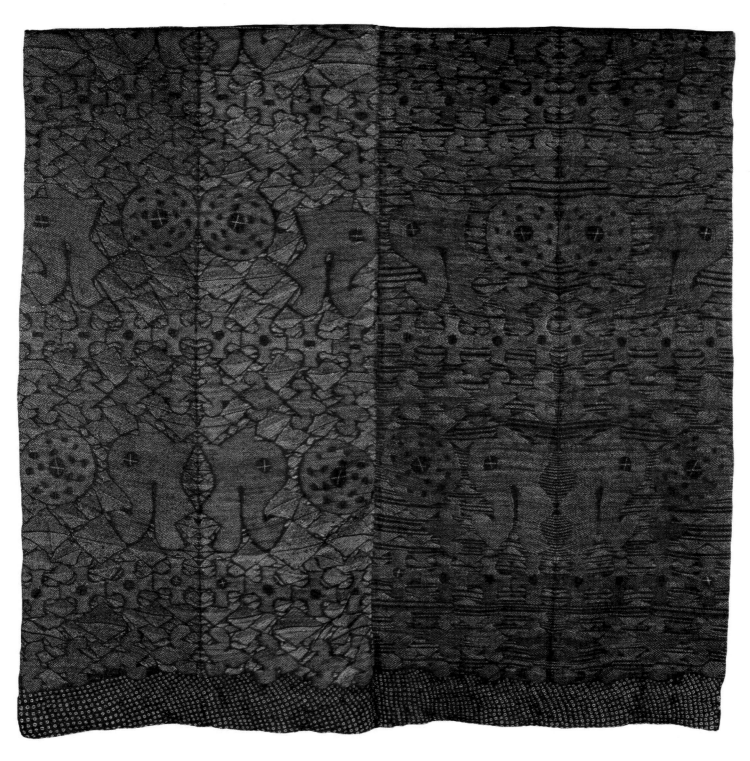

1

NIKE DAVIES OKUNDAYE
Nigerian, b. 1954
Indigo Resist-Dyed Cloth (*adire alabere*)
c. 1980
Cotton, indigo dye
56 x 65.5 in. (152.4 x 166.4 cm)
Gift of Christopher Hardymon Poynor
2006.32

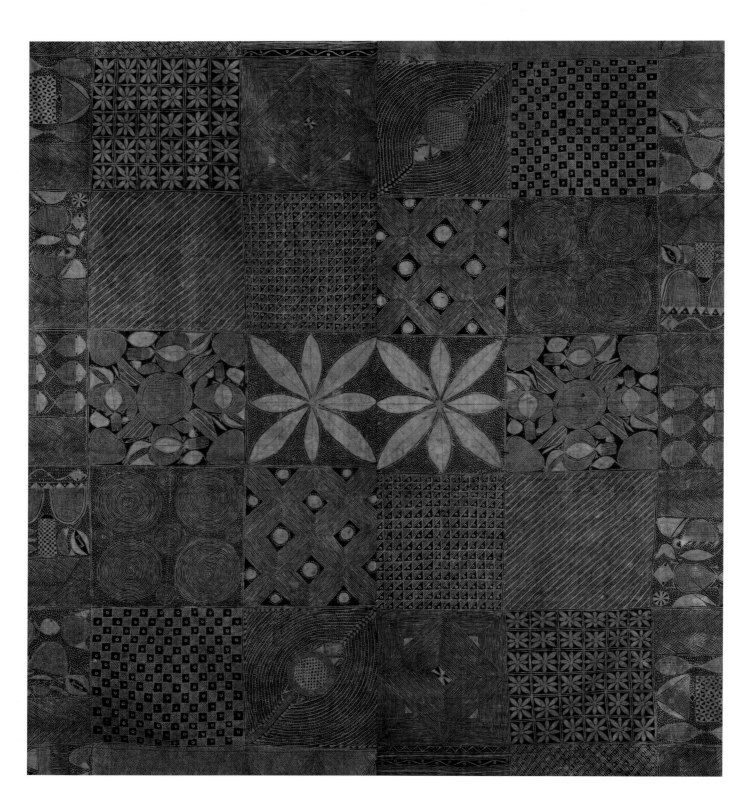

2 (above)
YORUBA PEOPLE
Nigeria
Cloth with Olokun, Goddess of the Sea Motif (adire eleko)
c. 1973
Imported cotton cloth, indigo dye with starch resist
77 x 71 in. (195.6 x 180.3 cm)
Gift of Dr. Robin Poynor
2007.30.1

3 (opposite page)
ABOUBAKAR FOFANA
Malian, b. 1967
Scarf
20th century
Resist-dyed cotton, indigo dye
24.5 x 55.12 in. (62.2 x 140 cm)
Museum purchase with funds provided by the Caroline Julier
and James G. Richardson Acquisition Fund
2010.2.4

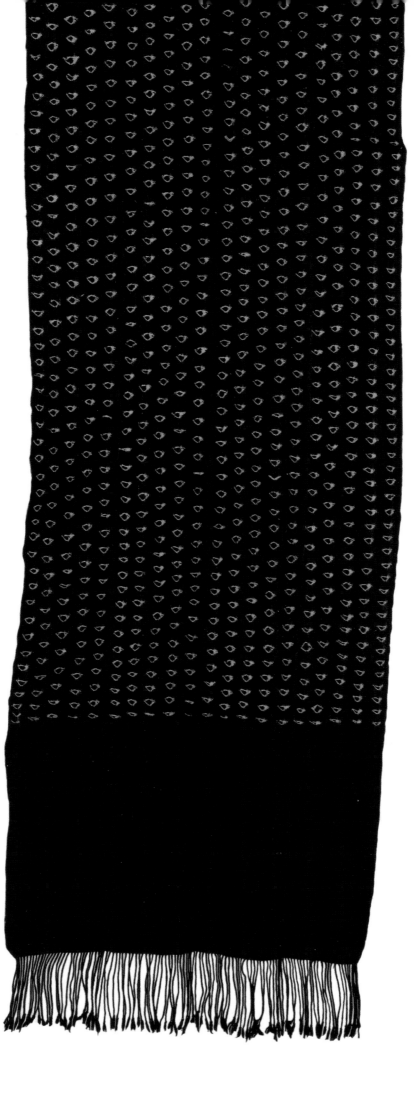

4 (opposite page)
YORUBA PEOPLE
Nigeria
Woman's Bridal Wrapper (oparo eleto)
1980
Cotton and silk with indigo and *albari* dye
68 x 55 in. (172.7 x 139.7 cm)
Museum collection, University Gallery purchase
T-82-156

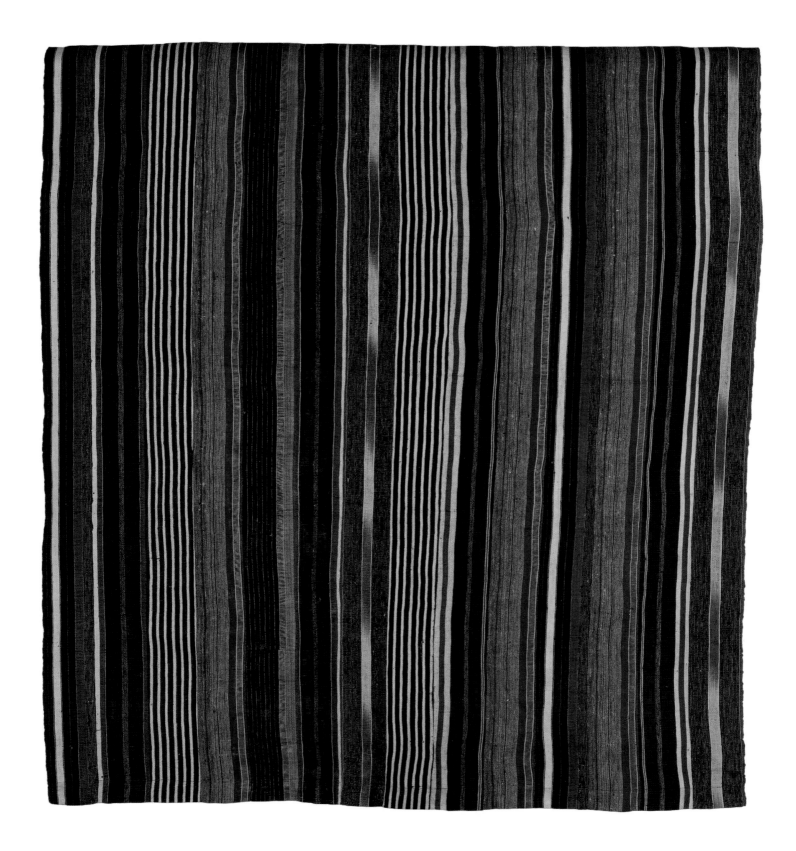

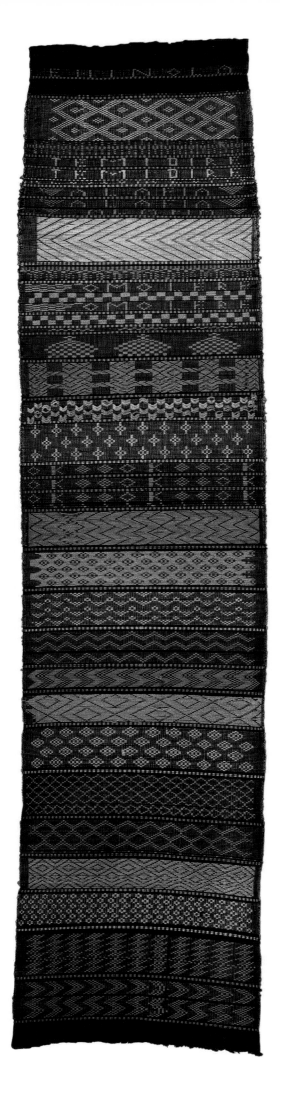

5
ELIZABETH ADEROGBA
Nigerian
Weaver's Sampler Cloth
c. 1973
Cotton, rayon
18.5 x 74.25 in. (47 x 188.6 cm)
Gift of Dr. Robin Poynor
2007.30.2

Robin Poynor

A Noble Multimedia/Intermedia Event:

THE *AKO* CELEBRATION OF THE OWO YORUBA KINGDOM

The year is 1943. A procession of women wearing their best wrappers flows through the streets of the city, dancing and singing, accompanying themselves with the percussive beats of the right hand slapping against a handwoven folded cloth held in the other. In the midst of the women, the king, Olagbegi II, moves. Escorting the throng, men and boys carry bundles of luxury foods and goods—200 plantains, 200 bean cakes, 200 sticks of sugar cane, 200 eggs, 200 kola nuts, 200 shillings, 200 pigs, 200 spinning sticks, and many other goods in groups or bundles of 200. All of them are members of the family of the king, and all the women are weavers.

Olashubude, the beloved mother of Olowo Olagbegi, had died some years before, and it is time now to honor her with *ako*. The celebration, sometimes referred to as "the second burial," may take place one, five, ten, perhaps even twenty years after the death of a noble person. It takes years to accumulate the wealth, to make the arrangements, and to carry out the many acts required.

Nine days after the first procession, after hundreds of fabrics have been cut from the vertical looms on which they have been ritually woven by women of the family, a life-sized effigy figure of Olashubude, dressed in her regal finery, will be set up in a decorated niche so family and friends can come to honor her memory (Fig. 1).

Finally, on the seventeenth day, the effigy will be paraded through the city accompanied by thousands who will sing, dance, and chant in her honor. Each of the hundreds in the family will wear a piece of the specially woven cloth. Hundreds of goats will be herded along the streets with the procession, to be distributed to families along the way or sacrificed at key shrines throughout the city. Then the effigy and one large piece of ritually woven fabric will be buried, and Olashubude will be a royal ancestor.

I have chosen the *ako* celebration to address the importance of cloth in the ritual activities of the community, but also to emphasize the ways in which many media have worked together to express the cultural and religious beliefs of the Owo Yoruba. In this event, which takes place over a period of seventeen days, processions, singing, the weaving of vast amounts of cloth, the carving of an effigy figure, the elaborate display of the figure, the wearing of ornate dress, the eventual burial of the figure and a portion of the cloth, and the preservation of the rest as cherished heirlooms all work together as a set of acts and visual phenomena to underscore the significance of the deceased, the position and importance of her noble offspring who sponsors the event, and the worth of the extended aristocratic family that he represents. In the distant past *ako* was likely a means, too, of establishing the deceased within the ranks of

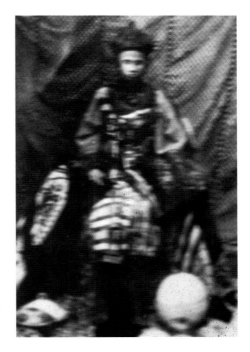

Fig. 1. This old and unclear photograph likely shows the effigy of Olashubude seated in state during the *ako* performed in her honor. The splendidly dressed figure is displayed in a niche festooned with large handwoven cloths and seated on a chair draped with cloths. It is not clear whether the crown on her head is carved as one with the figure or whether it is a coral bead coronet. Unknown photographer, 1943. Photograph courtesy of Robin Poynor.

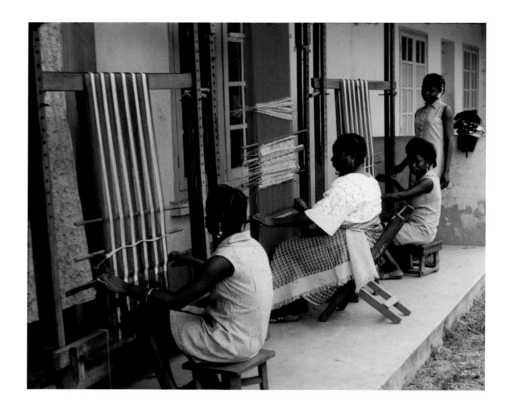

Fig. 2. Mrs. Olawalu and apprentices weave on carpentered vertical looms. Note the three sticks creating sheds, and the single-string heddle (*asa*) on the near loom and the multiple-string heddles on the central loom. Photograph by Robin Poynor, 1973.

the ancestors in the spirit world, but by the middle of the twentieth century it had become an ostentatious event that celebrated the living family and recalled the love and devotion with which the honoree was remembered.

In this essay I want not only to recognize the textiles produced by women in the Yoruba city of Owo, Nigeria, but also to explore how the act of production is a significant ritual activity, and how textiles and their production work in concert with other art objects and their creation in these contexts.

Owo, a large Yoruba town some 70 miles north of Benin and about 100 miles east of Ife, was once the capital of a powerful kingdom of the same name.[1] A center for weaving, it was known for the fabrics produced by women on vertical looms.

When I carried out fieldwork there in 1973, it was assumed that every woman in Owo was capable of weaving. I noticed the typical vertical loom (*ofi*) on verandas in almost every courtyard. For the traditional loom, two posts are set vertically in the ground. Two crossbeams are attached to them, over and

around which two ropes are temporarily looped. Three sticks are worked into the ropes, which hold them in place during the warping process. Eventually the ropes are removed. A single warp thread is tied to the lower crossbeam, to be passed over the top and back under the lower beam, which is repeated multiple times to achieve the desired width of the fabric, creating two parallel surfaces of vertically oriented threads. The threads in front are passed over or under the three sticks held by the ropes, in preparation for creating sheds of four/four threads. Eventually a heddle (*asa*) is created by placing the midrib of a palm leaflet behind the threads, and attaching every other thread to it by means of a string threaded in front of and behind the tread. When this heddle is pulled forward, a shed is created in which every other thread is either in front of or behind a stick or "sword" (*apasa*) inserted into the space. Secondary heddles can be created, sometimes as many as 35, in a similar manner, tying various numbers of threads to the *asa* in order to create patterns. In the traditional loom, a pit is dug

between the two vertical posts so that the weaver can sit on the floor of the veranda as she faces the loom, her feet comfortably positioned in the hole. More recently, some women have had looms constructed by carpenters to allow easier manipulation of the various parts, and rather than sitting on the ground with their feet in the pit, women sit on stools in front of the loom (Fig. 2).

In a 1928 District Officer's report, J. A. MacKenzie estimated that 80 percent of the women during that period of time produced fabric.[2] Textiles were created to be used by the family, but they were also produced on commission, and some were apparently sold in the market. MacKenzie assumed that cloth woven by the women of the community brought in a significant amount of income. Women's weave was used for dress, especially in garb that indicated status and prestige, but it also played significant roles in activities associated with religion, leadership, and passing from one age grade to another.

Owo's position on the far eastern edge of Yoruba territory makes it transitional between Yoruba-speaking peoples

to the west and Edo-speaking peoples to the east and south.[3] Archaeological excavations carried out in 1970 support Owo's claim of origin from Ife, the sacred city of Yoruba origins. In fact, naturalistic terra-cotta sculptures excavated there are quite similar to those created in Ife between the eleventh and fifteenth centuries.[4] Owo also seems to have been at times a significant power in its own right, its territories stretching north to Kabba, northeast to Akoko, and south to Okeluse. For a long time prior to the nineteenth century, however, Owo was drawn into the sphere of the dominant Benin Empire, just to the south, much more than it was drawn toward other centers of Yoruba civilization to the west. Benin, in fact, claims to have exercised military control over Owo, as well as over a number of other eastern Yoruba kingdoms, at least as early as the fifteenth century. Owo's location in this transitional area made it a kingdom of ethnic diversity. Local oral histories suggest that immigrants were accepted long after the settling of the territory by the Olowo (ruler) and his band from Ife. From all directions war refugees, losers in succession disputes in other kingdoms and towns, prisoners of war, and slaves captured by Owo war chiefs were absorbed into the amalgam that has become Owo. As might be expected in such a conglomerate, the art styles of Owo demonstrate a lack of homogeneity. Stylistic diversity is almost overwhelming and points to style areas from which many of the Owo immigrants claim to have come—Ekiti, Akoko, and especially from the Edo area, including both the kingdom of Benin and outlying Edo groups.[5] Textile production, like the creation of other art forms in Owo, reflects give-and-take among the various groups of people who make up the population.[6]

To consider the importance of textiles and textile production, I focused on a single type of textile used in the context of memorial activities for de-

ceased nobles in the past. My research into the *ako* celebration allowed me to realize the importance assigned to textiles in Owo life, the role of women in the production of textiles, and, perhaps more importantly, how textiles and textile production worked with other art forms to create a ritual whole. Among several types of burial ritual in Owo, *ako* is second only to the royal funeral ceremonies performed for the Olowo. But *ako* does not in fact involve actual burial of the deceased (Fig. 3). It is a long, complex, delayed funeral ritual that incorporates at least two lesser types of burial ceremonies, *ashigbo* and *oposi*. It is performed in honor of those few people, both male and female, who are members of a ruling family or of families of certain high chiefs.[7] In the recent past, it has been extremely rare. When Frank Willett visited Owo, chiefs were able to recall eleven ceremonies that had taken place from about 1909 to 1944.

Justine Cordwell photographed an effigy carved for an *ako* held in a village in the Owo vicinity in 1949, (Figs. 4 and 5) and I was told of two that took place in 1972—one in a satellite village, Ipele, and the other in a neighboring kingdom, Ifon. No *ako*, however, have apparently been staged in Owo proper since 1944. The proceedings for *ako* may start as soon as nine days after the burial of the deceased,[8] but as mentioned earlier, the ceremony is expensive and the family may have to save for years after the interment to amass the amounts of money and in-kind payments necessary to perform the elaborate funeral. Cordwell was told in 1949 that the second burial can take place anywhere from three months to three years after the corpse is disposed of,[9] and informants in Owo in 1973 suggested that even greater lapses of time may be necessary.

A number of art forms and what we might consider art events—displays and processions—are part of the seventeen-day celebration of the memory

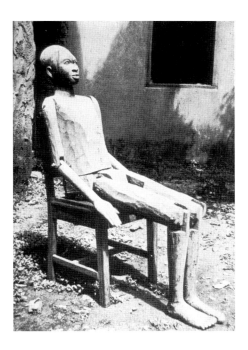

Fig. 3. (above) The effigy carved by Ologan for the *ako* celebration of Olashubude in 1943. This figure was not used; another, carved in its place (perhaps that shown in Fig. 1), was actually buried as part of the ritual. Photograph by Frank Willett, 1958.

31

of the deceased. What many consider to be the most important is the ritual carving of the *ako* effigy, a jointed wooden puppet intended to be clothed in the most sumptuous gowns of the deceased. The faces, hands, and feet of the images are finished with attention to detail, whereas the parts of the body that will be covered by clothing are less carefully carved (see Figs. 3 and 4). The arms and legs are attached to the body with bolts and spikes, and the hip joint is made so that the figure can assume a sitting position. Willett maintains that such wooden images are of recent invention.[10] He believes they replaced an older type made of straw, less naturalistic because of their medium.[11] He even believes that the recent naturalism of the wooden figures could possibly be the result of European influence. Rowland Abiodun claims that straw was indeed used before wood and that its light weight enabled the figure to be carried throughout the town on men's shoulders.[12] The introduction of a rickshaw-like vehicle to carry the image on its ritual journey through Owo made the heavier medium

acceptable if not preferable. In his view, however, the naturalism associated with the figures preceded the introduction of wood. He asserts that a special kind of clay-like material called *amaje* was modeled over the straw for the head, arms, and legs, and that the application of vegetable pigments to these portions of the figure further heightened the naturalistic effects.[13]

The *ako* celebration takes seventeen days to perform. Preparations begin when a number of cows are sacrificed to announce the performance.[14] After this, all the women of the family march together to the house of the Sashere to seek permission to use the special *ashigbo* funerary cloth. It would appear that the "copyright" to *ashigbo* belongs to two Owo families, those of the Sashere and the Ugwaba, and the right to use it must be purchased with vast quantities of ritual goods. *Ashigbo*, described as having stripes of light blue and dark blue interspersed with white and black bands, is said to have been brought to Owo by a slave woman captured during war by the Ugwaba, who was a sub-chief of the Sashere.[15]

When she was presented to the Sashere, he asked what she could do, to which she replied that she could weave a cloth called *ashigbo*. Thus the most prestigious cloth in Owo was introduced by a slave woman of unknown (today) origins.

On occasions when an effigy is not used, the *ashigbo* rite is considered to be a second burial in itself. For the *ako* ceremony, the *ashigbo* must be woven during a nine-day period under ritual conditions. The courtyard in which the weavers work must be kept immaculately clean, the walls scrubbed daily and the floor swept often. Sexual intercourse or any other activity that may jeopardize the ritual purity of the artisans is avoided during this ritually hazardous period. The women must produce a prodigious amount of weaving: one very large piece to be buried in the grave, a second large piece to be kept by the successor of the deceased, and great numbers of smaller pieces to be kept as mementos by other family members who have participated. Once the weaving of the ritual cloth has begun, so can the carving of the lifelike figure.[16] This, too, is considered a part of the

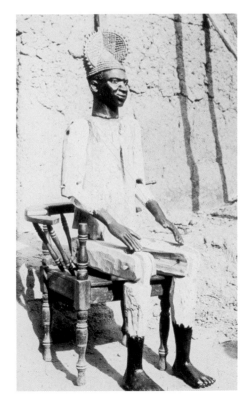

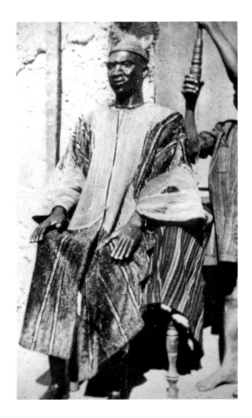

Fig. 4. (left) An effigy figure carved in a satellite village of Owo was buried as part of the *ako* ritual. Notice that those portions of the figure to be covered by garments are less carefully finished. Photograph by Justine Cordwell, 1949.

Fig. 5. (right) Another view of the effigy figure shown in Figure 4. Photograph by Justine Cordwell, 1949.

ceremony, and numerous ritual pro-
scriptions, not unlike those placed on
the weavers of *ashigbo*, are placed on
the artist, his assistants, and those who
come into contact with them during
the carving process. The courtyard in
which the activity takes place, the carver
himself, and his assistants must be
physically clean as well as ritually pure.

After the figure has been carved,
it is dressed in rich clothing and beads.
If it is male, it is dressed in the full
paraphernalia of the chief it represents.
If it is a chief's mother, it is dressed in
her most splendid garments. The figure
is placed in a "well-decorated" place
in the house, where it is visible for a
nine-day period called *ako gwigwe*.[17] Two
extremely unclear 1943 photographs
of *ako* figures seated in state show
effigies in extravagant handwoven
wrappers (Figs. 1 and 6). They indicate
that that the display area was draped
with large handwoven cloths. Such
cloths form the backdrop, a drape to
cover the chair, and a ground in front
on which to place offerings and gifts.
In at least one display, sculpted atten-
dants were placed on either side of the
effigy figure. Bowls and calabashes
appear to have held gifts for the deceased.
Those I interviewed suggested that
the front of the house was decorated
as well.

During the ritual viewing period,
women selected from important families,
especially those families that had per-
formed *ako* in the past, sit in a semicircle
around the effigy, singing songs and
chanting the praises of the deceased.
The family offers large amounts of
food and drink to the vast number of
callers who visit during *ako gwigwe*.[18]

Nine days prior to the final cere-
mony, men of the family begin to dig
a grave. Five days before the final
ceremony, the *oposi* rite takes place.[19]
Willett states that among the Yoruba,
the second burial ceremony generally
employs an empty coffin.[20] The Owo
oposi ceremony, in which a coffin is
paraded around town, is performed

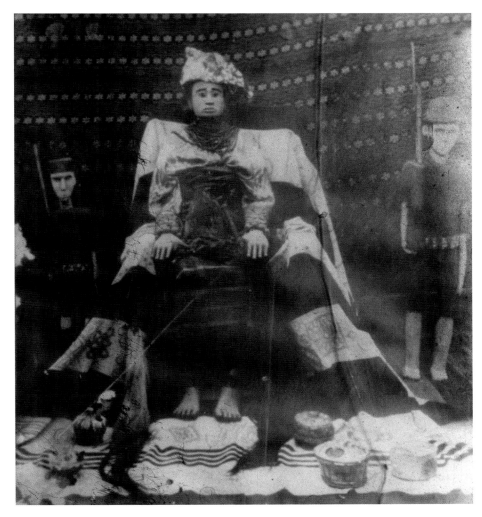

as a part of the actual interment or as
part of the second burial rites. The
coffin is made of palm ribs and is
kept in the house of the Osowe of
Ehinogbe quarter. When a family
wants to perform *oposi* as a second
burial, a representative asks the Osowe
for the use of the coffin. It is then
spread with cloth to suggest that the
body is actually in the casket. If the
ashigbo ceremony is being performed,
the *ashigbo* cloth is spread over it. The
draped coffin is then danced around
the town with a procession of musi-
cians and "plays."[21]

In the *ashigbo* ceremony,[22] the
cloth is taken from the casket and
placed in the reopened grave. Once
the ceremony has been performed, the
palm-rib casket is returned to its place
in the house of the Osowe. Abiodun
states that *oposi* was traditionally recog-
nized as a part of the first burial. After

Fig. 6. (above) This out-of-focus photograph
from the 1940s shows an *ako* figure seated in
state. The sumptuously dressed figure sits upon a
cloth-draped chair against a backdrop of
patterned women's-weave. The *ako* figure, perhaps
carved to represent the mother of the Sashere in
1943 or 1944, is flanked by sculpted attendants in
military dress. Unknown photographer, 1943.
Photograph courtesy of Robin Poynor.

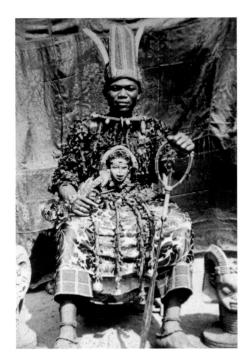

death, the corpse was kept in the house for eight days and preserved by burning various herbs. On the eighth day an empty coffin (*oposi*) was paraded around town by relatives and friends, and eventually to the house where the deceased lay. The *oposi* was then removed and returned to its keeper, and the corpse was publicly displayed for the first time. Modern health laws now prevent the keeping of the body for that length of time, and *oposi* has thus come to be seen as a "separate stage of burial."[23]

Finally, on the last day of *ako*, the figure is taken through the streets on a cart or is placed on a stool and carried on the shoulders of servants or male members of the family. Many shrines are visited as the procession follows the image around the town, accompanied by the successor of the deceased.

Any other titled members of the family dress in full chiefly regalia, wearing the *orufonran* costume (Fig. 7). The *orufonran* (or *ofon*) costume is said to have been introduced from Benin. The tunic is made of imported red wool cut into scalloped pieces that are sewn in overlapping layers to suggest the scales of the pangolin, or scaly anteater. In Figure 7, a wrapper of two-colored damask in a floral or foliate pattern is worn over a pair of embroidered trousers as the lower portion of the costume. Ivory or cast-brass ornaments in various forms are attached to the tunic, including representations of human faces, human figures, ram's heads, leopards, crocodiles, frogs, and bells. Two objects are tied at the waist—a sword or dagger, called *udamalore*, and a tie that ends in rather large diamond shapes. The sword may be made of brass or

Fig. 7. (above) An aristocratic, titled man who sponsors *ako* in honor of a deceased parent, such as the Oludasa of Owo shown here, wears the elegant *orufonran* costume on the last day of the ceremony to process through town. Photograph by Justine Cordwell, 1949.

Fig. 8. (right) Each of the hundreds of members of the extended family wears a narrow piece of ashigbo during *ako*. Women of the family are said to wear the piece with three narrow indigo bands as a head-tie. Men wear strips with two bold indigo stripes flanking a central white stripe diagonally across the chest. Photograph by Donna Poynor, 1973.

ivory, and a number of them have been made of wood covered with decorative imported beads. Armlets of either brass or ivory serve also as rattles when the chief moves and dances. Such an elegantly dressed title-holder will also carry an *ape*, or ceremonial dance sword, which he throws into the air to catch on its return to earth. The dance sword also has jangles that serve as sound-making devices.[24] Hundreds of relatives dressed in finery, friends, and curious onlookers join the throng as it progresses through Owo.

A great many goats—some say 200, others say as many as 300—are taken to be sacrificed at shrines along the way[25] and to be presented to each compound in which *ako* was performed in the past.[26] Well-wishers present the celebrants with gifts of palm wine as groups of musicians and dancers, each followed by a multitude of admirers, make their way along the figure's path. Informants suggest that each individual unit within the extended family is expected to sponsor such a group, and that between 50 and 100 such "plays" may be performed during the event. The procession is followed by drinking, feasting, and dancing at the home of the deceased.

After all this has taken place, the *ako* figure is borne back to the compound, where it is placed again in its textile-decorated niche. Then, the day after the procession, it is buried as if it were a human body, clothed in finery and wrapped in *ashigbo*.[27] It is said that in the past a slave was sacrificed and buried with it, but in more recent times a sheep has been killed and placed in the grave.

Three months after the *ako* burial, the head of the compound takes a he-goat and calls the family together to parade once more around the town singing. On the return home, the goat is sacrificed. *Ako* is complete. Now the deceased has been buried properly, and the living members of the family have increased their status and prestige. Each person has one of the many small pieces of *ashigbo* as a sign of participation (Fig. 8), and the family has the right to claim a goat the next time *ako* is performed in Owo.

The seventeen-day festival is thus a multimedia/intermedia event that includes the ritual weaving of great quantities of cloth by great numbers of individuals in a collective effort by the family. An effigy that is intended to resemble the honored ancestor is carved under ritual conditions at the same time. A special niche is decorated with handwoven textiles, offering containers, and often with secondary guard figures, as a place to pay respects to the deceased and to honor his or her family. On the final day, the sumptuous garments of the celebrants are set off by pieces of the ceremonial fabrics as the procession moves through the town making sacrificial offerings. Finally both the effigy and one large piece of fabric are buried, bringing to a close the multimedia, intermedia event of *ako*. The event is remembered through the individual pieces of cloth kept by celebrants and family members as heirlooms. ◆

Acknowledgments

Original research for this project was funded by a Fulbright Hays Fellowship. Scott Horsley, acting director of the Visual Resources Center at the University of Florida, scanned a number of my 1973 field slides to be used in this essay.

References

Abiodun, Rowland. 1976. "A Reconsideration of the Function of *Ako*, Second Burial Effigy, in Owo." *Africa* 46, no. 1: 4–20.

Bradbury, R. E. 1957–61. BS Series field notes from Benin Scheme 1957–61. The Library, University of Birmingham, Birmingham, England.

Cordwell, Justine. 1952. "Some Aesthetic Aspects of Yoruba and Benin Cultures." Ph.D. dissertation, Northwestern University.

Eyo, Ekpo. 1972. "New Treasures from Nigeria." *Expedition* 14, no. 2: 2–11.

Fagg, William. 1951. "De l'art des Yoruba." *Présence Africaine* 10, no. 1: 103–35.

Lawal, Babatunde. 1977. "Art and Immortality among the Yoruba." *Africa* 47, no. 1: 50–61.

MacKenzie, J. A., and Mr. Purchas. 1928. *Report on Owo Division, Ondo Province*, 1928. National Archives, Ibadan, Nigeria. Serial #124, agency mark 21546.

Poynor, Robin. 1987. "Ako Figures of Owo and Second Burials in Southern Nigeria." *African Arts* 21, no. 1 (November): 62–63, 81–83, 86–87.

———. 1981. "Fragment of an Ivory Sword (*Udamalore*)." In Susan Vogel, ed., *For Spirits and Kings: African Art from the Paul and Ruth Tishman Collection*, 133–34. New York: The Metropolitan Museum of Art.

———. 1980. "Traditional Textiles in Owo, Nigeria." *African Arts* 14, no. 1 (November): 47–51 and 88.

———. 1976. "Edo Influence on the Arts of Owo." *African Arts* 9, no. 4 (July): 40–45 and 90.

Willett, Frank. 1966. "On the Funeral Effigies of Owo and Benin and the Interpretation of Life-Size Bronze Heads from Ife, Nigeria." *Man* n.s. 1: 34–45.

Notes

1 According to the GeoNames geographical database, the current population of Owo is 276,574. http://www.geonames.org/

2 MacKenzie 1928, 25.

3 Owo is located at 7° 11′ 0″ North, 5° 35′ 0″ East.

4 See Eyo 1972. Radiocarbon dates for terracotta heads and figures from Owo suggest they were created in the middle fifteenth century, coincident with the period of Ife archaeology known as the Pavement Period. See ibid.

5 I discuss relationships between Owo and the Edo region and resulting stylistic influences in Poynor 1976.

6 For a more extensive exploration of weaving traditions in Owo, see Poynor 1980.

7 Rowland Abiodun states that *ako* is usually reserved for men with titles, but a woman "may be eligible" when she is the mother, daughter, or wife of a chief. A man who does not have a title at the time of death but who has been successful by traditional standards may be installed as a chief posthumously by the Olowo at the request of his children. This must take place before the burial of the corpse. See Abiodun 1976. In at least one instance, according to my Owo sources, *ako* was performed for a living person: Omakogbe, an illustrious holder of the title Oludasa, had the ritual performed for himself before his death, acting as host and "figure" at the same time. He was carried from point to point in the procession, and at places where dancing took place, he himself got down and danced. After his death, his children performed *ako* for him a second time. I was told of another instance in which a person performed a funeral ritual before her death, in this case a childless woman who wanted to ensure that she was sent off in a proper manner into the world of the dead. Her funeral was, of course, of a lesser type.

8 Abiodun 1976, 6.

9 Cordwell 1952, 224.

10 Willett 1966, 38.

11 In Benin, the deceased Oba, two other high chiefs (the Ezomo and Ihama), and the Queen Mother are honored in a ceremony also called *ako*. For this ceremony a figure about 48 inches high is constructed of a wooden frame covered with red cloth. It is dressed in ceremonial garb, including beads of office and a beaded crown. The figure is carried through the streets by two people supporting its hands and elbows. R. E. Bradbury (1957–61 BS Series field notes) states that the figure was carried on a person's head. Chief Ihama of Benin told Paula Ben-Amos that some may actually be rolled along the street on wooden wheels. (Paula Ben-Amos, personal communication, 1976). The figure in the Bradbury photograph (see Willett 1966, pl. 4a) is shown with its feet on the street, its elbows and hands supported by men positioned to either side. Bradbury speculates that the function of the ceremony was to establish the deceased in his own rank in the afterlife, and to express the perpetuity of

the earthly office. While the effigy was paraded dressed in the beaded insignia of office, the successor accompanied it wearing nothing but a wrapper around his lower body. After a period during which he and the effigy were isolated from the community, he would appear at his own installation wearing the beads of office (Willett 1966, 35). It is enticing to look to the *ako* ceremony in Benin as the unquestioned source for the Owo *ako* tradition. Owo was under the control of that Edo kingdom for many years, and many other cultural similarities suggest that Owo derives much of its court ritual and art from Benin. Willett, for one, believes that *ako* in Owo may have derived from that source, pointing out that the word *ako* is also used in Benin for both the figure and funeral ceremonies for the Oba, the Queen Mother, and the two high-ranking chiefs (Willett 1966, 35), as already mentioned. Abiodun, in contrast, does not believe the purposes of the two are necessarily the same, and he questions Willett's assumption that the Benin phenomenon is the original one. Also, considering the ways in which certain Olowos of Owo renamed chieftaincies to make them more Benin-like, it is possible that older Owo rituals were given updated Benin names as well (Abiodun 1976, 7, 8). See also Poynor 1987.

12 Abiodun 1976, 9.

13 Ibid.

14 Abiodun's sources (1976, 9) suggested that as many as ten cows and an appropriate number of goats were offered to "wash the cow's" feet.

15 At the time *ashigbo* was introduced, the title was Ungagwe, but it was later changed to the Sashere. Sashere Osangbuse was supposedly in office at the time it was introduced. The first holder of the title arrived in Owo from Utelu.

16 In the late twentieth century it was said that the carver was shown a photograph of the deceased in order to ensure a more realistic likeness. Abiodun's informants (1976, 10) suggested that before the advent of photography, children who resembled the deceased parent would be asked to model for the effigy. It seems that photographs of the deceased can also serve as a substitute corpse in some instances. Lawal 1977, 52.

17 Abiodun 1976, 10.

18 This great amount of public ritual activity is not in accord with Cordwell's statement that the "visit of the dead to the living is kept secret until the last minute" and "the townspeople are caught by surprise when they see a figure that so closely resembles the one who has died" (Cordwell 1952). The preparations that take place prior to the appearance of the figure may be somewhat secret, but they cannot be completely so. The dancing of the women en masse to receive permission to weave *ashigbo* cloth; the accumulation of large amounts of thread for weaving it; the hectic weaving activity over a nine-day period; the accumulation of vast amounts of food and

the preparation of fresh foods daily for weavers, carvers, and all callers; the sounds of carving; the nine-day *ako gwigwe* period in which special songs are sung around the figure set up in a special courtyard—taken together, these do not suggest total secrecy on the part of the family or ignorance on the part of the public. The degree of surprise at the resemblance of the figure to the deceased may not be so great, either. The time lapse between the death and the celebration may serve to fog the memory. The fact that a photograph or another person has served as a model does not ensure an exact likeness. The effect is also lessened because figures are usually carved to represent the deceased at the peak of health and at a younger age. Moreover, one must consider that a certain degree of stylization takes place in even the most realistic works.

19 *Oposi* can be part of the actual interment of the body, a part of *ako*, or a separate second burial. In *oposi*, cloths are used to decorate the coffin, which is owned by a specific family and loaned to other families who want to use it.

20 Willett 1966, 43.

21 A "play" is any festive performance by a musical group, a dance troupe, a masquerade, or any sort of performer. Here the reference is to musical/dance performance.

22 As with *oposi*, *ashigbo* can be a stage in an actual burial, a part of *ako*, or a specific "second burial" by itself.

23 Abiodun 1976, 5, 6.

24 The *ape* is identical in form to the ceremonial sword (*eben*) used by the nobles of the court of Benin. For more on *orufonran*, see Poynor 1976 and Poynor 1981, 133–34.

25 Two especially important shrines are Onaola and Omitako. If these sites are not visited, the *ako* will be declared "not performed." These sites are said to be the places where early houses in Owo existed and where the first priest of Owo lived.

26 Abiodun (1976, 12) was told that more than 200 goats were used in this manner for a 1920 *ako*.

27 William Fagg (1951, 134) suggests that the figure was preserved "dans une sorte de tombeau." Willett (1966, 35) says it was buried in a normal grave, similar to that of the deceased and close to it. Several informants told me in 1973 that it is buried in the dung heap or trash heap. Sr. Philomena of the St. Louis hospital in Owo was invited to view the carving used in an *ako* ceremony in Ipele near Owo in 1972, and was told that it was to be taken to the bush and destroyed.

6
MRS. OLAWALU
Nigerian
Head-tie (*olifon*)
1973
Cotton
18.62 x 82 in. (47.3 x 208.3 cm)
Gift of Dr. Robin Poynor
2007.37

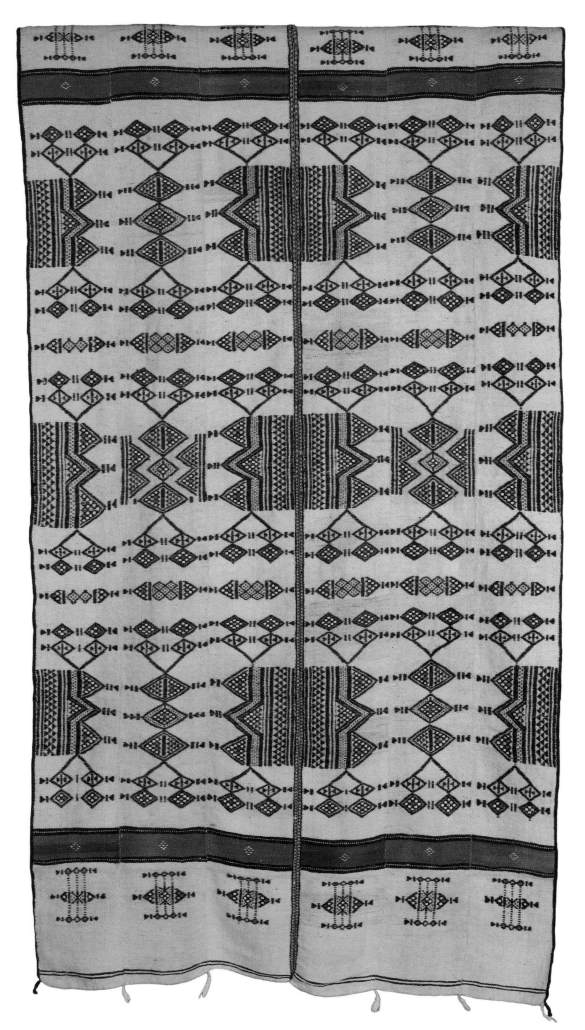

7
FULANI PEOPLE
Mali
Blanket (*khasa*)
20th century
Woven textile, wool, cotton,
camel hair, vegetable dyes
103.5 x 54.5 in.
(262.9 x 138.4 cm)
Gift of Dr. Ronald and
Diana Cohen
2001.38.1

Cynthia Becker

Trans-Saharan Aesthetics:

TEXTILES AT THE DESERT FRINGE

For centuries, nomads, scholars, merchants, and artisans interacted and traded across a web of trans-Saharan trails. People carried lightweight portable goods, such as woven textiles, silver jewelry, painted leather bags, and carved calabashes across the Sahara. Patterns easily crossed from one artistic media to the next. According to the scholar Labelle Prussin, the movement of people and objects across the Sahara resulted in "similarities in the iconography, materials, style, and technology of select forms and formats in architecture, metalworking, and embroidered and woven textiles."[1] Jewish artisans, who were renowned for their embroidery and dyeing skills, as well as Arab and Amazigh merchants and scholars, carried and traded cloth, jewelry, and other objects, many of which were influenced by Ottoman styles, across north-to-south and east-to-west routes, from urban to rural areas and back again.[2] In fact, centuries of trans-Saharan contact meant that Islamic beliefs and practices from the north became so deeply woven into Sahelian African cultural life that it is practically impossible to distinguish pre-Islamic aesthetics from those influenced by contact with the north.

The trans-Saharan trade began to decline with the arrival of Europeans off the Atlantic coast and with the resulting competition between Atlantic and Saharan trade. By the beginning of the twentieth century, the importance of trans-Saharan commerce had severely declined. Europeans defined the Sahara as the dividing line between Africa south of the Sahara and Africa north of it, and this increasingly shaped African history, contributing to the ideas of a "sub-Saharan" Africa and of an African continent separated along racial lines.[3] The group of textiles in the Harn collection that originated along the fringes of the Sahara, including the contemporary nations of Morocco, Tunisia, Egypt, Mali, and Niger, demonstrates the deep interwoven history of Africa north of and south of the Sahara. Although they were woven and used after the decline of the trans-Saharan trade, their shared aesthetic style demonstrates the historical legacy of this contact.

The Legacy of Amazigh Textiles

Key to understanding the trans-Saharan aesthetics that define textiles at the desert fringe is the history of the Imazighen, the indigenous inhabitants of northern Africa, popularly known as Berbers in the north and as Tuareg in the Sahara and Sahel. Nomadic women across northern Africa once commonly wove wool tents and storage bags on horizontal ground looms. In addition, they used vertically mounted looms to make a variety of carpets, clothing, belts, and bags. The origin of the vertical loom remains unknown,

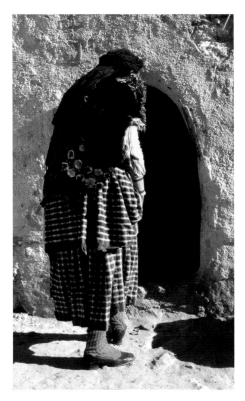

Fig. 1. (below) A woman wearing a flatwoven woolen shawl draped over her shoulders. Tajira, Tamerza (town), Matmata Region, Tunisia. Photograph by Irmtraud Reswick, January 1986.

but Phoenician and/or Roman settlers may have introduced it to Amazigh women at an early date.[4] Similarities in Amazigh weavings from the Siwa Oasis in Egypt to the mountains of Morocco can be attributed to the portability and versatility of the vertical loom used by women, which is lightweight and easy to assemble and move.[5]

In rural northern Africa, until the 1970s, women's dress typically consisted of garments woven on a vertical loom. Women's styles of dress corresponded to principles of modesty within Islam, but, unlike women in urban areas, rural women typically did not cover their faces with cloth when leaving their homes because the manual labor they performed made this cumbersome and impractical. Instead, Amazigh women living along the Saharan fringes once commonly wore flatwoven wool shawls draped over their shoulders and/or their heads (Fig. 1). Specific styles varied from region to region but typically featured intricate woven or embroidered geometric patterns, such as those seen in the woman's head-shawl (*tajïra*) from the small rural Tunisian town of Matmata included in the Harn exhibition (Pl. 12).

A woman wove the head-shawl from white wool and added narrow patterns to the lower edge with white cotton thread. She dyed the entire shawl with dark blue dye, but before it was dyed, she tied chips of wood or grains of wheat into small bunches with a dye-resistant material, such as a sliver of palm leaf. The entire fabric was dyed blue, and the resisted areas were then spot dyed with various colors so that the base and its fringes were enhanced with repeating red, yellow, and orange circular tie-dye patterns. The narrow cotton patterns did not absorb the dye and remained white.[6]

Several aspects of this head-shawl from Matmata (see Pl. 12) reveal the complex multicultural history of southern Tunisia and its history of contact with Sahelian Africa. Until the early twentieth century, the tie-dye technique was widely practiced by Imazighen in southern Libya, Tunisia, and Morocco to adorn shawls as well as women's belts. Tie-dye is also associated with a wide area of western Africa from Sierra Leone to Nigeria, and the existence of this technique on both sides of the Sahara suggests a historical connection between the two regions. Moreover, most scholars believe the tie-dyeing technique moved to the north from the south.[7]

The embroidery on the upper border of the Tunisian head-shawl resembles that found throughout northern Africa, where women use brightly colored yarn purchased in local markets to embroider designs on their shawls. More specifically, the embroidery found on the Tunisian head-shawl resembles that woven on the indigo-dyed head-coverings typical of southeastern Morocco (Fig. 2). In both examples, women have treated cloth as an empty canvas and used a running stitch to embroider designs. Unlike the embroidery in Morocco, rural embroidery in Tunisia tends to the figural and includes stylized birds, fish, palm trees, leafy plants, and five-fingered hands. Five is an auspicious number because there are five obligations of Islam and Muslims pray five times a day. Therefore hand motifs, as well as abstract patterns with five projections that can be interpreted as stylized hands, protect against the evil eye. The evil eye can be described as a glance or look accompanied by a compliment that hides feelings of envy. The evil eye can cause bad luck, illness, and even death, and women may embroider or weave motifs to absorb the harmful effects of this malevolent gaze. In southern Morocco and Tunisia, Amazigh women often sewed metal sequins on their embroidered shawls. While sequins enhance the decoration of the garment and allow it to shimmer in the bright sun of this desert environ-

Fig. 2. A group of Amazigh women in the southeastern Moroccan town of Hafira sit with the backs of their embroidered indigo-dyed and black cloth head-coverings facing the camera. Photograph by Cynthia Becker, 2000.

Fig. 3. An Amazigh bride rides a mule to the bridal tent and is joined by a procession of women in rural southeastern Morocco. Photograph by Cynthia Becker, 2001.

ment, they can also be interpreted as mirrors that deflect the dangerous energy of the evil eye.

The motifs and colors used to embroider a larger Tunisian shawl (Pl. 9) also resemble those embroidered on an Amazigh woman's wedding dress in Egypt. For example, in the Siwa Oasis, unmarried Amazigh girls embroider geometric patterns on the many dresses and trousers that they expect to wear during their seven-day wedding (Pl. 13). Each day of the wedding, the bride changes her clothing and her jewelry. On the third day, when the bride receives her parents and family in her new home, she wears a white tunic with two narrow panels of black fabric on its sides. A girl will cover the white wedding tunic, called an *asherah nahuak*, with red, green, yellow, and black embroidered designs that include seven intricately embroidered

squares arranged around the V-shaped opening of the dress. In addition, girls embroider numerous lines of geometric patterns on the front of the dress so that they appear to radiate from the neckline. These are further adorned with mother-of-pearl buttons. On the seventh day of the wedding, the bride wears a similar garment, except in black. Under her dress, she wears white cotton trousers with embroidered cuffs. A girl's trousseau contains seven pairs of trousers, one for each day of the wedding. After the wedding, these trousers are worn on a daily basis as undergarments.[8]

Some scholars refer to the patterns that radiate out from the neckline as a sunburst and associate it with the worship of the ancient Egyptian sun god Amon-Re, since Siwa was home to a Pharaonic temple dedicated to the sun god.[9] However, it is problematic to assume that the belief system of those

living in the Siwa Oasis has remained unchanged since Pharaonic times. In many areas of the desert fringe, Amazigh women use similar colors and motifs, suggesting a shared aesthetic. Amazigh women throughout northern Africa commonly use black, yellow, and/or orange, red, and green dyed wool to weave carpets and blankets. They construct leather bags from these same colors and embroider these colors on their head-coverings. Rather than see the use of red, yellow, and orange as evidence of an ancient sun-worshipping cult, these colors are better analyzed as evoking fertility and prosperity.[10] In fact, women in the Siwa Oasis compare the colorful embroidery to the colors of ripening dates, a major cash crop in the oasis that signifies wealth.[11] In addition to signifying economic status, an analogy can be made between ripening dates

and the blossoming of a girl's body into that of a woman. The association of these colors with female fertility is also demonstrated by their being worn by Amazigh brides during wedding ceremonies across northern Africa (Fig. 3).

Women also weave protective motifs on textiles for their fathers, husbands, and sons. For example, in the Siroua Mountains, Ait Ouaouzguite men wore a hooded cape—called an *akhnif* in Tashelhit, the local Amazigh language—woven from dark brown or black wool and decorated with a long elliptical design woven with red or yellow wool, interpreted as a protective eye motif (Pl. 10). The region of the Siroua Mountains was also home to a large Jewish population, whose members were known as excellent textile dyers and who most likely influenced textile production in the region. In fact, while Amazigh men wore the striking eye-like decoration facing the outside, Jewish men of the region wore the same capes, but they wore theirs inside out as a sign of their difference.[12] Men in Morocco no longer wear this cape, and, although they continue to be woven in Morocco, such capes are reserved for the tourist market today.

The bold red eye-pattern of this complex woven-to-shape textile (see Pl. 10) is enhanced by intricate patterns done by tapestry-weaving and brocading techniques.[13] Unlike the figural embroidery worn by Amazigh women in southern Tunisia, the textile motifs on the *akhnif* do not visually depict plants or birds. Rather, they resemble greenish-blue geometric designs women once commonly had tattooed on their bodies. Women tattooed the faces, hands, and ankles of Amazigh girls when they reached first menstruation, making tattoos an important symbol of a girl's marriageable status.[14] Given the fact that tattoo and textile motifs resembled each other, one can deduce that both are gendered symbols of women's creative powers. When the warp threads

are attached to the vertical loom, women believe the carpet is metaphorically born and acquires a soul, echoing women's role in human reproduction. According to anthropologist Brinkley Messick, some Berber weavers physically straddle the warp threads and beams of the loom before they are raised, symbolizing the metaphorical birth of the textile.[15] In southeastern Morocco, women believe that a textile then moves through youth, maturity, and old age as it is woven. Women have the power of life over a weaving, and when the weaver finishes it, she cuts it from the loom and splashes it with water, as in the washing of the deceased before burial. This anthropomorphization of the textile underlines women's reproductive and creative powers and, by equating textiles with the giving of human life, reinforces women's centrality to the maintenance of Amazigh society.[16]

South of the Desert Fringe
Unlike Amazigh female weavers on the northern fringes of the Sahara, Peul weavers living near the Niger bend in Mali are men, and, rather than using a vertical loom, they weave on a narrow-strip treadle loom. The origin and age of the treadle loom in western Africa are unknown, but textile remains from the Bandiagara cliffs in Mali demonstrate that it was used as early as the tenth or eleventh century, and by the fourteenth century, cloth strips produced on a treadle loom served as currency across western Africa. As Islam spread across western Africa, the demand for modest Muslim attire increased, developing a market for weavers, tailors, and embroiderers.[17]

In Mali, male weavers belong to a hereditary group called Maboube, who are sedentary artisans who inherit their trade from their fathers. They weave a variety of blankets for transhumant Peul who move with their cattle in search of animal fodder. During Mali's cold dry season, which stretches

from November to January, men use blankets, called *khasa* (Pl. 7), to protect themselves from the cold weather as well as the mosquitos that breed in the large amounts of stagnant water that gather on the floodplains of the Niger River.[18] *Khasa* are made to order, so a man who wishes to commission a blanket purchases the necessary yarn, spun and dyed by women, in a local market and gives it to the weaver.[19] Until the early twentieth century, weavers made blankets from wool, but today weavers typically use cotton thread for the warp.[20]

Blankets are usually 6 to 8 feet in length and consist of four to six narrow panels sewn selvedge to selvedge. The background of the blanket is white, with patterns done primarily in black with red and yellow highlights (see Pl. 7). Patterns form distinctive lozenge, triangular, and chevron shapes. Fulani weavers name individual blanket motifs after aspects of the transhumant herder's environment. These geometric designs, made of repeating diamonds and triangles, represent water containers, the herders' path, various parts of a woman's body associated with fertility, and topographic features of the natural landscape.[21]

Once the first length of a blanket is woven, the weaver must carefully measure the distance between the designs of the remaining five, since the best blankets have patterns that match up when the lengths are stitched together. Intricately made *khasa* are kept in a family for years, though poorer-quality ones are often used for a season and then sold in the large market of Mopti in Mali.[22]

Since the 1960s, weavers in urban areas, such as Mopti and Bamako, have been weaving multicolored blankets from factory-spun and synthetic-dyed cotton threads. These blankets, called *tapi*, consist of strips sewn together to create innovative and vibrant patterns, such as the repeating diamond configuration seen in Plate 7. While these blankets often feature patterns adapted

from *khasa*, they demonstrate the creativity and diversity of Malian textiles. These colorful blankets, used as wall hangings and bed coverings, have begun to replace the prestigious woven *arkilla kereka* that commonly formed part of a Fulani bride's trousseau (Pl. 11).[22] Typically made of goat and sheep's wool with the recent addition of cotton, the large size of the *arkilla kereka* and its intricate patterns mean that few weavers have the skills necessary to make one and that few families can afford to buy one. Upon commission, the weaver moves to the client's village and lives there during the two months required to weave the textile. The cloth is so prestigious that a client kills a bull when half of the textile is complete and holds a festival when it is entirely finished.[23] A similar tradition of itinerant weavers also existed in the urban centers of northern Africa, where professional male weavers once commonly traveled from city to city, plying their trade on demand.[24]

Further comparisons can be made between textiles north and south of the desert fringe. Although Fulani textiles are made from individual narrow strips that are sewn together, patterns between the strips are aligned in order to replicate the horizontal bands common to Amazigh textiles woven on the vertical loom.[25] In fact, the word *khasa*, used by the Fulani to refer to woven blankets, also means "blanket" in the Moroccan dialect of Arabic, reinforcing the historical connection that existed between northern and Sahelian Africa. A similar word is also used in the Tunisian Sahel to refer to boldly colored wall hangings, which are called *ksaya*. Women in the Tunisian Sahel, in particular the coastal city of Jebeniana, weave boldly colored textiles that feature bands filled with repeating geometric patterns and separated by solid colored bands. The flatwoven *ksaya* in the Harn collection (Fig. 4) was used as a wall covering. People regarded the elaborately woven *ksaya* as a luxury item, and, rather than

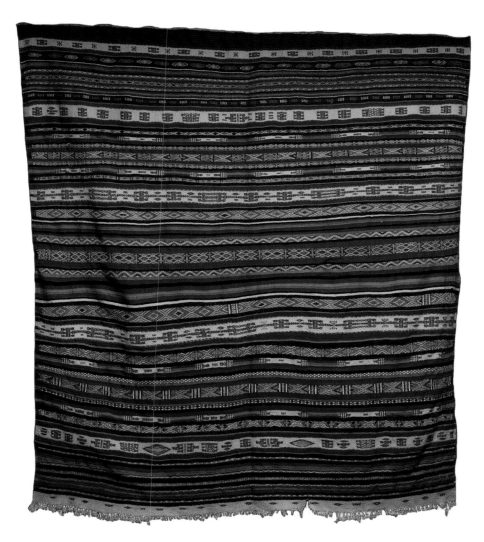

making it for the market, it was woven as part of a bridegroom's trousseau to be displayed in his bedroom. Further demonstrating the valor given to such textiles is the fact that they were rolled around a beam above the bed and only taken out of storage to be displayed during festive occasions.[26]

The dominant color of both the Tunisian *ksaya* and the Malian *kereka* is red. In addition to sharing similar color palettes, individual patterns found on both sides of the Sahara resemble each other. Repeating zigzag, triangle, diamond, and X-shaped configurations dominate. On both sides of the Sahara, weavers name zigzag patterns after things present in their everyday environment, such as "the road," "water," or "snake." Women on the desert fringe also tattoo similar patterns on their cheeks, temples, and foreheads. In Niger, these motifs

Fig. 4. Tapestry (*ksaya*), Berber people, Tunisia, c. 1973. Harn Museum of Art collection; museum purchase with funds provided by the Caroline Julier and James G. Richardson Acquisition Fund.

43

resemble those embroidered on garments worn by Wodaabe men and women, a pastoralist subgroup of the Fulani.

Aesthetics among pastoralists, such as the Wodaabe, concentrate on body adornment, such as tattooing, body painting, braided hairstyles, and such lightweight, easily portable objects as leather amulets and carved calabashes for milk and millet porridge. The repeating symmetrical geometric and curvilinear patterns tattooed on bodies and carved on calabashes include an hourglass form that is called different names by Wodaabe, such as "temple tattoos," "Qur'anic slates," and "calf-rope." More important than individual names is the fact that these patterns assert ethnic identity, are considered to cure eye diseases and other illnesses, and evoke aesthetic pleasure for the Wodaabe, who consider them beautiful.[27]

Women embroider these same patterns onto the indigo-dyed cotton tunics worn by Wodaabe men (Pl. 17) during the annual performances, such as the *geerewol* and the *yaake* dances. The narrow rectangular tunic, open at the sides, is formed of thin strips of handwoven and hand-dyed indigo cotton cloth. The body and sleeves are embroidered with rectangles filled with repeating patterns. The tunic served as one part of an elaborate ceremonial ensemble worn by men, which could also include leather belts, headbands adorned with ostrich plumes, broad-

rimmed hats covered with feathers and tassels, as well as layers of beaded jewelry and leather amulets. The long, narrow textile emphasized the ideal characteristics of a young male dancer—which include a tall, slim figure, a "red" or light complexion, an aquiline nose, a narrow face, thin lips, big eyes, and white teeth, in addition to being well dressed and exhibiting charm and intelligence. In addition, men shave their hairlines to heighten their foreheads, and darken their eyes and lips with black kohl to make the whites of their eyes and their teeth appear whiter. Men may also paint a straight line of yellow or red pigment across the center of their foreheads and along the top of their noses to make their noses appear long and slim. Symmetrical patterns are also favored, and men paint similar patterns on both sides of their cheeks.

During their dances, men stand in a row, shoulder to shoulder, and compete in a contest that includes chanting and dancing (Fig. 5). During the competition, men widen their eyes and quiver their black-painted lips in order to please the young female judges who choose the most attractive and charismatic performer. During the *yaake* dance, for example, male dancers rise to the tips of their toes, bending their knees while gracefully swinging their arms forward and backward. In doing this, they strive to imitate the grace and elegance associated with the long-legged white cattle egret, attempting to harness the power of the bird. Young women, who stand at a distance, choose the winner among the men, and the "names of male beauty contest winners are remembered for several generations."[28] Clearly, the aesthetics of the long, narrow, symmetrically embroidered cotton tunics, which evoke characteristics associated with male attractiveness, are infused with rich cultural meanings deeply interwoven into Wodaabe ceremonial life.

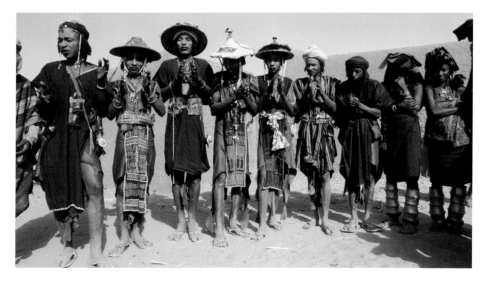

A Shared Aesthetic on the Desert Fringe

Although contemporary scholarship typically divides the African continent across racial lines, into an Arab Muslim "white" north and a sub-Saharan indigenous "black" south, this artificial boundary, "which slices Africa in two, conceals the extraordinary combinations that have been created over the centuries."[29] A historically complex and rich artistic culture developed in the Sahara and at the desert fringe. Although this essay has concentrated on woven and embroidered textiles such as shawls, blankets, and clothing, there is also a consistency of style across artistic media, with engraved calabash bowls, body tattoos, and leather bags resembling each other.

Centuries of contact in and around the Sahara as well as the mobility of artisans resulted in the movement and exchange of artistic styles across this vast geographic zone. Influencing this shared trans-Saharan aesthetic is also the fact that the adornment of the body and the exchange of lightweight portable items, rather than bulky and heavy terra-cotta objects or figurative wooden sculptures, characterizes the aesthetics at the desert fringe. Many people living in or near the Sahara share a nomadic or pastoralist history. While the Islamic faith discourages the representation of the human body, art created and used by nomadic and pastoral cultures, inspired by the anthropometry of the human body, displays intricate symmetrical surface patterns that can be divided into two halves that mirror each other. Jewelry, textiles, and leather bags often contain long fringes or chains that move when the body moves, suggesting that kinetic energy and movement are also important aesthetic elements.[30]

In addition, there is a preference for dark blue textiles across the desert fringe, from Tunisia to Niger, for many of the textiles include wool or cotton thread dyed a dark blue that was undoubtedly inspired by natural indigo dye. Though synthetic dyes have been common since the nineteenth century, early Islamic writers mention the preference for indigo in Sahelian Africa at an early date, and according to Prussin, Jewish merchants likely controlled the trade in indigo.[31] Over the centuries, designs, symbols, materials, and beliefs crossed from north to south and east to west as nomads, scholars, and artisans communicated, traveled, and traded across a web of trans-Saharan trails. Although the trans-Saharan trade declined in importance by the early twentieth century, textiles from northern and Sahelian Africa continue to reflect the legacy of this historical contact and reveal the shared trans-Saharan aesthetic that exists along the desert fringe. ◆

References

Becker, Cynthia. 2006. *Amazigh Arts in Morocco: Women Shaping Berber Identity*. Austin: University of Texas Press.

Bovin, Mette. 2001. *Nomads Who Cultivate Beauty: Wodaabe Dances and Visual Arts in Niger*. Uppsala: Nordic Africa Institute.

Gardi, Bernhard. 2003. "Textiles contemporains du Mali: utile à porter, beaux à regarder." In Bernhard Gardi, ed., *Textiles du Mali d'après les collections du Musée National du Mali*, 106–112. Bamako, Mali: Musée national du Mali.

Imperato, Pascal James. 1979. "Blankets and Covers from Niger Bend." *African Arts* 12, no. 4: 38–43, 91.

———. 1976. "Kereka Blankets of the Peul." *African Arts* 9, no. 4: 56–59, 92.

———. 1973. "Wool Blankets of the Peul of Mali." *African Arts* 6, no. 3: 40–47, 84.

Kriger, Colleen. 1990. "Textile Production in the Lower Niger Basin: New Evidence from the 1841 Niger Expedition Collection." *Textile History* 21, no. 1: 31–56.

Lamb, Venice. 1975. *West African Weaving*. London: Gerald Duckworth & Co. Ltd.

McDougall, Ann. 1998. "Review Article: Research in Saharan History." *Journal of African History* 39, no. 3: 467–80.

Messick, Brinkley. 1987. "Subordinate Discourse: Women, Weaving, and Gender Relations in North Africa." *American Ethnologist* 14, no. 2: 210–25.

Prussin, Labelle. 2006. "Judaic Threads in the West African Tapestry: No More Forever?" *Art Bulletin* 88, no. 2: 328–53.

———. 1986. *Hatumere: Islamic Design in West Africa*. Berkeley: University of California Press.

Reswick, Irmtraud. 1985. *Traditional Textiles of Tunisia and Related North African Weavings*. Los Angeles: Craft and Folk Art Museum.

———. 1981. "Traditional Textiles of Tunisia." *African Arts* 14, no. 3: 56–65, 92.

Sorber, Frieda. 2002. "Textiles of Daily Life, The Siroua: Siroua Costumes." In Niloo Imami Paydar and Ivo Grammet, eds., *The Fabric of Moroccan Life*, 251–59. Indianapolis: Indianapolis Museum of Art.

Spring, Christopher, and Julie Hudson. 1995. *North African Textiles*. London: British Museum Press.

Tissières, Hélène. 2002. "Maghreb-Sub-Saharan Connections." *Research in African Literatures* 33, no. 3: 32–53.

Notes

1 Prussin 2006, 328. Also see Prussin 1986.
2 Amazigh is the singular and adjectival form of "Imazighen," a word used to refer to the indigenous inhabitants of North Africa, popularly called Berbers.
3 McDougall 1998, 468.
4 Reswick 1981, 56.
5 For a discussion of the horizontal and vertical loom, see Spring and Hudson 1995, 35–39.
6 Ibid., 114–15.
7 Ibid., 114.
8 Ibid., 75.
9 See ibid., 66.
10 Women in southeastern Morocco, for example, consider red and yellow to be bright colors associated with sunlight, and describe green and black as dark colors. Hence they carefully arrange their embroidered patterns and place light and dark colors, which are believed to complement each other, next to each other in order to balance a textile design. See Becker 2006, 69–70.
11 Spring and Hudson 1995, 66.
12 Sorber 2002, 251–52.
13 Ibid., 252.
14 Becker 2006, 56.
15 Messick 1987, 213.
16 Becker 2006, 34.
17 Kriger 1990, 39. For early Arab and European sources on the history of West African narrow-strip weaving, see Lamb 1975.
18 Imperato 1973, 42.
19 Ibid.
20 Ibid., 47.
21 Ibid., 45–47.
22 Gardi 2003, 106–111 and Imperato 1979, 42–43.
23 Gardi 2003, 106 and Imperato 1976, 56–58
24 Prussin 1986, 48.
25 Ibid., 49.
26 Reswick 1985, 92.
27 Bovin 2001, 68–69.
28 Ibid., 68.
29 Tissières 2002, 32.
30 Becker 2006, 119.
31 For more information on the trans-Saharan indigo trade, see Prussin 2006, 345.

8

PEUL OR SONGHAY PEOPLE
Central Mali
Tent Liner or Wall Hanging (tapi)
20th century
Cotton, synthetic dyes
104 x 63.5 in. (264.2 x 161.3 cm)
Museum purchase with funds provided by the Caroline Julier and
James G. Richardson Acquisition Fund
2009.9.1

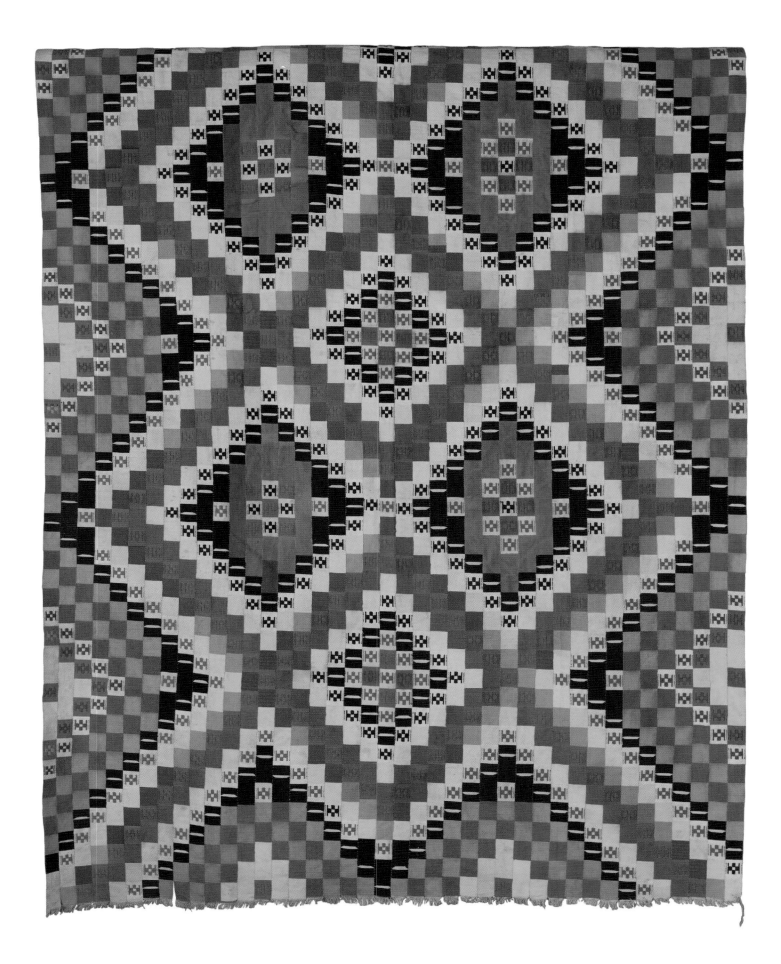

47

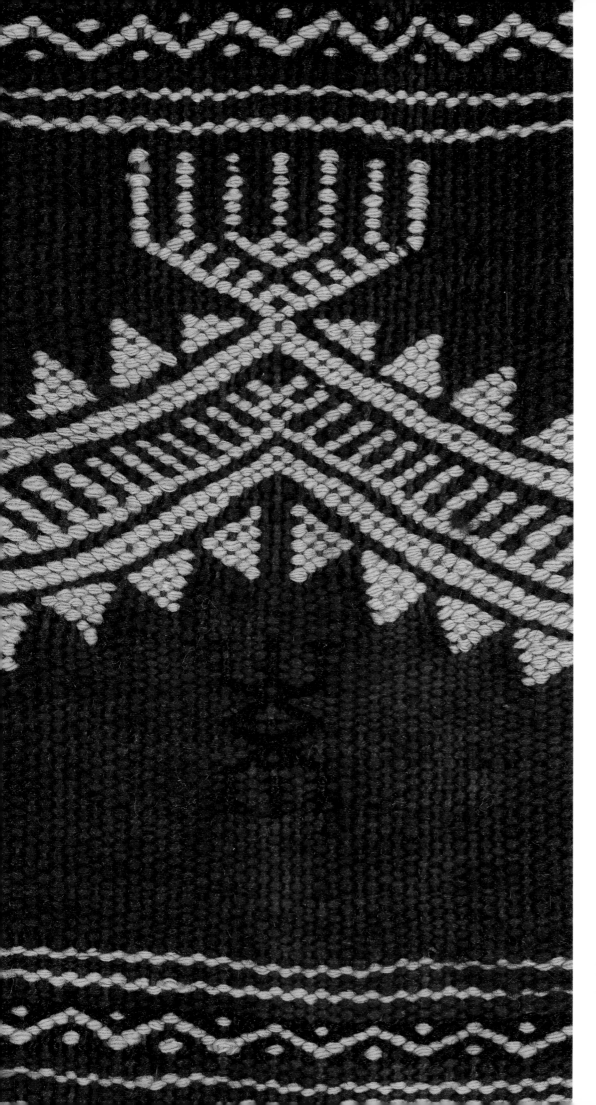
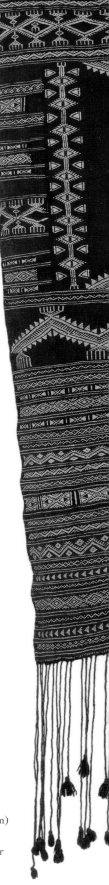

9

AMAZIGH PEOPLE
Tatouine, Tunisia
Woman's Head-Shawl (*bakhnug*)
20th century
Cotton, wool
67 x 65.25 in. (170.2 x 165.7 cm)
Museum purchase with funds
provided by the Caroline Julier
and James G. Richardson
Acquisition Fund
2009.32.3

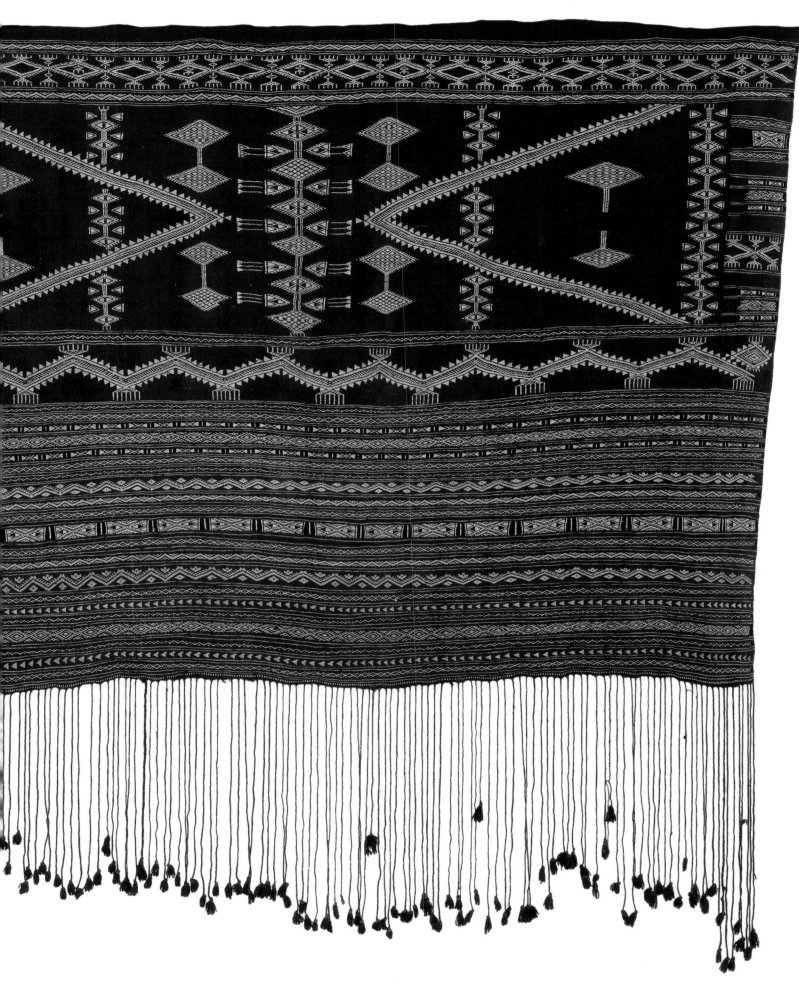

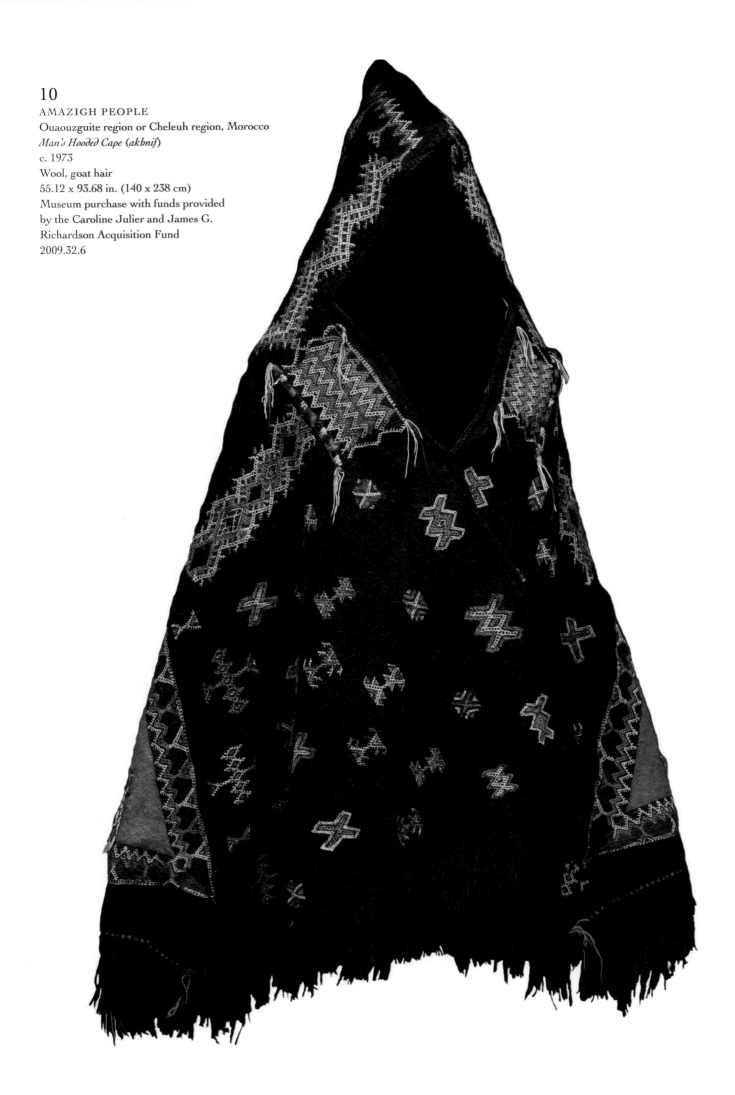

10
AMAZIGH PEOPLE
Ouaouzguite region or Cheleuh region, Morocco
Man's Hooded Cape (*akhnif*)
c. 1973
Wool, goat hair
55.12 x 93.68 in. (140 x 238 cm)
Museum purchase with funds provided
by the Caroline Julier and James G.
Richardson Acquisition Fund
2009.32.6

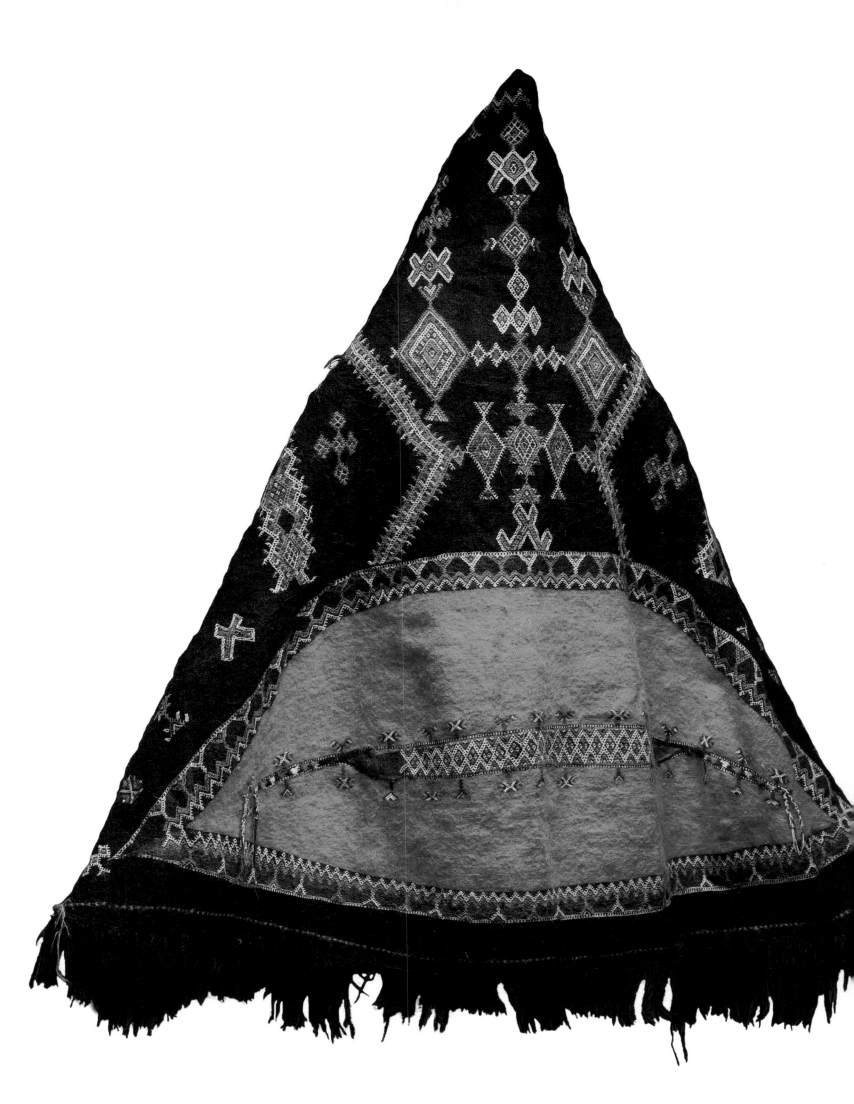

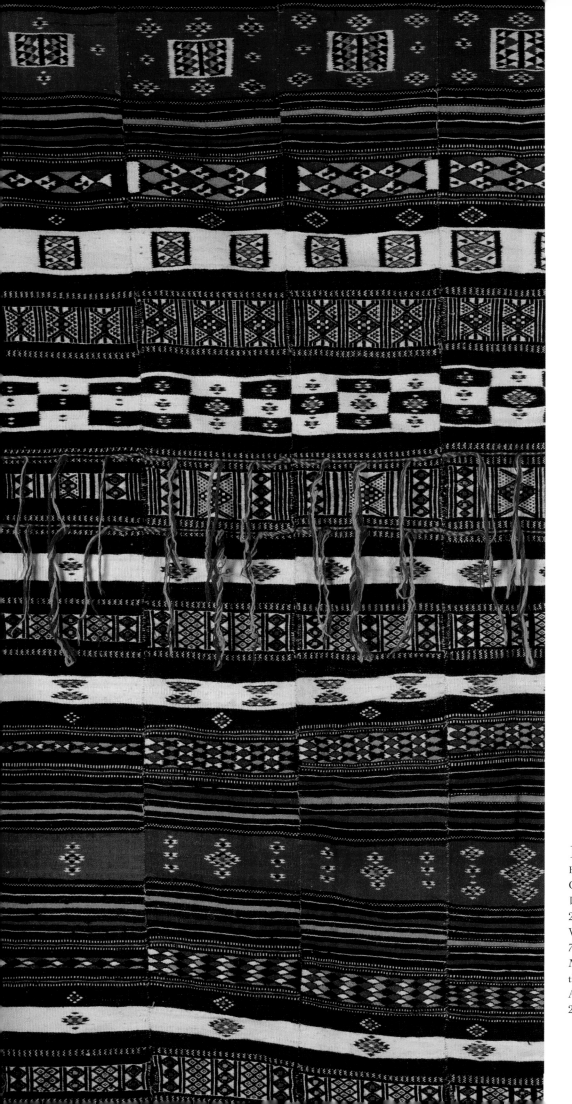

11 (opposite page and left for detail)
FULANI PEOPLE
Goundam, Mali
Wall Covering (*arkilla kereka*)
20th century
Wool, cotton
70.87 x 181.5 in. (180 x 461 cm)
Museum purchase with funds provided by
the Caroline Julier and James G. Richardson
Acquisition Fund
2009.32.8

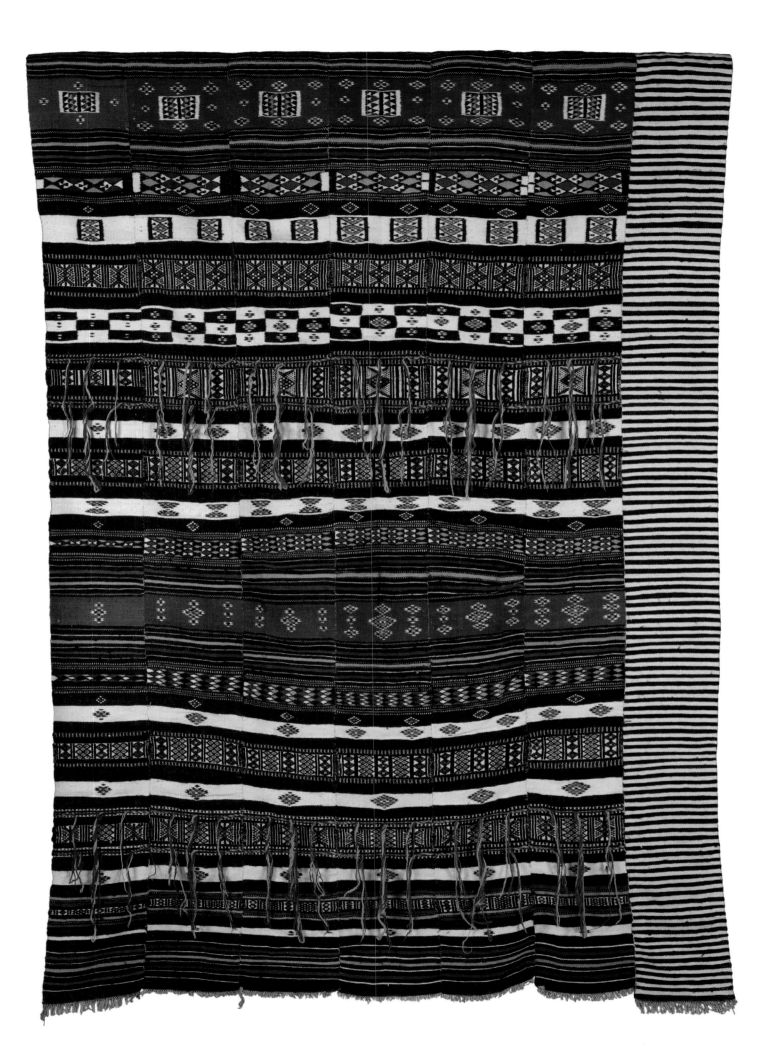

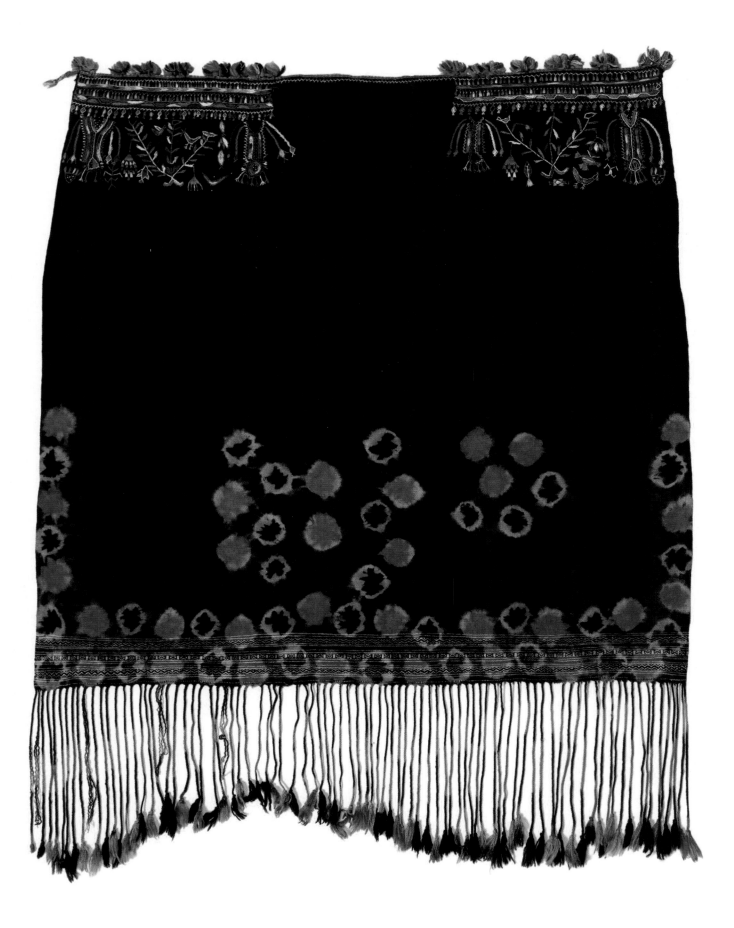

54

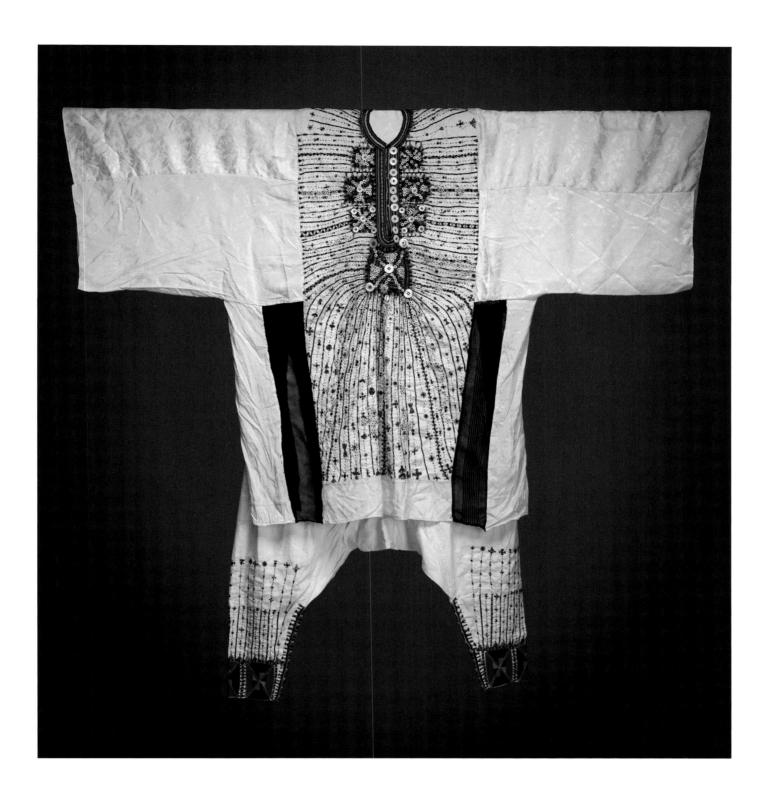

12 (opposite page)
AMAZIGH PEOPLE
Matmata, Tunisia
Woman's Head-Shawl (tajira)
Late 20th century
Wool
44 x 33 in. (111.8 x 83.8 cm)
Museum purchase with funds provided by the Caroline Julier
and James G. Richardson Acquisition Fund
2009.32.9

13 (above)
AMAZIGH PEOPLE
Siwa, Egypt
Woman's Wedding Ensemble (asherah nahuak)
Late 20th century
Synthetic cloth, silk, cotton, buttons
Top: 48.62 x 82.5 in. (122 x 209.6 cm)
Trousers: 36 x 41 in. (91.4 x 104.1 cm)
Museum purchase with funds provided by the Caroline Julier
and James G. Richardson Acquisition Fund
2009.32.15

14
HAUSA PEOPLE
Nigeria
Man's Robe (*riga or girke fari*)
Early 20th century
Cotton, silk
96 x 60 in. (243.8 x 152.4 cm)
Museum purchase with funds
provided by the Phillips Art
Acquisition Funds
2008.8

Victoria L. Rovine

West African Embroidery:

HISTORY, CONTINUITY, AND INNOVATION

Embroidery is a prominent element of many West African dress practices, past and present. Whether applied by hand or machine, stitched patterns and images enhance the beauty of garments and the status of their wearers. Although embroidery is practiced all over the world, in West Africa the technique has achieved special significance that is intertwined with religious practice, social identity, and global networks of trade. The region's long history of un-tailored or minimally tailored garments provides broad expanses of fabric that make an ideal canvas for embroidery. The embroiderers who create the garments that are our subjects bring together long-established precedents and the constantly changing styles that characterize fashionable dress the world over. These garments reflect historical and cultural contexts, as well as indi-vidual tastes, skills, and originality. A close examination of West African embroidery provides cultural and artistic insights intertwined with the intricate stitches and knots.

Before addressing specific histories and styles, I offer some general thoughts on the symbolic and technical attributes of embroidery:

—Like many textile forms, embroidery lends itself to metaphor. In English-speaking cultures, we talk about beliefs and practices that are stitched into the fabric of everyday life, and when we make something elaborate, we embroider it, enhancing the ordi-nary to transform it into something exceptional. This is the role of embroi-dery in West Africa.

—Embroidery is a practical medium. It requires only a needle and thread, and it can be practiced with little training or experience (though fine embroidery requires highly developed skills). Although it is an extension of the stitching by which garments are assembled, it is purely ornamental—a dramatic shift in purpose. In fact, the placement of embroidery motifs on many West African garments may have originated in a practical need to reinforce the areas where they might otherwise be likely to tear, on pockets and around necks (Picton and Mack 1979, 193).

—In West Africa, embroidered garments bear meanings with a wide range of specificity, from general-ized styles that reflect regional trends to motifs that are interpretable with symbolic or even linguistic precision. Embroidery, in short, can commu-nicate through a range of languages, both stylistic and linguistic.

—Embroidery is a flexible technique, enabling artists to transpose motifs from other media into stitched thread. Patterns and images can be based on woven or dyed textiles, on basketry, metalwork, or an infinite array of other sources. One art form is of particular relevance to West Africa's embroidery traditions: calligraphy, and specifically the verses of the Koran and related Muslim sacred texts in the original Ara-bic. This association with calligraphy lends embroidery symbolic weight.

All of these traits—accessibility, flexibility, and adaptability—have made embroidery a central element of dress practices in West Africa. In communities throughout the region, embroidery elevates garments both visually and symbolically; wherever they are worn, embroidered garments indicate high status, in addition to bearing more specific meanings.

The garment styles that are the focus of this essay all emerge out of a common universe of dress practices, spanning a vast region from the Saharan expanses of Mauritania, Niger, and Mali, south to the Atlantic coast from Senegal to Cameroon. Although their techniques, styles, and associations vary, the common ancestry of the diverse garments produced across these nations and cultures is evident in their basic form and in the social contexts of their manufacture and use. Through-out the region, men and women wear large, untailored robes or tunics that are adorned with stitched patterns and, occasionally, figurative imagery. Most of these garments also have in

Fig. 1. (below) A Fulani aristocrat on horseback wearing festival regalia, including embroidered robe and trousers. Kano City, Nigeria, 2002. Photograph by Sarah Worden.

common an association with Islam (though they are not worn solely by Muslims), and nearly all are customarily made by men.[1] The embroidery is focused on yokes and on pockets, usually attached to the upper left front of the garment. In many instances, the pocket is the work of a specialist who covers the fabric with tightly packed stitches in intricate patterns.

The visual impact of these garments is dramatic; their broad expanses of cloth are animated by carefully stitched patterns and by layers, folds, and creases that constantly shift with the movements of the wearer. A well-made *boubou*, *agbada*, or *riga* (three of the most important types of embroidered garments) makes a dramatic sartorial statement. Even where they are no longer part of the dress of daily life, they remain de rigueur for important events; at weddings, baptisms, and religious holidays throughout West Africa, the array of embroidery on rich fabrics creates a spectacular display (Fig. 1). For men, these garments are worn with an undergarment (a tunic or, more recently, a T-shirt) and large drawstring pants. Women wear *boubous* with a wrapper and a head-tie. Their elegance and their adaptability to changing tastes enables these dress styles, which are rooted in centuries-old precedents, to remain fashionable today.

Despite their formal similarities, little can be said with certainty concerning the precise relationships between the styles that traverse this region. Like so many garments, particularly those associated with high status, embroidered robes travel readily as trade goods, as gifts bestowed to mark favor, and as sources of inspiration for local clothing innovations. From the earliest years of Islamic influence in North Africa, beginning in the seventh century, Muslim traders moved goods across the Sahara desert, along the Niger River and other waterways, and farther south to the coast. Along with trade goods, these contacts brought religion—the early

adoption of Islam in Africa occurred largely through trade networks—as well as cultural influences such as dress practices. According to Bernhard Gardi, "It seems that if Islam didn't itself introduce this garment style, it nevertheless contributed to its diffusion" (2002, 25).

My examination of West African embroidery addresses both well-known and little-documented practices. Discussions of dress in West Africa often feature one highly visible family of embroidered garments: the Nigerian gowns known as *agbada* (Yoruba) or *riga* (Hausa). These garments provide insights into the transformation of embroidery styles in response to new technologies and new influences, and the continued prominence of embroidered garments as symbols of status. Two types of embroidery from Mali—the *tilbi* style of *boubou* (robe), and tunics in a style referred to as "Ghana Boy"—are less well known outside their places of origin. They exemplify the diversity of styles and meanings within a single region.

The *Agbada* and the *Riga*: Nigerian Robes of Status

The most iconic and widespread form of African embroidery is arguably the style associated with men's dress in northern and western Nigeria, as well as in neighboring countries. This well-known "family" of embroidery has distinctive regional variations found throughout West Africa and extending into Central Africa. These garments are characterized by distinctive embroidered motifs on the garments' yokes and backs; their geographic and cultural diffusion has led to a wide array of sub-styles and variations, all of which share compositional elements, though their motifs may vary.

Despite the fact that the history of embroidery is not well documented, John Picton and John Mack have asserted that it has been an important element of dress in northern Nigeria

since the fifteenth century (1979, 189). The earliest preserved examples of garments adorned with the distinctive embroidery that defines *agbada*, *riga*, and related forms date from the mid-nineteenth century, though European travel accounts from as early as the mid-seventeenth century mention this dress style (Gardi 2002, 11). Embroiderers from several ethnic groups have historically made these gowns, including Hausa, Nupe, Yoruba, and Fulani (Fig. 2). The style's appearance across a vast region likely reflects the wide influence of the early nineteenth-century Fulani Empire, inspired by an Islamic reform movement that spread across Nigeria and into Cameroon (Pl. 16). It is more closely associated with Islam than with a specific ethnic group. As Colleen Kriger notes in her discussion of the *riga*, "Members of many ethnic groups contributed to their production. . . . Moreover, their most important feature was their use by the Muslim elite, regardless of ethnic affiliation" (1988, 52). Embroiderers often doubled as scholars of Islam, creating a connection so deep that some of the words used to describe the tools of embroidery are derived from Arabic, the language of Islamic prayer (Kriger 2006, 97). In his analysis of the Islamization in one

nineteenth-century Nigerian state, Yoshihito Shimada notes that the religion was inseparable from the wearing of these flowing robes, as reflected in the Hausa term for Muslims, *ɗan riga*, which means "children of the gown/robe" (1992, 376).

Two Hausa men's robes, or *rigona* (the plural form of *riga*), in the Harn exhibition are adorned with variations on a pattern called *aska takwas*, or "eight knives," a classic style (Pl. 14). Large robes, whether from Nigeria, Mali, Liberia, or elsewhere in the region, are usually assembled in three sections, nearly equivalent in size: two wide sleeves, and a central section that bears most of the embroidered adornment. The strips—oriented vertically in the center and horizontally on the sleeves—create a bold, architectonic field that complements the intricacy of the embroidery. One of the garments presented here is a rich blue color, made of strips of indigo-dyed cotton cloth that have been sewn together edge to edge (Pl. 19).[2] The embroidered motifs that adorn the other *riga* (see Pl. 14) are made of tan silk stitched onto undyed white cotton. The subtlety of the colors—tan on a white ground—is typical of these high-status garments.

The motifs that adorn these garments include *aska takwas* and its smaller

variation, *aska biyu* ("two knives"), named for the number of pointed elements on the left side of the chest. Though interpretations of these and other motifs may vary, they are generally considered to be protective. Scholars have speculated that this embroidery style is rooted in talismanic gowns and shirts, garments onto which Koranic verses were written in ink (Perani and Wolff 1999, 141). Talismanic garments are associated with warfare, hunting, and other contexts in which the wearer requires spiritual as well as physical protection.

Though the embroidery on both of these types of robes shares the same basic composition, including the knives on the left side of the chest and the spiral (called a *tambari* or drum) on the right, the solid blue *riga* (see Pl. 19) is more elaborately adorned. It incorporates a motif associated with the Nupe: the *gambiya*, or triple leaf, which appears at the bottom left corner of the chest. Thus it offers a subtle example of the blending of influences that characterizes dress practices in West Africa's cosmopolitan cultures.

The shorter man's tunic (Pl. 15), made of richly colored strip cloth, represents another variation on this style of dress. The cut of the garment as well as its embroidery distinguish

this type of men's garment—associated with Nupe and Yoruba ethnic groups—from the typically Hausa style of the other robes. Triangular inserts or gussets create a bell-like shape, with two pockets just below the chest. The interlaced oval motifs that adorn the front and back of the robe, called *pako* in Yoruba, are typical of the style (Lamb and Holmes 1980, 55). The fabric is also associated with Yoruba or Nupe women's weaving. Along with indigo blue and magenta, it incorporates stripes that pulsate from white to blue and back again, made using pre-dyed threads—a technique called *ikat*.

Since the early twentieth century, the prevalence of factory-woven cloth has provided a constantly changing array of brocades and vividly patterned prints. These textiles have dramatically expanded the possibilities for the production of embroidered gowns. Another important source of innovation was the introduction of sewing machines in the first decades of the twentieth century, which has permitted new forms and speedier production of embroidery in Nigeria and elsewhere in West Africa.

Embroidery in Mali: Three Styles, Three Stories

Due to a fortuitous coincidence of climate, topography, and funerary practice, Mali's archaeological record contains an exceptional corpus of textiles, including embroidered garments. The cliffs and plains of the famous Dogon region in central Mali were first inhabited by the Tellem, a culture known only through the bodies and grave goods they left behind, and, since the fifteenth century, by the Dogon. Hundreds of textiles were found in the caves where the Tellem entombed their dead, located high up in the sheer cliffs of the Bandiagara Escarpment. The blankets, tunics, hats, and other garments were miraculously well preserved, due to the dry climate and the inaccessibility of the caves.

These textiles, which date from the eleventh to the sixteenth century,

attest to the longevity of weaving and dyeing technologies in the region. In addition to the woven patterns created by the indigo-blue and white threads, the Tellem adorned their clothing with embroidery. Textile fragments indicate that embroiderers focused their attention on the yokes of tunics and gowns, applying graceful curvilinear motifs that complement the geometry of the assembled strips of cloth (Bolland 1992).

Centuries later, embroidery continues to thrive in Mali, where *boubous* are the only appropriate attire for formal wear, even for men and women who ordinarily wear jeans, dresses, or business suits. Most of these *boubous* are adorned with machine-stitched embroidery, applied by specialists who work in the ateliers of tailors. The three types of Malian embroidered garments presented here encompass a wide range of styles and markets. Two are hand-embroidered, and the third is part of the large market in machine-embroidered garments.

The *Tilbi*: An Icon of Tradition

The *tilbi* (Pl. 20) is a style of *boubou* associated with two ancient centers of Islamic learning in Mali—Djenne and Timbuktu—and the surrounding region. Timbuktu, founded in the twelfth century, was also a major trade center until the seventeenth century, when European access to port cities along Africa's west coast created a new route for trade. The city's storied history of wealth, cosmopolitanism, and learning has preserved its name in our collective imagination; Timbuktu is still legendary today, even if few people outside Mali know where it is located. The *tilbi* reflects the region's history both in its complexity of form and in the intricacy of its symbolism.

This garment embodies ideals of piety, prosperity, and social belonging. The wearing of a *tilbi* requires maturity as well as means. A young man or woman would never have the temerity

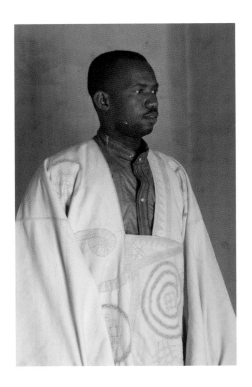

Fig. 3. (above) Baba Djitteye modeling a mid-century *tilbi*. Timbuktu, Mali, 2009. Photograph by Victoria Rovine.

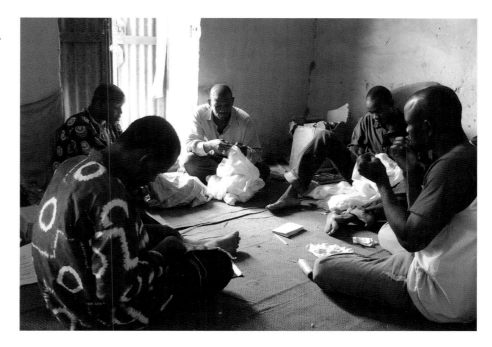

Fig. 4. Embroidery atelier of Baba Djitteye, Timbuktu, Mali. Photograph by Victoria Rovine.

to wear one, for the garment is both literally and symbolically too powerful to be worn by a person who has not earned the respect of the community through age and accomplishments. Baba Djitteye, one of the few embroiderers in Timbuktu who continues to make *tilbi*, is in his forties and therefore too young to wear one himself (Figs. 3 and 4).

The garment's status is rooted in its history, for it represents the continuity of social structures and values; in short, the *tilbi* represents tradition. We know that embroidery has been an important occupation in Timbuktu for centuries, and that it has long been associated with Islam (Saad 1983, 86). In the past century, European visitors have provided clear documentation of this connection. In 1900, a French priest who lived in Timbuktu identified the *tilbi* as the primary attire of both men and women of means, noting that the amount of silk embroidery on the garment directly reflected the wealth of its owner—a measure of *tilbi* quality still in use today (Hacquard 1900, 28). In 1921, another French resident published a discussion of professions in Timbuktu that includes precise depictions of the embroidered motifs on *tilbi boubous*, which are identical to those used today (Dupuis-Yacouba 1921, 29).

The impact of a *tilbi boubou* is subtle, for it does not rely on bright colors or bold patterns to make a visual statement. Instead, these garments are understated. They are made of the finest materials, which in the past would have meant the assembly of as many as 100 meters of narrow strips of cotton into a large robe, and which today entails the purchase of the highest-quality imported damask (called *bazin* in Mali). In addition, white or tan silk thread, often imported from Europe through North Africa, is required.

Because a *tilbi* is customarily made of white fabric, whether locally woven or imported, and undyed silk thread, its embroidery emerges softly, requiring close examination to appreciate its fine details. The motifs are abstract, though they are named for elements of the natural world, including "mouse teeth," "cat's eye," "serpent," "lizard's head," and "chameleon." The styles of stitches are each named as well, designating the length of the stitches, the way they are grouped together, or the direction in which they are oriented (Bah and Brunet-Jailly 2002).

In addition to these descriptive names, motifs can be interpreted as references to Islamic history, belief, and

cosmology. These motifs originally served protective functions and have become stylistic conventions. For example, *tilbi boubous* incorporate the magic square motif, found throughout the Islamic world, as well as highly abstracted references to Arabic text. As in Nigeria, embroiderers are often scholars of Islam, and in the past embroidery ateliers doubled as schools in which young boys learned to read and recite the Koran. In her discussion of the region's embroidery, Labelle Prussin notes that, "like the written word, embroidery is a system of visual communication, and it could be considered a logical extension of script . . . the scholar-cum-embroiderer endowed the surface of the cloth with the potency wielded by sacred script" (2006, 341). Because of its association with the text and symbols of Islamic faith, the *tilbi* has protective properties. And while individual embroiderers may slightly alter the style of the motifs, much as each person's handwriting is different, they may not change them. As embroiderer Baba Djitteye firmly stated: "If one changes the motifs, it is as if one has changed something in the Koran" (interview, 6/17/09).

Embroiderers create *tilbi* only on commission, rather than creating a stock of garments ready for sale; the

investment of time and materials is far too great to make a *tilbi* without a client already identified. The making of a *tilbi* is exceptionally labor-intensive for an embroidery atelier; depending on the complexity of the motifs and the size of the embroidery workshop, a single *tilbi* can take three years or more to complete. Clients who wish to expedite the work on their garment may bring gifts to the embroiderer, providing meals, tea, materials, or other goods in order to make their commission a priority. Because a complex *tilbi* can take years, these artist-client relationships may endure over a lifetime, as new *tilbi* and other garments are periodically commissioned.

"Ghana Boy" Tunics: The Status of the New

I turn now to a second type of Malian embroidery, which is from the same region as the *tilbi*. Yet the two could scarcely be more dissimilar in their style and their social associations. This second style of embroidery is the product of a very specific subculture and a particular moment in time—the mid-twentieth century. This style of dress is self-consciously new, constituting a trend rather than an icon of tradition. Tunics in this style are referred to as "Ghana Boy" because they were first made and worn by young Malian men who traveled to Ghana in search of employment. Like *tilbi boubous*, Ghana Boy tunics are status symbols, yet they reflect status of a very different kind (Pl. 21).

These garments are not made of expensive, high-prestige materials like *bazin* and silk thread, but of coarse cotton sheeting with bright cotton-thread embroidery. Rather than complex stitches and motifs mastered through years of apprenticeship, bold patterns and images are created using only straight stitches. Ghana Boy garments are distinctly different in style from *tilbi*, *riga*, and other embroidered garments that have a long history in West Africa.

Unlike the *tilbi's* abstract, calligraphic forms, the motifs and images stitched into these tunics are not rooted in local precedents. Abstract patterns are hard-edged and bold, and figurative elements abound—people, animals, and objects appear on many of the tunics, depicted in flat fields of color outlined in black. Clearly, the sources of inspiration for these garments lie outside the realm of local custom and tradition. Although Ghana Boy garments are local in neither their materials nor their iconography, they do reflect local practices and social systems.

Ghana Boy embroidery is applied to tunics, which are much smaller and less imposing garments than the voluminous *boubou* and *riga* that are associated with wealth and status throughout West Africa. Tunics, essentially a *boubou* without sleeves, are extremely simple garments—a long, rectangular piece of fabric with a neck hole in the middle, often with a simple pocket on the front. They are the customary work garments of rural Mali, worn by farmers hoeing their fields, fishermen tossing nets, and laborers of all kinds. For young men such as the migrants seeking their fortunes in Ghana, this garment would have been very familiar.

The predominantly young men who traveled in search of employment on the streets of Ghana's cities, towns, and rural areas left home for months or years. Such labor migration has a long history in West Africa, and in some communities such travel is an important element of young men's coming-of-age much like customary initiation societies. By leaving the familiarity of home, Ghana Boys hoped to earn money and gain experience, so that when they returned to their towns and villages they would attain new status as worldly, prosperous adults. According to the few published references to Ghana Boy embroidery, and my own conversations with embroiderers and others in Mali, the young men made these garments while living in Ghana. They wore them

when they returned home, during public festivities and on market days.

Like young people throughout the world, these adventurers used clothing to distinguish themselves from their elders and their juniors, drawing attention to their newfound adulthood. Their new status was the result of experience abroad, not deep roots at home. Neither was it associated with piety or spiritual protection. In inventing something new, these young men drew inspiration from diverse sources. The abstract patterns that adorn the tunics resemble leatherwork from their home region—a new source of inspiration, rather than a perpetuation of the past. Alternatively, the patterns bear a general resemblance to a textile associated with southern Mali, called *bogolan* or *bogolanfini*. Whether leatherwork or *bogolan*, these young men were reaching beyond familiar dress practices to create something new.

The figurative elements of the tunics represent a more dramatic departure from precedent. Here, my conversations in Mali indicate one potential source of inspiration, and I will suggest a second source as well. Kariba Boré, a Djenne resident and embroiderer who had himself traveled to Ghana seeking employment in 1972, said that the figures were depictions of the people and practices he and other migrants encountered in Ghana. Boré told me that the tunics were in part a form of evidence: it was important to prove that he had actually made the trip himself by depicting details that an imposter could not know (interview, 6/20/09). Amadou Tahirou Bah, an expert on Djenne's artistic traditions, characterized the message of Ghana Boy tunics in a phrase: "This is what I saw!" (interview, 6/16/09).

And yet, Ghana Boy tunics depict figures and scenes that would have been unlikely at best on the streets of Accra and Kumasi. On them, men and women wearing bellbottoms and platform shoes brandish pistols while mounted on horses. Miniskirts and

halter-tops abound, along with bouffant hairstyles. Such figures look more like movie stars than ordinary city-dwellers. Bollywood movies (popular films produced in India and hugely popular in many parts of the world since the mid-twentieth century) are more likely the source of inspiration for these figures than what Ghana Boys actually saw on their travels. Historical circumstances support this hypothesis. The division of West Africa into French and British colonies created separate global networks in which material culture and social systems circulated. Ghana, like India, is a former British colony, whereas Mali was colonized by the French.[3] Thus it is certainly reasonable to assume that the products of one former British colony might have been introduced early in another former colony, so that Ghana likely had Bollywood films before Mali did. In depicting these figures, young Malian men emphasized the exoticism of the cultures they encountered, whether that exoticism was rooted in their association with Ghana or had more distant roots in the Indian film industry.

Maimouna Diallo: Embroidery and the Urban Fashion Industry

I conclude with a brief introduction to the most prevalent incarnation of embroidery in Mali today: the market in machine-embroidered garments made in tailoring shops and fashion designers' ateliers, in urban communities large and small. For both men and women, though more prominently for women, any special occasion requires the wearing of an embroidered *boubou*. For weddings, holiday celebrations, or simply a night out with friends, women are likely to wear large or small *boubous*, adorned with embroidered patterns around yokes, fronts, and backs. These garments are made on commission, often from a favorite neighborhood tailoring shop. These shops, staffed nearly exclusively by men, vary greatly in size. Some have full show-

rooms and large staffs of tailors and embroiderers, while others are little more than a room with an awning extending out over the street, beneath which one or two tailors ply their trade.

Using photo albums of the tailors' past work, locally or regionally produced magazines that feature spreads on current styles, or borrowed garments that serve as prototypes, women select embroidery motifs and provide the fabric (sometimes having it dyed by one of the many dyeing establishments, usually run by the women in a single family). The prices of these garments depend on the complexity and amount of work, yet generally women of a wide range of means can afford to purchase an embroidered *boubou* for important events.

Less widely accessible is the market in embroidered garments by well-known designers, whose methods have more in common with the methods of European fashion designers than with those of the embroiderers of Timbuktu or the tailors who skillfully copy the garments that appear in magazines. These designers market a brand along with their clothing, focusing on the creation of distinctive styles rather than on simply meeting the needs of the average consumer. They promote their work in fashion shows (held at hotels and nightclubs, sponsored by local businesses or under the aegis of government entities), in magazines, and on television. The few who succeed are able to command large workshops, with specialist pattern-makers, cutting machines, and other investments in their business. They can charge high prices for their work because it comes with the prestige of their brand name. And, in turn, they must continuously innovate in order to keep that brand vital.

Embroidery figures prominently in this rarified world of fashion design, continuing a long history in Mali. One designer who has taken the medium in strikingly new directions is Maimouna

Diallo, whose boutique/atelier, called Maïmour Style, is located in Bamako, Mali's capital. She employs approximately twenty people, including tailors, embroiderers, a pattern-maker, and beaders. Diallo trained as a fashion designer in Casablanca, Morocco, and she travels frequently to present her work at fashion shows in Senegal, Côte d'Ivoire, Niger, and elsewhere. Her work is known for its distinctive embroidery, which is densely worked, boldly colored, often with angular geometric patterns in flat fields of color.

Diallo also incorporates beadwork into her embroidery designs, creating multiple textures and multilayered patterns that make her work distinctive, much coveted, and, importantly, very difficult to copy. Her sources of inspiration vary widely. As she puts it, Diallo draws from her own Fulani heritage as well as from far-distant cultures: "I am inspired by Fulani weaving as well as South African beadwork" (interview, 2/17/10). The ensemble in the Harn Museum of Art's collection (Pl. 30) incorporates a style of beadwork associated with Songhai women, from the northern regions of Mali and neighboring countries. Diallo used Songhai women's headbands as central elements in the garment's adornment, along with embroidery that features bold colors and linear patterns to create a visual fusion of beaded and stitched patterns. Thus, innovation is key to the success of Maïmour Style, as is an appreciation for the long and vibrant history of embroidery and other forms of personal adornment in Mali's many cultures and markets.

These three types of embroidery—the *tilbi*, the Ghana Boy tunic, and embroidery in urban fashion markets—exemplify distinct approaches to innovation within the bounds of cultural expectation. Maimouna Diallo succeeds only through innovating, yet even as she is free to draw inspiration from distant sources, she retains the essential elements of women's formal dress in

Mali—the shape of the garment and the quality of the fabrics. In the case of the *tilbi*, a garment whose social cachet is based on its affiliation with long-established forms of status, the parameters of that innovation are much more circumscribed. Yet embroiderers can still bring their own "hand" to the motifs. Close examination of the Ghana Boy tunics reveals that, though their style and iconography emphasize the new, they, too, are rooted in local practice: the production of embroidery, and perhaps of *bogolan* and leatherwork, and, most importantly, the pursuit of status through travel. The newness of Ghana Boy tunics is, in a sense, as much part of local tradition as the *tilbi*'s conservatism. In Nigeria, Mali, and elsewhere in West Africa, the practice of embroidery balances innovation and precedent. Little wonder that this art form continues to thrive today throughout the region, where embroidered garments are a sign of status, fashionability, and the continuity of cultures. ◆

References

Bah, Amadou Tahirou, and Joseph Brunet-Jailly. 2002. "Métiers d'art de Djenné: la Broderie." In Brunet-Jailly, ed., *Djenné: d'hier à demain*, 97–120. Bamako: Editions Donniya.

Bolland, Rita. 1992. "Clothing from Burial Caves in Mali, 11th–18th Century." In Roy Sieber et al., eds., *History, Design, and Craft in West African Strip-Woven Cloth*, 53–81. Washington, D.C.: National Museum of African Art, Smithsonian Institution.

Dupuis-Yakouba, Auguste. 1921. *Industries et Principales Professions des Habitants de la région de Tombouctou*. Paris: Émile-Larose.

Gardi, Bernhard, ed. 2002. *Le Boubou — C'est Chic: Les boubous du Mali et d'autres pays de l'Afrique de l'Ouest*. Basel: Museum der Kulturen Basel / Christoph Merian Verlag.

Hacquard, Mgr. Augustin. 1900. *Monographie de Tombouctou*. Paris: Société des Études Coloniales & Maritimes.

Heathcote, David. 1995. "Aspects of Embroidery in Nigeria." In John Picton, ed., *The Art of African Textiles: Technology, Tradition, and Lurex*, 38–40. London: Barbican Art Gallery.

Kriger, Colleen E. 2006. *Cloth in West African History*. Lanham, Md.: AltaMira Press.

———. 1988. "Robes of the Sokoto Caliphate." *African Arts* 21, no. 3: 52–57.

Lamb, Venice, and Judy Holmes. 1980. *Nigerian Weaving*. Roxford, UK: H. A. and V. M. Lamb.

Perani, Judith, and Norma H. Wolff. 1999. *Cloth, Dress, and Art Patronage in Africa*. Oxford: Berg.

Picton, John, and John Mack. 1979. *African Textiles: Looms, Weaving, and Design*. London: The British Museum.

Prussin, Labelle. 2006. "Judaic Threads in the West African Tapestry: No More Forever?" *Art Bulletin* 88, no. 2: 328–53.

———. 1986. *Hatumere: Islamic Design in West Africa*. Berkeley: University of California Press.

Renne, Elisha P. 2004. "The Production and Marketing of Babban Riga in Zaria, Nigeria." *African Economic History*, no. 32: 103–22.

Saad, Elias N. 1983. *Social History of Timbuktu: The Role of Muslim Scholars and Notables, 1400–1900*. New York: Cambridge University Press.

Shimada, Yoshihito. 1992. "Formation de la civilisation 'complexe' Islam et vêtements en Afrique sub-saharienne: étude de cas de l'Adamawa." *Senri Ethnological Studies*, no. 31: 373–422.

Notes

1 The gendered division of labor has changed in some cultures. In her discussion of embroidery in the predominantly Hausa city of Zaria (Nigeria), Renne notes that while it was traditionally a male occupation, since the 1990s women have participated actively in the production of *riga* and other embroidered garments (Renne 2004, 110).

2 Throughout West Africa, strip-weaving is the work of men who use horizontal looms to create long rolls of cloth.

3 Ghana gained independence in 1957, Mali in 1960.

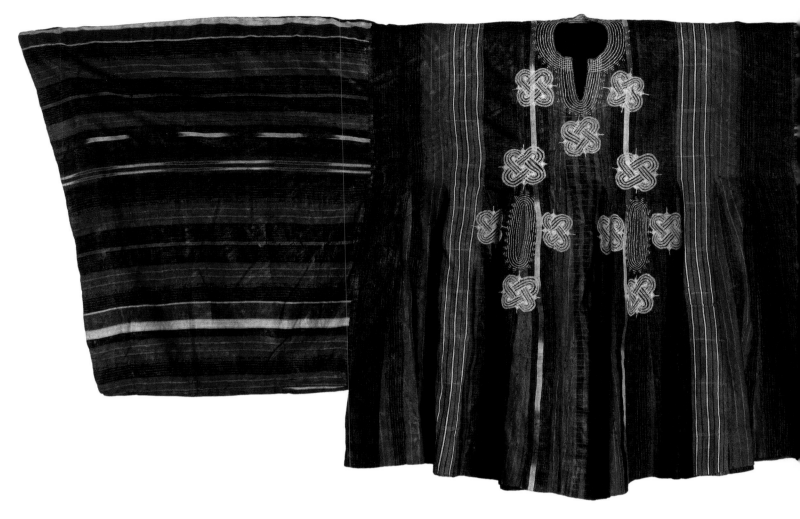

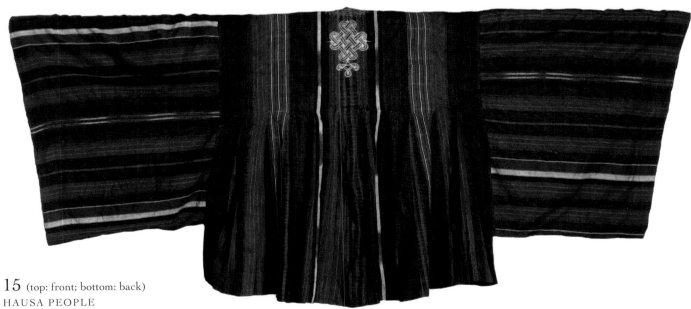

15 (top: front; bottom: back)
HAUSA PEOPLE
Nigeria
Man's Tunic (*riga or agbada*)
20th century
Cotton, indigo dye, synthetic dyes
48.5 x 110.25 in. (123.2 x 280 cm)
Museum purchase with funds provided by the Caroline Julier
and James G. Richardson Acquisition Fund
2009.9.2

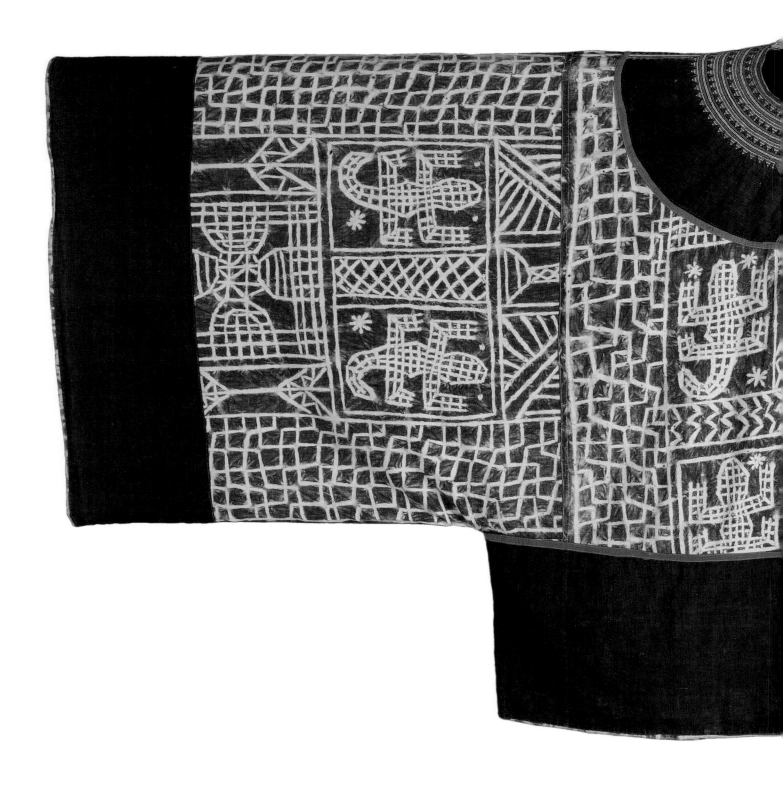

16 (top: front; bottom: back)
BAMILEKE PEOPLE
Cameroon
Man's Tunic
20th century
Cotton, indigo dye, synthetic dyes
45.5 x 97 in. (115.6 x 246.4 cm)
Museum purchase with funds provided by the Caroline Julier
and James G. Richardson Acquisition Fund
2009.9.3

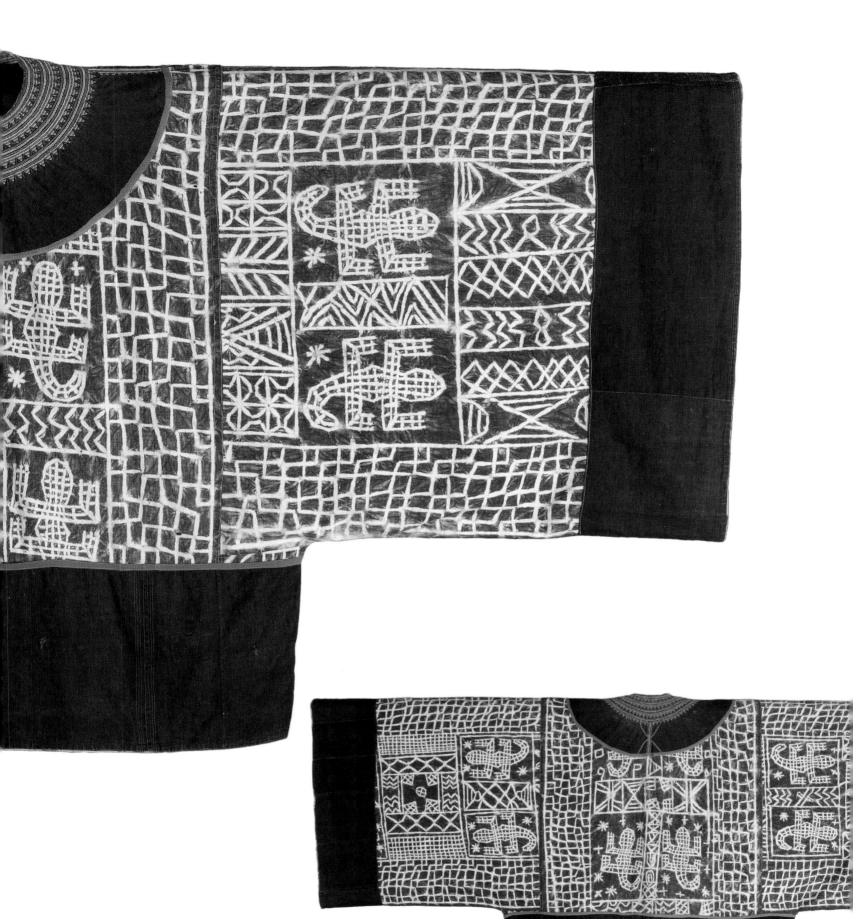

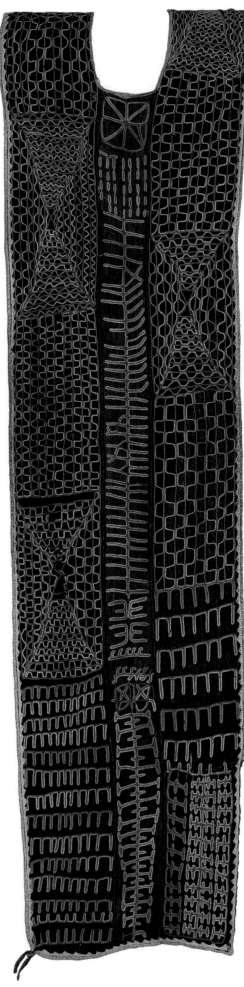

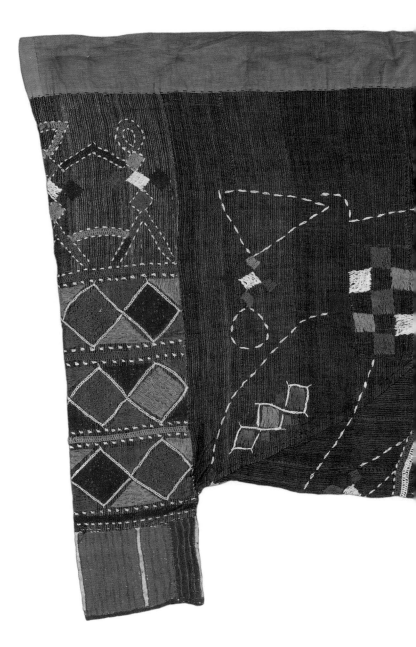

17 (left)
WODAABE PEOPLE
Niger
Embroidered Tunic (*henaare*)
Late 20th century
Cotton
54.5 x 13.5 in. (138.4 x 34.3 cm)
Museum purchase with funds provided by the Caroline Julier
and James G. Richardson Acquisition Fund
2009.32.17

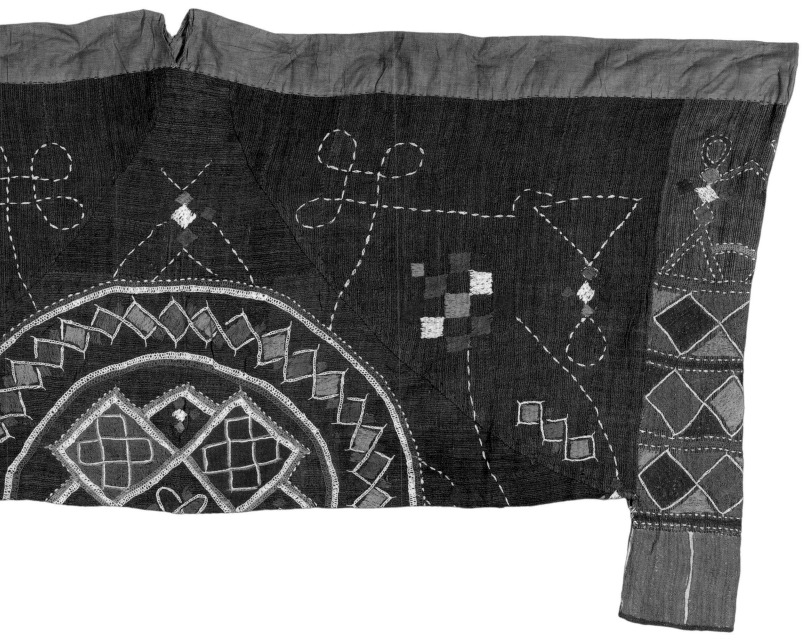

18 (above)

HAUSA PEOPLE

Nigeria

Man's Ceremonial Trousers (*wando*)

20th century

Cotton, wool, indigo dye, synthetic dyes

36 x 68 in. (91.4 x 172.7 cm)

Museum purchase with funds provided by the Caroline Julier

and James G. Richardson Acquisition Fund

2009.9.4

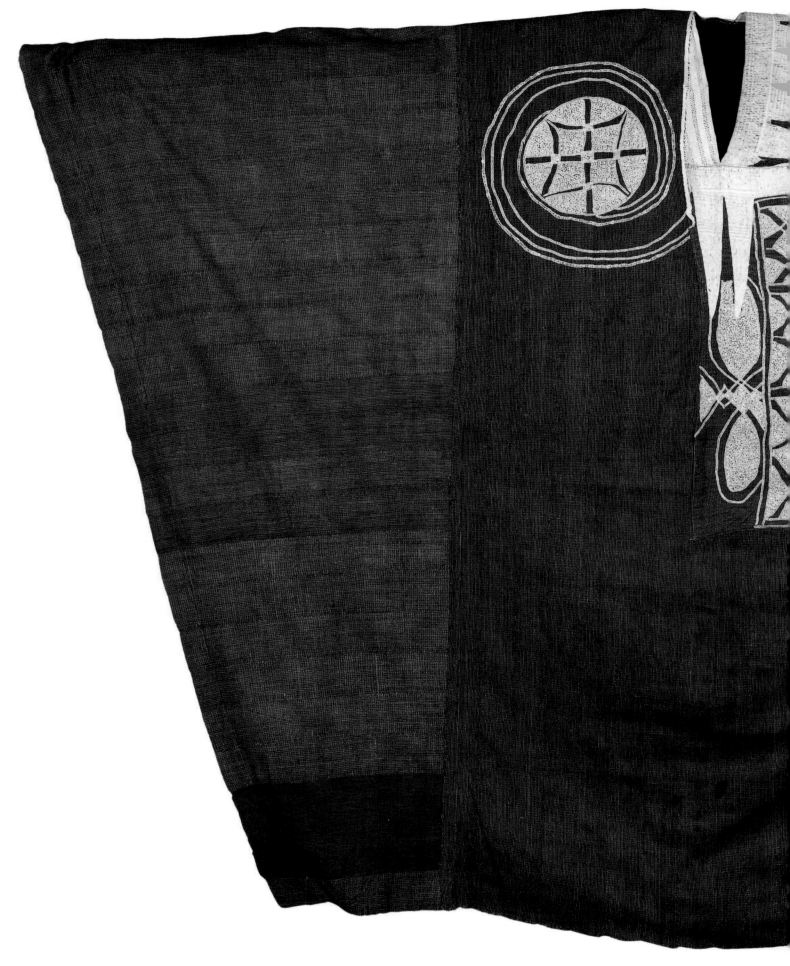

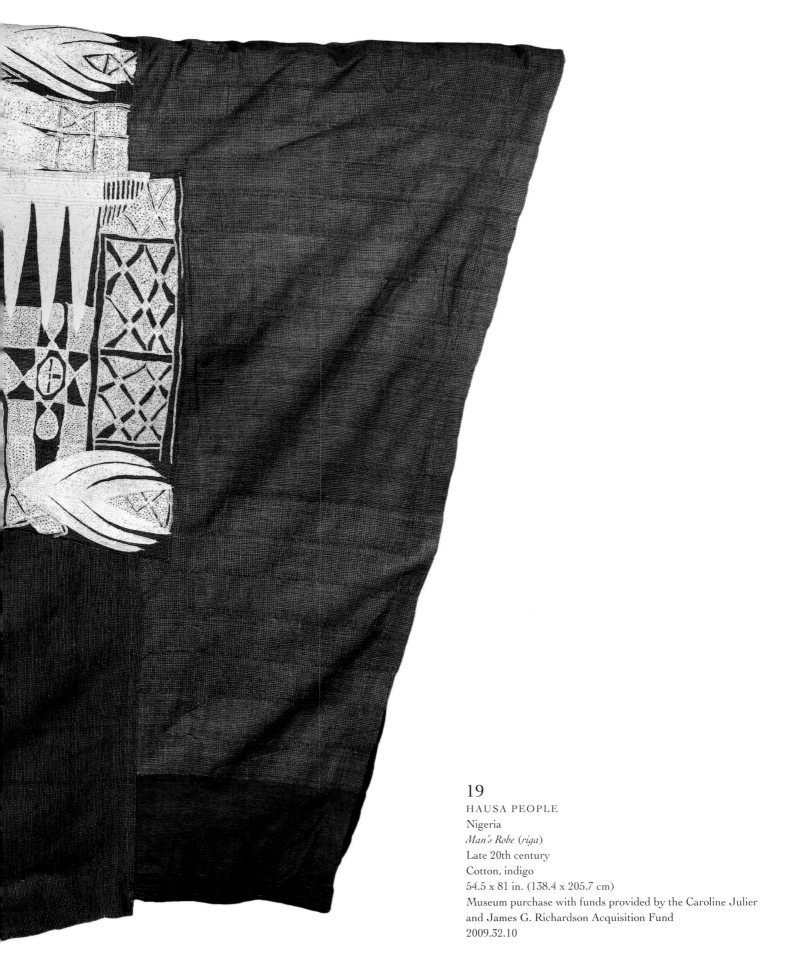

19
HAUSA PEOPLE
Nigeria
Man's Robe (*riga*)
Late 20th century
Cotton, indigo
54.5 x 81 in. (138.4 x 205.7 cm)
Museum purchase with funds provided by the Caroline Julier
and James G. Richardson Acquisition Fund
2009.32.10

front

back

20 (above)

BABA DJITTEYE

Malian

Woman's Robe (*tilbi*)

20th century

Cotton factory cloth (*bazin*), silk embroidery

58 x 55 in. (147.3 x 139.7 cm)

Museum purchase with funds provided by the Caroline Julier

and James G. Richardson Acquisition Fund

2010.2.6

21 (opposite page)

Mali

"Ghana Boy" Tunic

Mid-20th century

Cotton

42.75 x 34 in. (108.58 x 86.36 cm)

Loan from Victoria Rovine

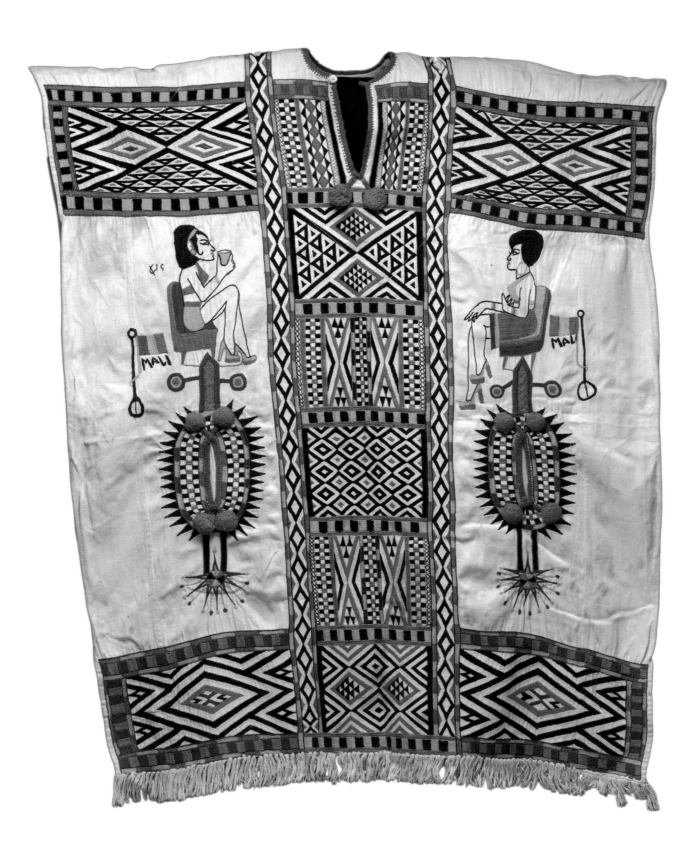

Suzanne Gott

Ghanaian *Kente* and African-Print Commemorative Cloth

The Ghanaian textiles in this exhibition offer colorful, visually compelling evidence of Africa's cosmopolitan, interwoven textile history. For centuries, West Africa has been actively engaged in interregional and transcontinental trade, and cloth has been one of the most widely circulated items of trade and cultural exchange. As new textiles and production techniques were introduced into the region through the trans-Saharan and coastal trades, they were adopted and transformed into new, locally meaningful forms.

At first glance, the two categories of Ghanaian textiles on display—handwoven strip-cloth, popularly known as *kente*, and factory-made commemorative African-print cloth—appear to have little in common. Yet each textile form owes its development to centuries of West African involvement in long-distance trade and cross-cultural interaction.

Both Ghanaian *kente* and African-print commemorative cloth are textiles that have strong political associations. Beginning with Ghana's mid-twentieth-century independence movement, *kente* began to acquire new national and international significance as an expression of Ghanaian, Pan-African, and African Diaspora pride and identity. African-print commemorative cloth designs have chronicled and celebrated major political movements and events of the twentieth and early twenty-first centuries.

The production and consumption of Ghanaian *kente* and African-print commemorative textiles have been affected by the world's increasingly globalized culture and economy. Ghana's ever-widening textile diasporas are complex historical developments, offering challenges as well as opportunities.

Strip-Woven *Kente* Textiles

Southern Ghana is home to two strip-woven textile traditions that are represented in the Harn exhibition: Asante *kente* from the Asante peoples of the south-central Ashanti Region (Pl. 26), and Ewe *kente* produced by the Ewe peoples of southeastern Ghana and neighboring Togo (Pl. 25). These sophisticated, interrelated textile

Fig. 1. (below) *Kente*-weaving instructor, College of Art, Kwame Nkrumah University of Science and Technology. Kumasi, Ghana, 2005. Photograph by Suzanne Gott.

traditions have been the subject of several important studies (Lamb 1975; Adler and Barnard 1992; Ross 1998; Kraamer 2006).

Asante and Ewe *kente* textiles are composed of long narrow strips of cloth woven in widths of 4–4½ inches (Fig. 1), which are cut at fixed intervals and sewn together along their selvages/finished edges. Ghanaian strip-woven cloth is traditionally worn in men's and women's wrapped styles. A man's wrapper is a voluminous cloth, typically composed of 18–20 strips, that is worn in a toga-like style. A woman's *kente* is composed of 14–16 strips and can be worn as a wrapper or as an upper cloth, draped toga-style, for Asante women's customary two-piece wrapped ensemble. Since the mid-twentieth century, women have also worn *kente* fashioned into the Ghanaian *kaba* ensemble, consisting of a tailored *kaba* top (8 strips) and sewn skirt, or *slit* (10 strips), perhaps with the addition of an unsewn cloth (8 strips) that can be worn as a stole or folded and draped over one shoulder.

The development of Asante and Ewe *kente* textiles began with the introduction of the horizontal narrow-band treadle (pedal-operated) loom—a strip-cloth weaving technology, primarily cotton-based, that spread throughout much of West Africa. The precursors of this versatile loom are believed to be the pit looms of eastern and southern Asia, and the South Asian subcontinent is also considered a major point of origin for cotton cultivation (Kriger 2006, 72–73). The earliest archaeological evidence of West African cotton textiles woven on narrow horizontal treadle looms is the eleventh- and twelfth-century strip-woven cotton cloth and clothing discovered in the sandstone cliffs of Mali's Bandiagara Escarpment, in burial caves of the historic Tellem culture (Bolland 1992).

Trans-Saharan trade, along with the spread of Islam, provided important conduits for the introduction and dispersion of cotton strip-cloth weaving technology throughout West Africa. A significant factor fueling the development and spread of West African strip-weaving was the establishment of strip-cloth as a widely accepted form of currency (Johnson 1980; Kriger 2006, 80–84).

Following the introduction of strip-cloth weaving, West Africa's textile artists developed their own local variations, creating a diversity of regional styles. The strip-woven *kente* textiles of Ghana's Asante and Ewe peoples are considered to be among the most complex and colorful of these regional traditions. Ghanaian *kente* weaving, like other West African strip-weaving traditions, has historically been the preserve of men. However, in recent years, Asante and Ewe women have begun to enter the still largely male strip-weaving profession.

Ghanaian horizontal treadle looms consist of an open rectangular wooden frame in which the weaver sits facing the warp mechanism of heddles and pulleys. Long horizontal warp threads extend several feet in front of the loom, secured by a weight that maintains thread tension. These looms usually have two pairs of heddles suspended from pulleys attached to upper crosswise beams. Cords attached to the bottom of the heddles end in toeholds that enable weavers to use their feet to raise and lower the heddles in order to create an opening for passing through shuttles bearing the weft threads (Fig. 2).

Ghanaian *Kente's* Interwoven Traditions

The nature of the historical relationship between Asante and Ewe *kente* weaving has remained a subject of ongoing debate, particularly with respect to which ethnic group first developed Ghanaian strip-weaving and what influences each group has had upon the other. The complex, interwoven history of Ghanaian *kente* may never be fully understood.

A recent investigation into Ewe and Asante textile history by Malika Kraamer suggests that Ghanaian *kente's* double-heddle technique initially developed in the Ewe weaving center of Agotime, spreading to other Ewe and Asante weaving centers in the eighteenth and early nineteenth centuries (2006, 37–38). It is this double-heddle technique, using two pairs of heddles, that enables weavers to produce the narrow strip with alternating warp- and weft-faced weave that, along with supplementary weft-float designs, has become a defining characteristic of both Ewe and Asante *kente* (2006, 53). Kraamer's research indicates that Ewe and Asante weaving styles and techniques developed within the "separate, yet often interrelated paths" of southern Ghana's different weaving centers (2006, 38).

There are certain formal characteristics considered to distinguish *kente's* two ethnic styles: Ewe *kente* has largely remained a cotton textile, while the more prestigious forms of Asante *kente* produced during the late eighteenth and nineteenth centuries were made of silk, using thread initially obtained by unraveling imported silk textiles (see Bowdich [1819] 1966, 310, 331). During the twentieth century, rayon became a favored medium for Asante *kente*.

Ewe *kente* is considered more polychromatic, exhibiting greater variability of design. Asante weavers work within a particular palette to create more balanced and repetitive overall designs. Ewe *kente* is also known for its figurative supplementary weft-float designs, while the weft-float designs of Asante *kente* are nonfigurative.

Contemporary scholars, however, caution against overemphasizing such ethnically based stylistic distinctions. Doran Ross, noting the long relationship of cultural interaction and artistic exchange between Asante and Ewe peoples, observes that it has become "increasingly problematic to describe

Fig. 2. (left) Benjamin Cophie, son of master weaver Samuel Cophie, weaving *kente* on a double-heddle horizontal treadle loom. Bonwire, Ghana, 1990. Photograph by Suzanne Gott.

Fig. 3. (right) Master weaver Samuel Cophie. Bonwire, Ghana, 2010. Photograph by Suzanne Gott.

cultural phenomena solely in terms of ethnicity, especially if these 'ethnic groups' are nearby or contiguous" (1998, 21).

Changes that have taken place in twentieth-century Ewe textile production demonstrate the importance of factors other than ethnicity in influencing weaving styles. The growing demand for Asante *kente* since the 1950s, as a result of its popularity as a symbol of Ghanaian, African, and African Diaspora pride and identity, has stimulated Ewe weavers' production of Asante-style *kente* composed of silken rayon threads (Adler and Barnard 1992, 101; Kraamer 2006, 36).

The career of master weaver Samuel Cophie (Fig. 3), whose work is represented in the exhibition (Pls. 26 and 27), provides another example of the ways in which Ewe and Asante *kente* traditions are interwoven. An Ewe weaver by birth and early training, he has lived and worked in Bonwire, a major center of Asante *kente* production, since 1960. As a skilled weaver of both Ewe and Asante *kente*, Samuel Cophie has explored new design approaches combining Ewe and Asante *kente* styles and techniques (see Spencer 1998).

The Aesthetics of *Kente*

Ghanaian *kente* is a textile form that brings together visual, verbal, and musical expressive traditions. Asante *kente*, with its well-established system of named warp patterns and weft designs, is an exemplar of what Herbert Cole and Doran Ross have termed the "visual-verbal nexus" that is one of the aesthetic "cornerstones" in the arts of Asante and other Akan-speaking peoples (1977, 9–12).

The names given to Asante *kente* are determined by the warp design, with geometric weft and weft-float designs providing additional layers of meaning. The first systematic study of Asante textile-naming practices was conducted by British anthropologist R. S. Rattray (1927). The *kente* names Rattray recorded reflect Asante *kente*'s strong association with traditional rule and affairs of state, and many *kente* names commemorated royal men and women, prominent clans, and important historical events (1927, 235–50).

Ewe scholar and poet Kofi Anyidoho, reflecting on his own experiences as a child learning to weave, reveals the strong association between weaving and the poetics of song in Ewe aesthetic practice. Ewe master weavers are

often skilled poet-cantors (*heno*) and/or master drummers as well. Weavers would often sing to relieve the tedium of long hours at the loom. The rhythmic movements of the weaving loom provided "a natural drive for the flow of song," with the more "musically and poetically gifted" weavers creating their own musical compositions (Anyidoho 2008, 33–34). "Bonwire Kente," a popular song by pioneer Ghanaian musicologist Ephraim Amu, also captures the loom's rhythmic movements with its repetitive refrain, "Kro kro kro kro . . . kro hi kro" (2008, 34).

Kente as a Political Textile

The wearing of Asante and Ewe *kente* developed within two very different cultural and historical contexts. In Ewe culture's more decentralized political system, strip-woven *kente* could be commissioned and worn by anyone who could afford the prestigious textiles.

However, in Asante society's more hierarchical system of political authority, *kente* developed as a regalia form that, until the early twentieth century, was largely restricted to a political elite. Twentieth-century events—particularly British colonialism, followed by Ghana's independence movement—lessened

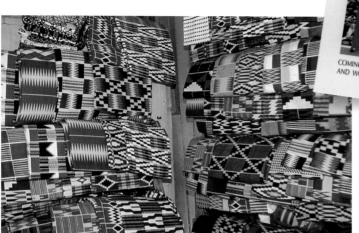

Fig. 5. (left) Shop display of roller-print *kente*. Kumasi, Ghana, 2005. Photograph by Suzanne Gott.

these sumptuary restrictions. Although Asante *kente* remained an important form of regalia for traditional authority-holders, it also became a prestigious textile that could be worn by non-royals.

As a well-established emblem of political authority and leadership, Asante *kente* has served as an especially appropriate symbol for Ghanaian independence and national identity. In the 1950s, the leaders of Ghana's independence movement dressed in *kente* robes, long associated with traditional authority, to legitimatize and strengthen new national political agendas. In 1957, when Ghana became sub-Saharan Africa's first independent nation, *kente* gained new international significance within the African subcontinent as an expression of Pan-African solidarity and emancipation from colonial rule.

In Ghana during the past fifty years, leaders of successive governments have worn *kente* robes of state to support the legitimacy of their political authority, from the administration of Ghana's first president, Kwame Nkrumah (1957–66), to the military regime and presidency of Flight Lieutenant Jerry Rawlings (1981–2001) and the democratically elected presidencies of John

Kufuor (2001–09) and John Atta Mills (2009–12). The continuing expectation for leaders to wear *kente* was demonstrated in the controversy provoked by President Kufuor's choice to wear a suit rather than *kente* robes for Ghana's Fiftieth Anniversary celebration in 2007.

Ghanaian *kente* continues to play a prominent role in cultural diplomacy, often being presented to visiting dignitaries. A special *kente* robe was presented to U.S. President Bill Clinton during the Clintons' 1998 state visit to Ghana (Fig. 4). This labor-intensive *kente* design, popularly known as the "Clinton *kente*," is represented in the Harn exhibition by a *kente* commissioned from the workshop of master weaver Samuel Cophie (see Pl. 26).

Samuel Cophie's "*adinkra kente*" (see Pl. 27) represents a new approach to *kente* design featuring the symbolic *adinkra* motifs that have become emblematic of Akan and Ghanaian culture. In the 1980s, *adinkra* symbols, which originally appeared as hand-stamped designs on cloth worn in ritual contexts (especially red, black, and brown mourning cloth), also began appearing on brightly colored men's robes embel-

lished with embroidered bands, as a new, festive style of special-occasion wear (see Mato 1986). Samuel Cophie's *adinkra kente* combines solid-color or simply designed strip-woven *kente* with this special-occasion style by the addition of large appliquéd *adinkra* symbols.

Kente and Globalization

The popularity of Ghanaian *kente* has also led to the development of more affordable, factory-made roller-print versions of traditional *kente* designs (Fig. 5). The availability of relatively low-cost roller-print *kente* since the 1980s has made *kente*-wearing accessible to the average Ghanaian, with *kente* roller-prints being fashioned into everyday dress styles of the younger generation (Fig. 6).

Whereas Ghanaians have maintained an awareness of differences between hand-loomed *kente* and roller-print imitations, Boatema Boateng observes that this distinction has often failed to be recognized or appreciated by many of *kente*'s global consumers (2004, 219–21). A machine-loomed textile manufactured in India, for example, was marketed in New York City as "African *kente*."

Fig. 6. (below) A young woman wearing a dress designed with roller-print *kente*. Kumasi, Ghana, 1990. Photograph by Suzanne Gott.

Fig. 7. (right) Three friends attending church wearing fashionable new designs of handwoven *kente*. Kumasi, Ghana, 2010. Photograph by Suzanne Gott.

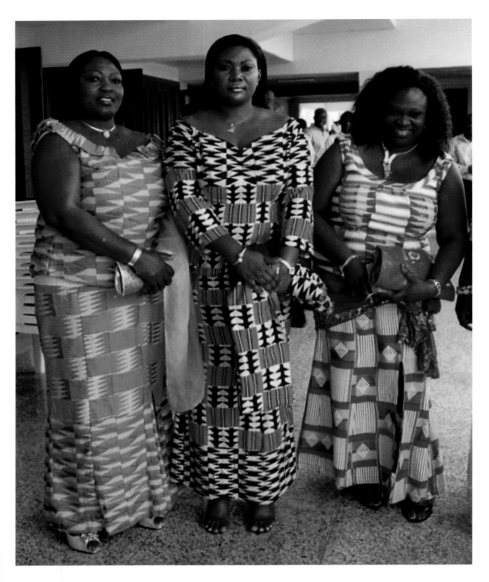

Since the 1960s, Ghanaian *kente* has become one of the most recognizable symbols of African Diaspora pride and identity (see Ross 1998). The combination of increased international demand and limited consumer awareness of distinctions between handmade *kente* and factory-made imitations (often produced in Asia and Southeast Asia) was addressed, at least symbolically, by Ghana's revision of its copyright laws in 1985 and 2000 to include cultural property such as Ghanaian *kente* designs (Boateng 2004, 212). In addition, there are African-American designers, such as Brenda Winstead, who maintain a strong commitment to using only high-quality handmade African fabrics, including hand-woven Ghanaian *kente* (Rabine 2010, 215–16).

Kente as a Fashion Fabric

In Ghana during the past decade, the wearing of hand-loomed *kente* has undergone a renaissance, becoming extremely fashionable. Photographs of the 2001 inauguration of President John Kufuor are notable for the prominence of handwoven *kente* worn by those attending. Ghanaian weavers are creating new, innovative combinations of traditional *kente* designs for men's robes and for stylish women's *kaba* ensembles.

Most recently, a new dimension of *kente* design has emerged—*kente* as a fashion fabric. *Kente* is now produced in striking new designs and fashion colors, with an emphasis on inventive surface design rather than customary

78

symbolic meaning (Fig. 7, also Fig. 3). Contemporary weavers are combining lavender and pale-blue rayon threads to create *kente* with an iridescent shimmer. Another example of fashion *kente*, combining different shades of burnt orange and umber, is woven with an abstract, flowing curvilinear weft design.

This new, fashion-oriented approach to *kente* design is being fueled by the inventiveness of Ghanaian seamstresses and tailors, as well as Ghana's new generation of fashion designers. These designers, mainly located in Ghana's coastal capital of Accra, are combining international fashion consciousness with a sophisticated reinvention of *kente* as a fashion textile to suit the cosmopolitan tastes of Ghana's small but growing professional population.

The Development of African-Print Cloth

Also on display in the Harn exhibition are two recent examples of African-print commemorative cloth (Pls. 22 and 28), a special category of the African-print textiles which are highly valued in much of western and central Africa.

In Ghana, the most respected modes of women's dress are stylish *kaba* ensembles made of African-print cloth (Fig. 8). The origins of African-print cloth are to be found in West Africa's coastal trade linking the region to Europe and the East Indies. Efforts to compete with handmade Javanese batiks that began in the first half of the nineteenth century provided the initial impetus for European textile companies to develop the "wax-print" manufacturing techniques that would eventually be used to produce African-print cloth (Kroese 1976, 16–17).

By the mid-nineteenth century, the Haarlem-based firm Prévinaire & Co. had succeeded in adapting a French textile-printing machine to wax- or resin-resist printing. The new machine, called *La Javanaise*, was capable of producing imitation wax-print batiks

(Rodenburg 1967, 46; Kroese 1976, 16–17). Although the factory-made batiks didn't find acceptance in Java, the imitation batiks' popularity with African consumers prompted Prévinaire & Co. to redirect their wax-print production toward West and Central African markets (Nielsen 1979, 473–76).

There are three categories of African-print cloth: *wax prints*, *Java prints*, and *fancy prints*—all with design motifs created especially for the African consumer:

Wax prints, the original and most highly valued form, are manufactured in a process imitating the handmade Javanese batik method, using mechanized rollers to apply a hot-wax or hot-resin resist to the cloth, usually creating an indigo design, which can be augmented with additional colors.

Java prints and *fancy prints*, first introduced into Africa in the 1930s, are produced by direct roller-printing of the cloth design. The higher-quality Java prints are preceded and/or followed by special dyeing or chemical processing. The less-expensive fancy prints are produced without additional dyeing or chemical procedures (see Bickford 1997; Picton 1999).

From the beginning, commercial success in the African-print cloth trade required European textile companies to develop a certain understanding of the local material culture, aesthetic tastes, and symbolic systems of different western and central African peoples (Steiner 1985, 97–100). To succeed in the West African textile market, European manufacturers adopted local name-giving practices as a means of increasing sales, a marketing strategy that has continued to the present day (Domowitz 1992; Bickford 1997; Gott 2010).

For Ghanaian women, who are the primary consumers of African-print cloth in Ghana, the general consensus is that named African-print cloth means "quality" (Gott 2010, 16–18). The naming of African-print cloth designs,

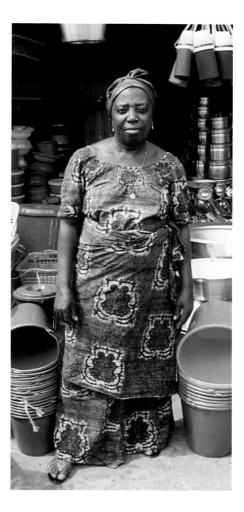

Fig. 8. (above) Madam Akua Abrafi wearing a *kaba* ensemble of African-print cloth in the long-established design, *Akyekyedeɛ Akyi* ("Back of the Tortoise"). Kumasi, Ghana, 1990. Photograph by Suzanne Gott.

largely by women cloth traders, is a continuation of naming practices associated with *kente* and other culturally valued textiles. In a manner similar to *kente*, certain African-print designs have been named for prominent individuals and historical events. Themes of leadership and state history are exemplified by the cloth *Bonsu* ("Whale"), reportedly named for the first Asante king to successfully lead a military campaign all the way to the sea (Buah 1998, 95).

The names of individual cloth designs, which refer to many aspects of Ghanaian culture and social life, often have different levels of meaning. One such example is the long-established African-print design *Akyekyedee Akyi*, or "Back of the Tortoise" (see Fig. 8). This cloth design, named after "the beauty of the tortoise shell," can also be worn strategically in situations of interpersonal conflict. If a woman is "at loggerheads" with someone in her household, she can put on this cloth when leaving the house, so as to declare "'do whatever you like in my absence' to my back—since the back of a tortoise is hard and nothing can hurt it" (Gott 1994, 67).

The special value associated with named cloth has remained a significant factor in women's purchase of African-print cloth throughout the twentieth and early twenty-first centuries, even though the importance of named African prints has declined somewhat due to recent changes in the African-print cloth market.

Commemorative Cloth

Commemorative cloth is a special category of African-print cloth that is created to commemorate and celebrate important events, political movements, and honored individuals (see Spencer 1983; Bickford 1994; Picton 2001; Faber 2010). Most commemorative African-print textiles are either Java or fancy prints, since the direct-printing technique is required to produce the finely detailed designs and photographic

images that characterize commemorative cloth designs (Spencer 1983).

Commemorative designs are created for a variety of important occasions, personal as well as institutional. A church may celebrate its founding anniversary by ordering a special commemorative cloth. In the past, bereaved families might order a commemorative cloth to wear for funeral observances, a practice now largely replaced by custom-made T-shirts with a silk-screened photographic image of the deceased.

The most widely worn commemorative African-prints are those honoring events of national and international importance. In 2007, the Ghanaian textile firm Printex Ltd. produced a special African-print cloth to commemorate Ghana's Fiftieth Anniversary of Independence (Fig. 9). The Printex design is an updated version of a 1957 commemorative cloth created to celebrate Ghana's independence from colonial rule (see Beauchamp 1957).

Fig. 9. An African-print commemorative cloth produced by the Ghanaian textile firm Printex Ltd. in 2007 to commemorate Ghana's Fiftieth Anniversary of Independence. Collection of Suzanne Gott.

The Harn exhibition includes a recent example of African-print cloth created to commemorate and celebrate an important political event. The 2009 commemorative cloth in the exhibition (Pl. 22) was created to celebrate the July 2009 state visit of U.S. President Barack Obama to the Republic of Ghana. The cloth features photographic images of Ghanaian President Prof. John Atta Mills and First Lady Naadu Mills, with President Obama and First Lady Michelle Obama. This cloth was produced by Ghana Textile Printing Company (GTP), which has been producing African-print textiles in Ghana since 1970.

Challenges of a Globalized Economy

In the late 1990s, Ghanaian and other African textile companies began to suffer from the effects of trade liberalization policies imposed by the IMF and World Bank Structural Adjustment Programs (SAPs), which opened local markets to cheaper imitations of African-print cloth designs produced in Asia and Southeast Asia (Quartey 2006; Sylvanus 2007).

One of Ghana's leading textile companies, Akosombo Textiles Limited (ATL), is now jointly owned in partnership with the Hong Kong textile giant CHA Group. It is unclear whether Ghana's remaining textile companies, GTP and Printex, will be able to effectively compete with the cheaper Asian/Southeast Asian textiles and remain in business. Although the 2007 commemorative cloth for Ghana's Fiftieth Anniversary of Independence (see Fig. 9) was commissioned from the Ghanaian firm Printex, consumers could also purchase cheaper Fiftieth Anniversary commemorative African-prints that were produced by textile manufacturers in China.

Ghanaian Textiles in the Twenty-First Century

The Ghanaian textiles in the Harn exhibition offer vivid testimony to the rich legacy of West Africa's cosmopolitan and interwoven textile history. These textiles are expressions of ongoing change and artistic innovation, which also direct our attention to issues of globalization.

The Ewe and Asante *kente* in the exhibition demonstrate local weavers' creative initiative in adopting and transforming a new textile form and technology. The "Clinton" and "*adinkra*" *kente* from Samuel Cophie's Bonwire workshop reveal the continuing vitality of Ghana's handwoven *kente* tradition. *Kente*'s particular significance for Pan-African and African Diaspora identity, coupled with processes of globalization and cultural appropriation, are bringing new opportunities and challenges to weavers of Ghanaian *kente*. Within Ghana, *kente*'s prominence in contemporary popular and designer fashions provides evidence of its enduring cultural significance and the innovative spirit of today's *kente* artists.

Recent examples of Ghanaian commemorative cloth (see Pls. 22 and 28) reveal the ongoing appeal of African-print textiles and the special role that commemorative cloth continues to play in Ghanaian politics and popular culture. In the case of African-print textiles, including commemorative cloth, Ghana's expansive "textile diasporas" now include Asian and Southeast Asian manufacturers of African-print cloth, whose cheaper production costs threaten the future of Ghana's own African-print industry. Ghanaian textile firms are endeavoring to meet this challenge. ◆

References

Adler, Peter, and Nicholas Barnard. 1992. *African Majesty: The Textile Art of the Ashanti and Ewe*. London: Thames and Hudson Ltd.

Anyidoho, Kofi. 2008. "Ghanaian *Kente*: Cloth and Song." In Lynn Gumpert, ed., *The Poetics of Cloth: African Textiles/Recent Art*, 32–47. New York: Grey Art Gallery, New York University.

Beauchamp, P. C. 1957. "A Gay Garb for Ghana." *West Africa* 41, no. 2081 (March 2): 209.

Bickford, Kathleen E. 1997. *Everyday Patterns: Factory-printed Cloth of Africa*. Kansas City: University of Missouri–Kansas City.

———. 1994. "The A.B.C.'s of Cloth and Politics in Côte d'Ivoire." *Africa Today* 41, no. 2: 5–24.

Boateng, Boatema. 2004. "African Textiles and the Politics of Diaspora Identity-Making." In Jean Allman, ed., *Fashioning Africa: Power and the Politics of Dress*, 212–26. Bloomington: Indiana University Press.

Bolland, Rita. 1992. "Clothing from Burial Caves in Mali, 11th–18th Century." In Roy Sieber et al., *History, Design, and Craft in West African Strip-Woven Cloth: Papers Presented at a Symposium Organized by the National Museum of African Art, Smithsonian Institution*, February 18–19, 1988, 53–81. Washington, D.C.: National Museum of African Art, Smithsonian Institution.

Bowdich, T. Edward. (1819) 1966. *Mission from Cape Coast to Ashantee*. London: Frank Cass & Co.

Buah, F. K. 1998. *A History of Ghana*. London: MacMillan Education.

Cole, Herbert M., and Doran H. Ross. 1977. *The Arts of Ghana*. Los Angeles: Museum of Cultural History, University of California.

Dennis, Ahiagble Bob. 2004. *The Pride of Ewe Kente*. Accra, Ghana: Sub-Saharan Publishers.

Domowitz, Susan. 1992. "Wearing Proverbs: Anyi Names for Printed Factory Cloth." *African Arts* 25, no. 3: 82–87, 104.

Faber, Paul. 2010. *Long Live the President! Portrait-Cloths from Africa*. Amsterdam: KIT Publishers.

Gott, Suzanne. 2010. "The Ghanaian *Kaba*: Fashion that Sustains Culture." In Suzanne Gott and Kristyne Loughran, eds., *Contemporary African Fashion*, 11–27. Bloomington: Indiana University Press.

———. 1994. "In Celebration of the Female: Dress, Aesthetics, Performance, and Identity in Contemporary Asante." Ph.D. dissertation, Indiana University.

Johnson, Marion. 1980. "Cloth as Money: The Cloth Strip Currencies of Africa." In Dale Idiens and K. G. Ponting, eds., *Textiles of Africa*, 193–202. Bath: Pasold Research Fund.

Kraamer, Malika. 2006. "Ghanaian Interweaving in the Nineteenth Century: A New Perspective on Ewe and Asante Textile History." *African Arts* 39, no. 4: 36–53, 93–95.

Kriger, Colleen. 2006. *Cloth in West African History*. Lanham, Md.: AltaMira Press.

Kroese, W. T. 1976. *The Origin of the Wax Block Prints on the Coast of West Africa*. Hengelo, The Netherlands: N. V. Uitgeverij Smit.

Kyerematen, A. A. Y. 1964. *Panoply of Ghana*. London: Longman.

Lamb, Venice. 1975. *West African Weaving*. London: Duckworth.

Mato, Daniel. 1986. "Clothed in Symbol— The Art of Adinkra among the Akan of Ghana." Ph.D. dissertation, Indiana University.

Nielsen, Ruth T. 1979. "The History and Development of Wax-Printed Textiles Intended for West Africa and Zaire." In Justine M. Cordwell and Ronald A. Schwartz, eds., *The Fabrics of Culture*, 467–98. The Hague: Mouton.

Picton, John. 2001. "Colonial Pretense and African Resistance, or Subversion Subverted: Commemorative Textiles in Sub-Saharan Africa." In Okwui Enwezor, ed., *The Short Century: Independence and Liberation Movements in Africa 1945–1994*, 158–67. New York: Prestel.

———. 1999. *The Art of African Textiles: Technology, Tradition, and Lurex*. London: Lund Humphries.

Quartey, Peter. 2006. "The Textiles and Clothing Industry in Ghana." In Herbert Jauch and Rudolf Traub-Merz, eds., *The Future of the Textile and Clothing Industry in Sub-Saharan Africa*, 135–46. Bonn: Friedrich-Ebert-Stiftung.

Rabine, Leslie W. 2010. "Translating African Textiles into U.S. Fashion Design: Brenda Winstead and Damali Afrikan Wear." In Suzanne Gott and Kristyne Loughran, eds., *Contemporary African Fashion*, 204–19. Bloomington: Indiana University Press.

Rattray, Robert S. 1927. *Religion and Art in Ashanti*. Oxford: Clarendon Press.

Rodenburg, G. H. 1967. "Dutch Wax-Block Garments." *Textiel-historische Bijdragen* 8: 39–50.

Ross, Doran H., ed. 1998. *Wrapped in Pride: Ghanaian Kente and African American Identity*. UCLA Fowler Museum of Cultural History Textile Series, No. 2. Los Angeles: UCLA Fowler Museum of Cultural History.

Spencer, Anne M. 1998. "Samuel Cophie, Master Weaver." In Doran H. Ross, ed., *Wrapped in Pride: Ghanaian Kente and African American Identity*, 96–101. Los Angeles: UCLA Fowler Museum of Cultural History.

———. 1983. *In Praise of Heroes: Contemporary African Commemorative Cloth*. Newark, N.J.: Newark Museum.

Steiner, Christopher B. 1985. "Another Image of Africa: Toward an Ethnohistory of European Cloth Marketed in West Africa, 1873–1960." *Ethnohistory* 32, no. 2: 91–110.

Sylvanus, Nina. 2007. "The Fabric of Africanity: Tracing the Global Threads of Authenticity." *Anthropological Theory* 7, no. 2: 201–16.

Yankah, Kojo. 2009. *Otumfuo Osei Tutu II: The King on the Golden Stool*. Accra, Ghana: Unimax Macmillan Ltd.

Christopher Richards

Prints and Politics:

REFLECTIONS ON PRESIDENT OBAMA'S VISIT TO GHANA

My first trip to Ghana occurred during June and July of 2009. This trip was my second visit to the continent of Africa, and it served as an initial investigation into Africa's fashion industry. I attended Ghana's Third Annual Ghana Fashion Weekend and was surprised to discover the vibrant and burgeoning fashion industry within Ghana's capital city, Accra. The following is a brief personal account of my experiences in Ghana leading up to President Obama's visit to Accra, and indirectly illustrates how textiles played a significant role in visualizing this historic occasion.

After traveling in Ghana for several weeks, I had grown accustomed to the cries of "Obruni" (which means "foreigner" in Akan). Whether catching a cab in Kumasi or exploring the small town of Anomabo, I was continually referred to as "Obruni." Imagine my surprise when I visited a market in Accra and was greeted with excited shouts of "Obama." For the rest of my time in Ghana, the word "Obruni" vanished from the Ghanaian lexicon and was replaced with "Obama," a linguistic revision I found entertaining and refreshing. It was the first time in my international travels that an American president had been celebrated, and it was a fantastic feeling.

Ghana's Obama-mania culminated on July 11, 2009, the day of Obama's speech in Accra. My friends and I hailed a taxi and began our journey toward Osu, a district in central Accra known to be popular with expatriates and foreigners (and home to one of the few restaurants with a television on which to watch Obama's speech). As our cab driver maneuvered through the heavy traffic of Accra, the flow of cars began to slow. Although our driver had an impeccable knowledge of Accra's side streets, he could not avoid the inevitable. We eventually found ourselves on a dirt road in stand-still traffic, with no sign of further progress. Against our cab driver's wishes, we vacated the cab and began walking toward Accra's main highway; nothing was going to stop us from reaching Osu and participating in this momentous occasion. As we reached the main highway, the scene that unfolded was nothing short of astounding. Parked cars lined the thoroughfare, and hundreds of Ghanaians were abandoning their cars and walking to their destinations (Fig. 1). Ghanaians traveling to work, school, and even funerals were all halted by Obama's trip to Parliament (Fig. 2). As my friends and I joined the throng, we walked past a large group of Ghanaians arguing loudly with several police officers. They were complaining about the road closures, which I immediately assumed would be attributed directly to Obama and the United States. To my surprise, the Ghanaians blamed their own government for poorly planning the event, and continued to celebrate Obama's presence in Accra. Nothing seemed to diminish the overall feeling of elation and celebration.

Upon arriving in Osu, the excitement of Obama's arrival was palpable. Everywhere I turned there were souvenirs commemorating Obama's visit. These souvenirs had been trickling into the various markets for weeks, but by the time of Obama's disembarkation, they flooded the market stalls and streets of Accra (Fig. 3). There were paintings of Obama and Ghana's president John Mills (Fig. 4), as well as flags, "Obama biscuits," and several men hawking CDs of Blakk Rasta's latest single, "Barack Obama." Out of this flurry of Obama tsotchkes, the factory-printed cloths captured my attention. In fact, these "Obama prints" served as some of the first visible indicators of Obama's impending visit to Ghana. On my taxi ride from the airport three weeks before Obama's arrival, I remember seeing a shirt in a market stall featuring large images of Obama's face juxtaposed with "Akwaaba" ("Welcome" in Akan). After seeing that shirt, I was on a mission to find every Obama print I possibly could.

After my first Obama cloth sighting, I began to scour the markets of Accra for Obama prints. The first cloth I found featured the previously mentioned motif—large portraits of Obama

Fig. 1. (top) Ghanians abandoning their cars on the highway. Accra, Ghana, July 11, 2009. Photograph by Christopher Richards.

Fig. 2. (middle) Ghanaians traveling to work, school, and even funerals were all halted by Obama's trip to Parliament. Accra, Ghana, July 11, 2009. Photograph by Christopher Richards.

Fig. 3. (right) A roadside vendor in Osu displaying an array of Obama shirts. Photograph by Christopher Richards, 2009.

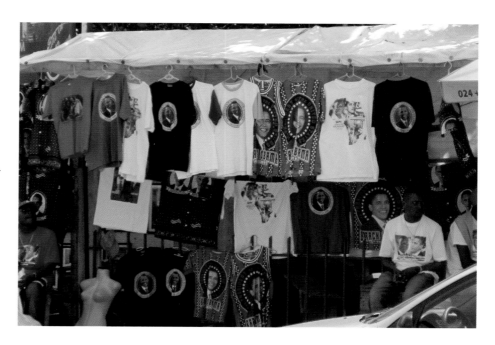

 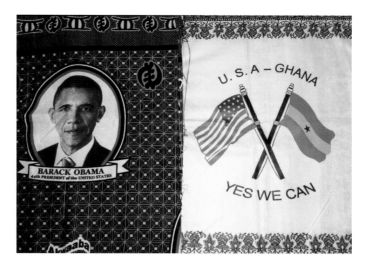

juxtaposed with "Akwaaba" on a bright blue background (Fig. 5). The next fabric I purchased, a sample of which is included in the Harn exhibition, featured portraits of Michelle and Barack Obama, as well as John Mills and his wife, Naadu Mills (Pl. 22). Both these fabrics were relatively common, but I diligently continued my search for more Obama prints. In Anomabo I found a print I hadn't seen anywhere else. It featured very large, bordered motifs of the American and the Ghanaian flag with the caption "Yes We Can" (See Fig. 5). There were many other Obama prints besides the three I've mentioned, but I found these cloths to be particularly striking as examples of the dual importance of politics and factory cloth within Ghanaian society. These cloths were more than souvenirs of Obama's visit; they were used to create garments for everyday dress.

I saw several Ghanaians wearing shirts fashioned from the previously mentioned fabrics, as well as countless dresses emblazoned with Obama's image. Obama-inspired clothing even found its way onto the runway. During Ghana's Fashion Weekend, an entire collection was devoted to Obama and his visit to Africa. The collection featured T-shirts with Obama's face superimposed over the continent of Africa (Fig. 6) and sayings such as

"My president is Black." Graphic T-shirts were equally present throughout Accra, particularly on the day of Obama's arrival. If Ghanaians weren't dressed in the aforementioned factory cloth, they wore T-shirts emblazoned with images of Obama and John Mills (Fig. 7). The variety of Obama-themed clothing resulted in an overwhelming visual mélange echoing Ghanaian support of President Obama and the United States.

The Obama textiles indirectly illustrate the cultural importance of textiles and clothing to Ghanaian culture and society. For centuries, textiles have played an integral role in distinguishing class, prestige, and ethnicity among Ghanaians. Contemporary Ghanaian fashion designs continue to serve similar purposes. The Obama cloths also illustrate how clothing and textiles can visually assert political opinions and allegiances. By dressing in Obama-printed cloth, Ghanaians expressed their support of America's then newly elected president, their excitement about his visit, and their hopes for Africa's future. Although the initial fervor over Obama's visit has undoubtedly passed, the Obama-inspired clothing and cloths are still present, serving not only as a reminder of this historic occasion but as a testament to the profound importance of textiles to the Ghanaian people. ◆

Fig. 4. (above left) A painting of U.S. President Barack Obama and Ghanaian President John Mills. Accra, Ghana. Photograph by Christopher Richards, 2009.

Fig. 5. (above right) Two cloths from the Accra market showing large images of Obama's face and the slogan "Yes We Can" juxtaposed with "Akwaaba" ("Welcome" in Akan). Photograph by Christopher Richards, 2009.

Fig. 6. (right) An Obama-themed collection from Ghana Fashion Weekend 2009. Photograph by Christopher Richards.

Fig. 7. (below) A Ghanaian man wearing a T-shirt with images of Obama and John Mills. Accra, Ghana, 2009. Photograph by Christopher Richards.

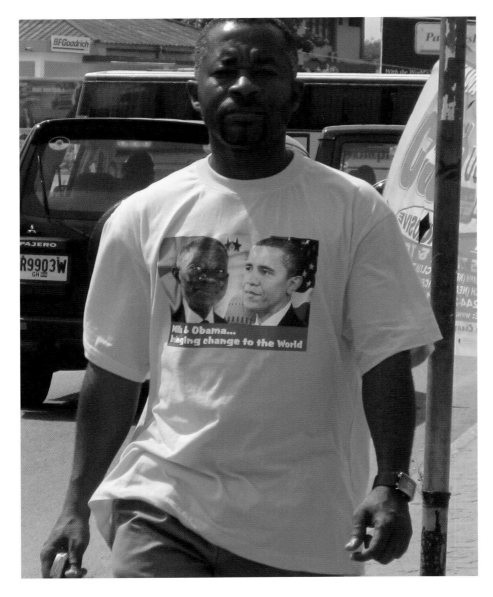

22 (opposite page)
Ghana
Cloth Commemorating Visit of President Obama
2009
Cotton commercial cloth
71 x 46 in. (180.34 x 116.84 cm)
Anonymous loan

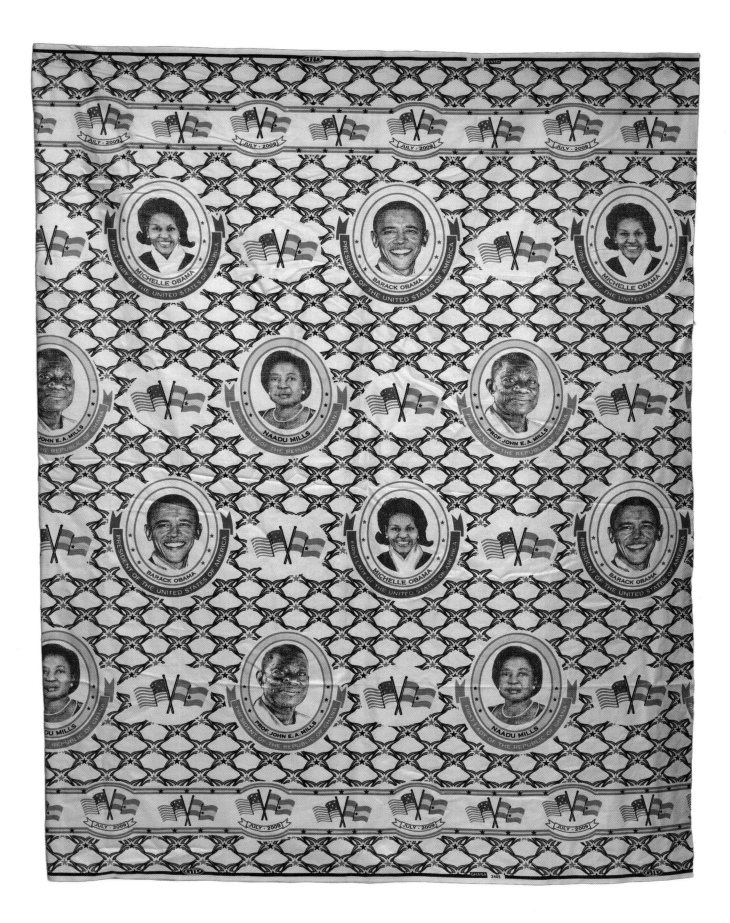

detail

23 (opposite page and detail above)
EL ANATSUI
Ghanaian, b. 1944
Old Man's Cloth
2003
Aluminum and copper wire
192 x 205 in. (487.7 x 548.6 cm)
Museum purchase with funds provided by
friends of the Harn Museum
2005.37

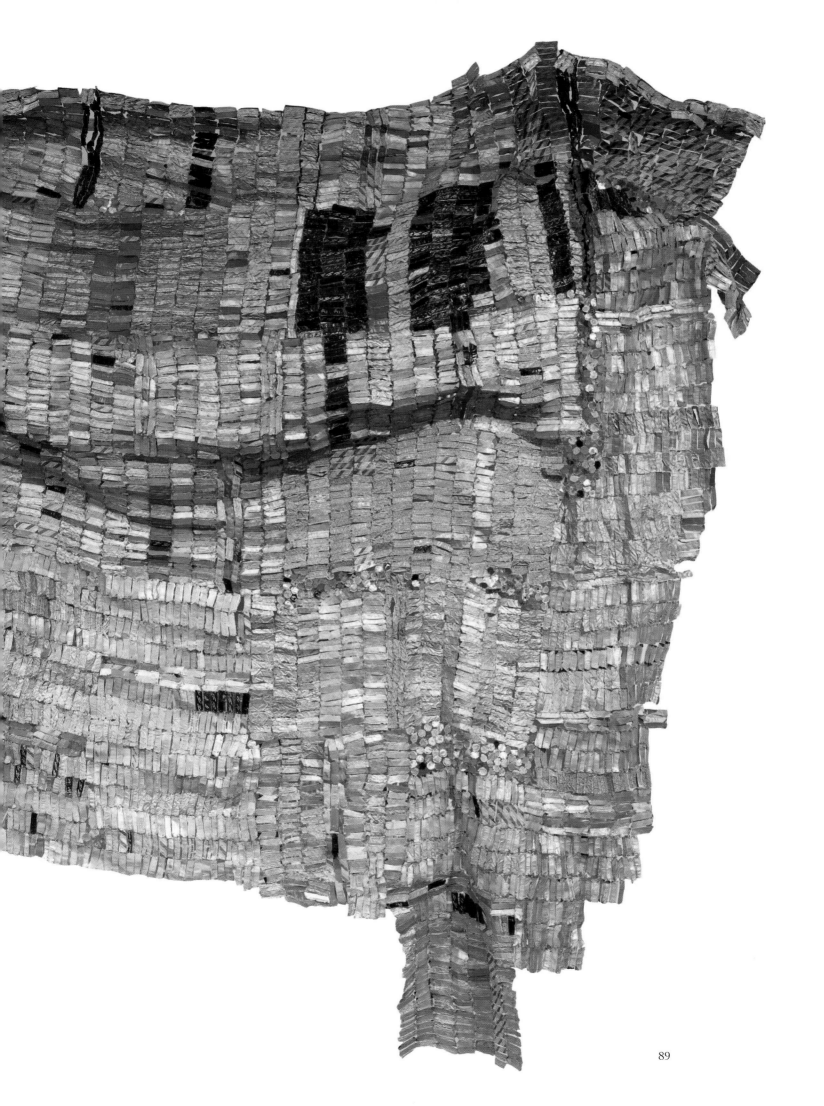

89

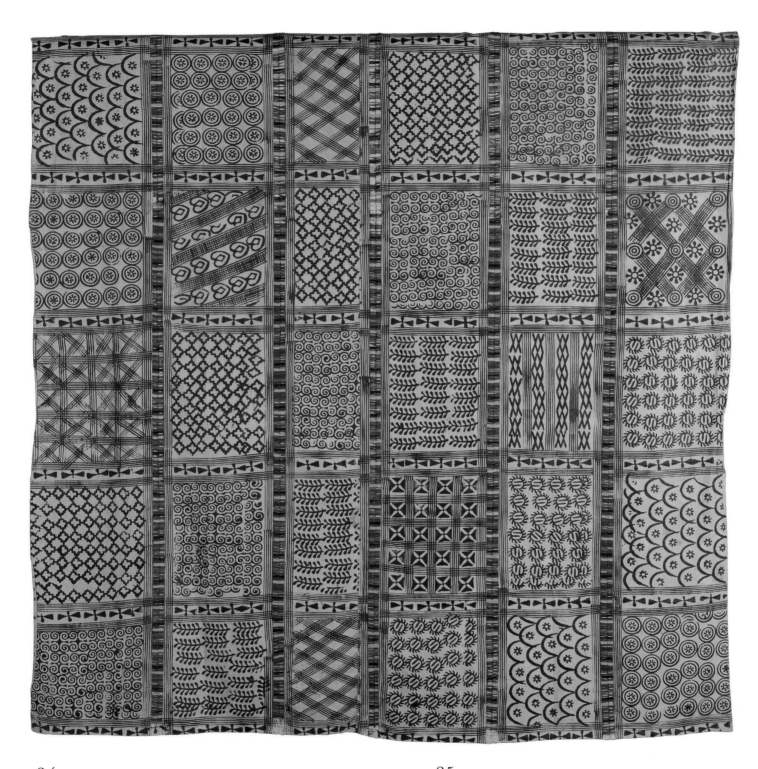

24 (above)
AKAN PEOPLE
Ghana
Adinkra Cloth
Late 20th century
Cotton, natural and synthetic dye
88.18 x 131.87 in. (224 x 335 cm)
Museum purchase with funds provided by the Caroline Julier
and James G. Richardson Acquisition Fund
2009.32.13

25 (opposite page)
EWE PEOPLE
Ghana
Man's Wrapper (*adanudo*)
Cotton
124 x 68.5 in. (315 x 174 cm)
Museum purchase with funds provided by the Caroline Julier
and James G. Richardson Acquisition Fund
2010.8.3

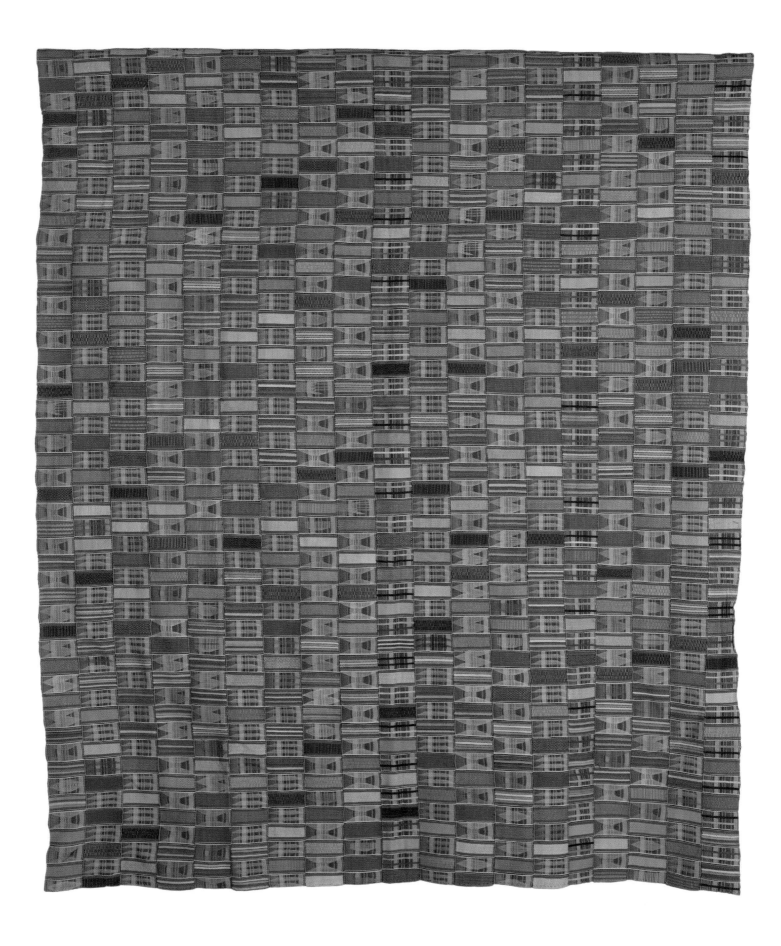

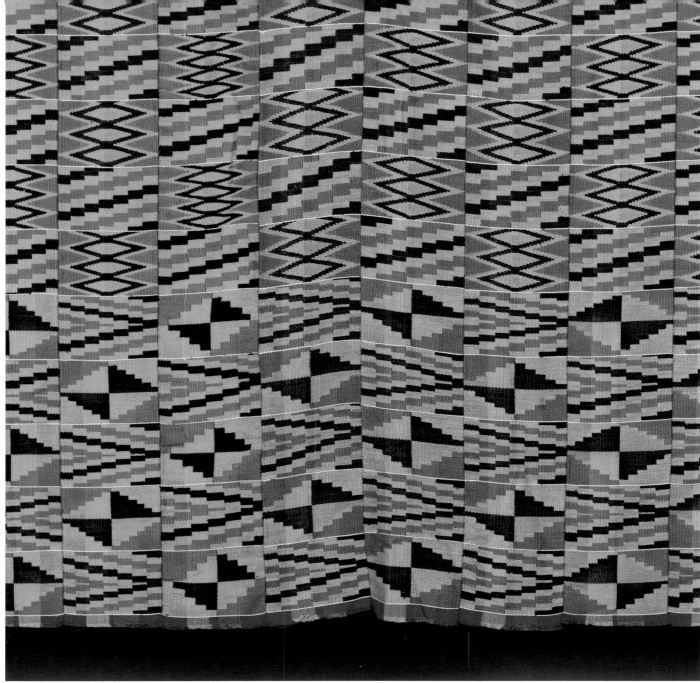

detail

26 (opposite page and above detail)
SAMUEL COPHIE
Ghanaian, b. 1939
Man's Cloth Commemorating Visit of President Clinton (*kente*)
2009
Rayon
144 x 87 in. (365.76 x 220.98 cm)
Museum purchase with funds provided by the Caroline Julier
and James G. Richardson Acquisition Fund
2010.53.1

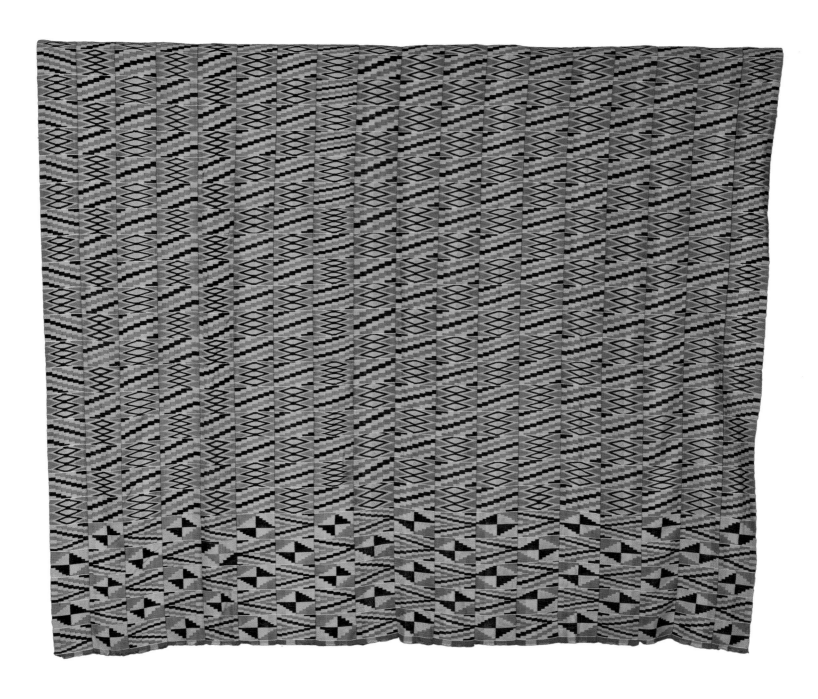

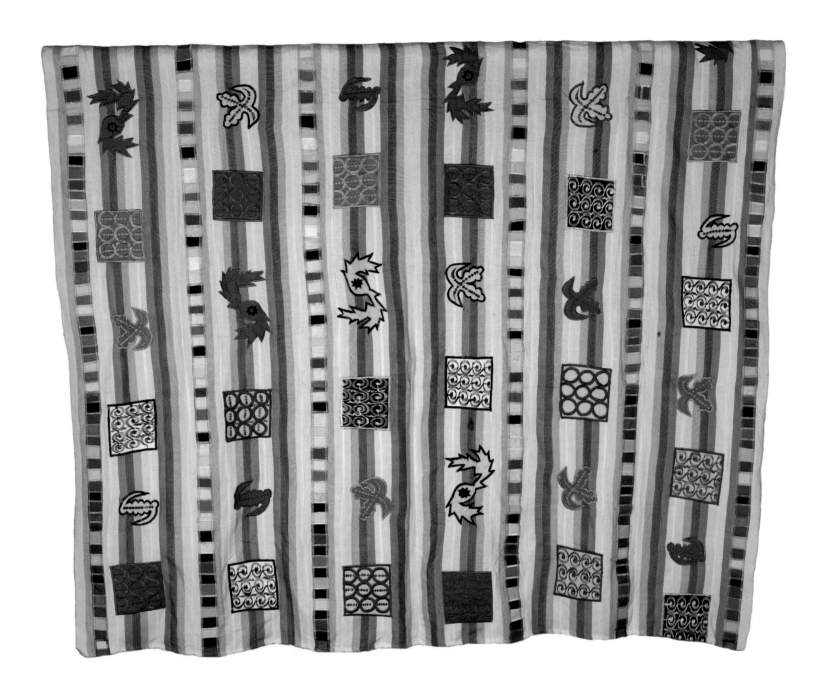

27 (above)
SAMUEL COPHIE
Ghanaian, b. 1939
Man's Cloth with Adinkra Motifs (kente)
2009
Cotton, synthetic thread, rayon
133 x 43.5 in. (337.82 x 110.49 cm)
Museum purchase with funds provided by the Caroline Julier
and James G. Richardson Acquisition Fund
2010.53.2

28 (opposite page)
Ghana
Cloth Commemorating 1939 Earthquake
c. 1939
Cotton
47 x 103 in. (119.4 x 266.7 cm)
Gift of Lewis Berner and Family
2002.31.9

94

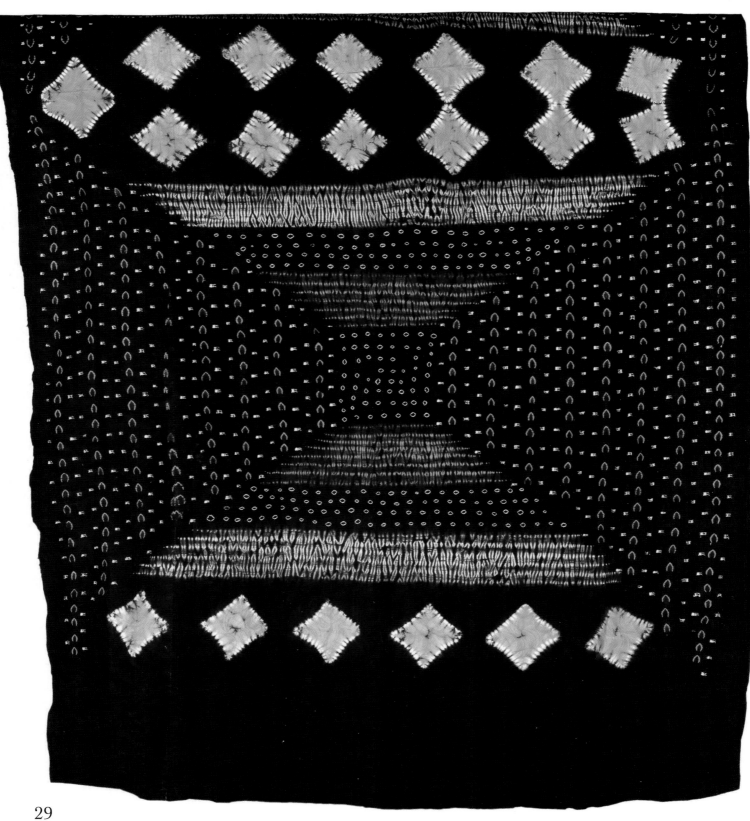

29
Mali
Cloth (*bazin*)
20th century
Cotton, synthetic dye
126 x 63.5 in. (320 x 161.3 cm)
Museum purchase with funds provided by the Caroline Julier
and James G. Richardson Acquisition Fund
2010.2.3

Susan Cooksey

Bazin in Mali:

THE CROSSROADS OF STYLE

Malian *bazin*, centered in the capital Bamako, is one of the most popular and widely traded hand-dyed textiles in West Africa. Beyond Mali, Senegal is one of the largest consumers of Malian hand-dyed textiles in Africa (Gérimont 2008), though Malian dyed textiles and garments also appear in markets in Europe and the United States and are traded globally through the internet. The current success of Malian hand-dyed cloth can be attributed to many factors. This essay focuses on the many sources that inform its aesthetics and production, the strength of its foundation in ancient practices, and the recent innovations on the part of Bamako textile artists who have capitalized on new materials, a brilliant sense of design, and an ability to keep up with changing preferences of consumers.

Throughout Mali and much of Francophone West Africa, both the imported cloth used for hand dyeing and the finished dyed cloth are referred to generically as *bazin* (or *basin*), a corruption of the word *bombasin*, derived from *bombagia*, the Italian word for cotton. The cloth is factory-made damask or brocade cloth made of cotton, or cotton blended with synthetic fiber, imported primarily from Europe and China. There are many gradations in quality, and local consumers are well aware of the differences between them. German-made cloth is considered the best of all because of its thread count,

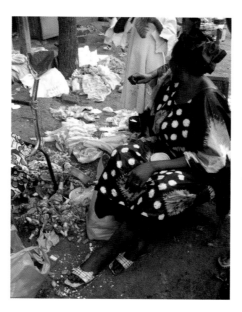

its silky texture, and its colorfastness and richness of color when dyed. The best quality is called *bazin riche* (rich *bazin*) and the second best, *bazin moins riche* (less rich *bazin*). In large cities, including Bamako, there are markets dedicated solely to the sale of undyed *bazin*, serving hosts of dyers and other textile artists, mostly women, working out of their homes (Figs. 1 and 2).

The first imports of *bazin* produced in France reached Mali in 1909. The imported cloth was widely consumed in Mali because it was more affordable than locally made cloth. Textile artists turned to the imported cloth readily since resist-dyeing techniques were more easily achieved because of its finer texture. Some of the most skilled dyers and textile artists working with resist

Fig. 1. (above left) A *bazin* dyer wearing a *bazin* dress. Bamako, 2006. Photograph by Susan Cooksey.

Fig. 2. (above right) A *bazin* vendor displaying a cloth with *tchopoti* motif. Bamako, 2006. Photograph by Susan Cooksey.

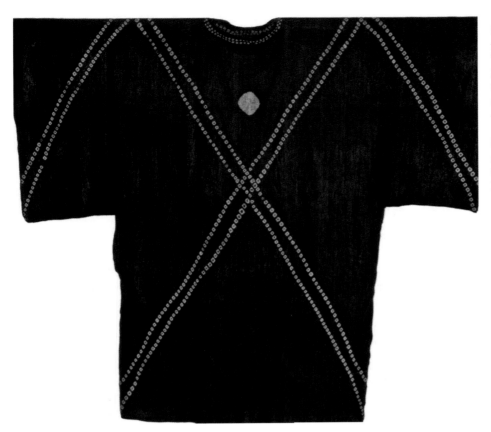

Fig. 3. (left) Seventeenth-century tunic from the Togo and Republic of Benin border zone. Weickmann Collection; before 1659. Ulmer Museum, Ulm, Germany. From Bernhard Gardi, *Le Boubou—C'est Chic* (Basel: Museum der Kulturen Basel, 2002), pp. 51 and 52, ill. 49 and 50.

Fig. 4. (below) Wolof family with Soninke-style resist-dyed textiles, 1909. Postcard. From Patricia Gérimont, *Tienturières à Bamako* (Paris: Ibis Press, 2008).

and other patterning techniques were the Yoruba and the Hausa (in modern-day Nigeria), and the Soninke (in modern-day Mali, Guinea, and Mauritania), who were originally from the ancient kingdom of Ghana. The Soninke championed the art of indigo dyeing and were active in production and trans-Saharan trade of indigo-dyed cloth as long ago as the eighth century. When the kingdom fell, the Soninke fled and settled across West Africa. Their descendants are now associated with groups throughout the region from Senegal to Côte d'Ivoire who are revered for their skill as textile artists. The Soninke-related peoples' experimentation with dyeing techniques, including resist dyeing, is evidenced by a tunic from the border zone between Togo and Republic of Benin dating from the seventeenth century (Fig. 3). The technique used to create blocks of resist areas compares to twentieth-century textiles from Côte d'Ivoire and Guinea (Gardi 2002). Later Soninke textiles are known particularly for fine resist-dyed patterning. A 1909 postcard shows a Wolof merchant's wife and children from Noro,

Mali, wearing garments with patterns made from a technique of stitch resist developed in Saint Louis, Senegal (Fig. 4).

The Soninke techniques that have persisted in Bamako today include *guinée*, a fine tie-dye that produces intricate designs, and a derivation of the

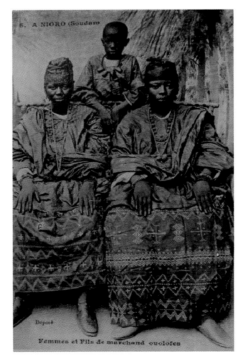

Soninke embroidery resist technique *topa*, which is now called *tchopoti* in Mali. *Guinée* and *tchopoti* are the most valued designs because they require such intensive labor. A *bazin* cloth in the Harn collection (Pl. 29) combines patterns categorized as *guinée* with the *tchopoti* technique of small circles called *potipotini* (a Bamana word meaning "little by little") and sewn resist areas of a repeated small crescent shape called *mununankalini*, which recalls a wooden stirrer used for porridge and is the smallest scale of the motif known throughout West Africa as "fishbone." The large diamond shape may be derived from playing card emblems.

In the 1960s and 1970s, after Malian independence, Malian artists traveled to Sierra Leone, Côte d'Ivoire, and other countries that had established successful synthetic-dyeing businesses (Downs 2007). Combining the knowledge and new synthetic dyes they acquired outside Mali, they developed innovative methods of resist using sewing, tie-dyeing, wax, stenciling, folding, and block printing. The names of techniques and the images pro-

duced reflect both local and global ideas and imagery. For example, one geometric pattern is derived from local architectural forms. Another mimics motifs that appear in Fulani textile designs and other art media. A tie-dye technique that binds the fabric into a cluster of long thin strands is called "*rastas*," while the technique that bunches cloth to produce a round configuration when dyed is called "balloons" (Gérimont 2008). The use of playing card motifs, such as diamonds and hearts, has already been mentioned.

There are many specializations within the large category of *bazin* dyeing, based on style and medium. For example, there are several types of thread-resist techniques, wax-resist techniques, stenciling methods of dyeing, and so forth. In some instances, a cloth may combine multiple techniques, so that several types of specialists are involved. The production is divided among those who prepare the cloth with a resist, whether by sewing, tying, folding, stenciling, block printing, or wax application; the specialist dyers; and those skilled in "finishing" the cloth by soaking it, folding it, and beating it. The finish of the cloth is commissioned accord-

ing to the amount of sheen or burnishing the client desires. The most highly burnished cloth is considered the most prestigious because it requires the most beating and is thus more labor intensive and expensive. A cloth with the greatest finish will crackle when it is unfolded.

Tailors comprise the final group of specialists, because the *bazin* sheeting is dyed as a large rectangular sheet. Most ensembles sold include a large rectangular piece suitable for a making a large robe, or *boubou*, and two smaller pieces suitable for a wrap (*pagne*) and a head-tie. Tailors are on almost every street corner in Bamako, and dyers often work with tailors on commissioned garments. A client normally approaches a dyer with a sheet of *bazin* and an idea of a type of garment he or she would like, and works with the dyer to choose colors and patterns. Dyers also keep photo albums showing different garments, to help the client conceptualize which patterns and colors will complement a particular design.

Bazin is so popular and *bazin* production has become such an economic force that it is now recognized as a leading national industry. Top *bazin* artists are regarded as local celebrities and are honored annually at a glam-

orous ceremony in Bamako, "Bazin Night" (Fig. 5; in 2010, both Atlanta and Oakland hosted Bazin Night events), and the National Museum of Mali has a large permanent exhibition dedicated to *bazin* (Downs 2007).

Bazin has become firmly rooted in urban Bamako culture as a textile that is considered fashionable, prestigious, and venerable. It is used both for the voluminous gowns, or *boubous*, that can be embroidered with sacred motifs and that are suitable for wear during religious ceremonies, and for haute couture designs that have moved far from the center of production in Bamako. An example in the Harn collection, of a design using *bazin* by Maimouna Diallo of Bamako (Fig. 6), incorporates both local and non-local materials and techniques. It features an innovative cut, extensive machine embroidery, and beaded adornment that is intentionally reminiscent of beadwork from South Africa (Pl. 30). The tunic and skirt are made of *bazin* dyed a deep blue-black that recalls the most prestigious indigo-dyed cloths of the Hausa in Nigeria. Burnished to a high sheen, it has the quality demanded by Bamako consumers combined with the slick look of patent leather. The thin, parallel

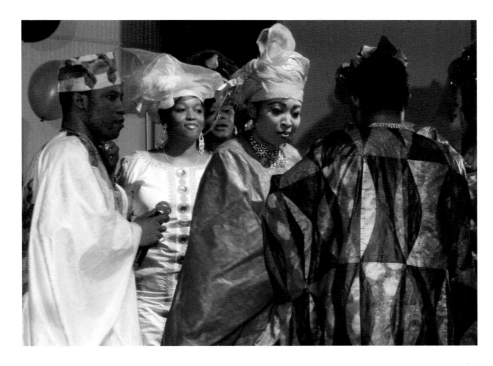

Fig. 5. "La Nuit du Bazin" in Oakland, California, 2010. Event participants offer gifts of cash in appreciation to the hosts Ousseynou Kouyate (left), and his brother Assan Kouyate (right, back turned). Photo courtesy of Maureen Gosling of Yanga Productions.

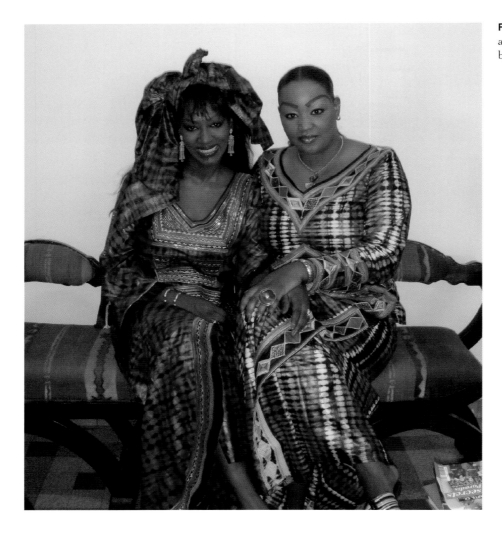

Fig. 6. Mme. Maimouna Diallo, pictured right, and a colleague. Bamako, 2010. Photograph by Victoria Rovine.

bands of glass seed-beads, sewn onto the front of the dark shiny tunic, recall the beaded skirts of the Zulu made with blackened leather.

The beaded bands on the garment by Mme. Diallo resonate with the beaded wedding capes of the Ngwane people of South Africa. A wedding cape, or *isikoti*, dating from the 1960s in the Harn collection bears similar polychrome beaded bands, sewn on overlapping flaps of textiles (Pl. 31). Such capes were made for brides by their female relatives, and reflect Ngwane family and ethnic solidarity (Fig. 7). The geometric patterning on the Ngwane beaded bands reveals an older style of beadwork that was once traceable to particular clans and regions; however, forced relocations of peoples throughout the twentieth century led to a loss of such associations. New designs in Ngwane beadwork, as seen in the Harn example, reflect a modern world and all that one might desire from it, including tall buildings, cars, trucks, and even imported clothing styles, such as the A-line skirt worn by the stylized figure on one of the bands.

The perception of *bazin* as chic imported cloth that was associated with fashionable urbanites evolved in the mid-twentieth century. Seydou Keïta (1921–2001), a studio photographer working in Bamako from 1948 to 1964, produced a series of portraits that give us a glimpse of local preferences for imported textiles during that period. Keïta's portrait of a woman (Pl. 32), adorned in a dress made of imported cloth against an imported cloth backdrop, simultaneously reveals the woman's taste, current fashion, and Keïta's own visual sense in supplying the swirling patterned cloth behind his subject. Keïta was known to provide props of

clothing, jewelry and textile backdrops for his clients, and both sitter and photographer chose among these objects for the shoot (Magnin 1995; Bigham 1999). Keïta's compositions fully exploit the textile patterns as formal elements that enhance the composition and keep the eye moving over the frame. In this image, the pattern activates the space behind the woman, both visually and psychologically.

Keïta's mastery in creating a subtle integration of visual and psychological elements attests to his aesthetics, but these images could also be seen as documentation of then current fashions (Bigham 1999; Cissé 1997). The woman's garment with short frills on the sleeves and a tightly fitted bodice (see Pl. 32) was a style inspired by European fashions. It has persisted, for I observed similar garments worn by Fulani women throughout Burkina Faso as recently as 2006, where this style appears to be an ethnic marker. The choice of the woman's dress in Keïta's photograph may have reflected his own aesthetics rather than a personal or ethnic preference on the part of his subject (Bigham 1999). Keïta's images, as an amalgam of personal and cultural appropriations, are a fascinating illustration of constructed identities that we as viewers are invited to enjoy and reinterpret. ◆

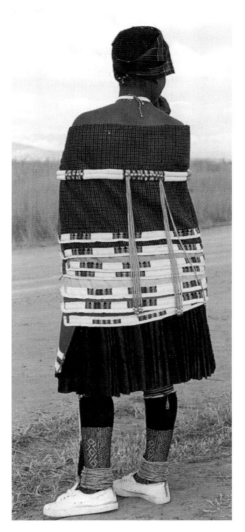

References

Bigham, Elizabeth. 1999. "Issues of Authorship in the Portrait Photographs of Seydou Keïta." *African Arts* 32, no. 1 (Spring): 56–67, 94–96.

Cissé, Youssouf Tata. 1997. "A Short History of Bamako and of the Family of the Famous Phototgrapher Seydou Keïta." In André Magnin, ed., *Seydou Keïta.* New York and Zurich: Scalo Press.

Downs, Maxine. 2007. "Microcredit and Empowerment among Women Cloth Dyers of Bamako, Mali." Ph.D. dissertation, University of Florida, Gainesville.

Gardi, Bernhard. 2002. *Le Boubou—C'est Chic: Les boubous du Mali et d'autres pays de l'Afrique de l'Ouest.* Basel: Museum der Kulturen Basel / Christoph Merian Verlag.

Gérimont, Patricia. 2008. *Tienturières à Bamako.* Paris: Ibis Press.

Magnin, André. 1995. "Seydou Keïta." *African Arts* 28, no. 4 (Autumn): 90–95.

Morris, Jean, and Eleanor Preston-Whyte. 1994. *Speaking with Beads: Zulu Arts from Southern Africa.* London: Thames and Hudson.

Fig. 7. (above) Ngwane woman wearing a beaded wedding cape, or *isikoti*. South Africa, Drakensberg area, 1975. Jean Morris and Eleanor Preston-Whyte, *Speaking with Beads: Zulu Arts from Southern Africa* (London: Thames and Hudson, 1994), p. 22. Photograph by Jean Morris.

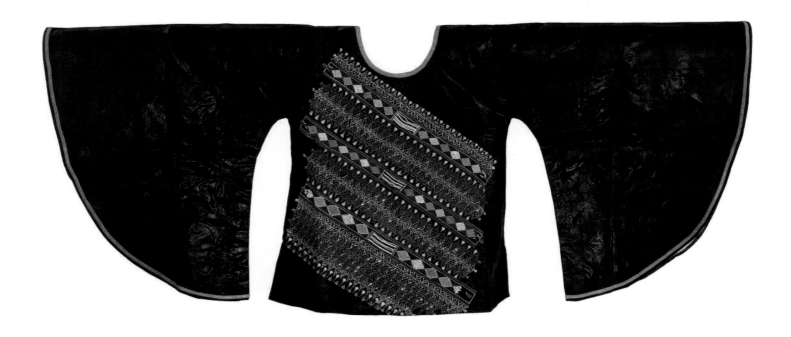

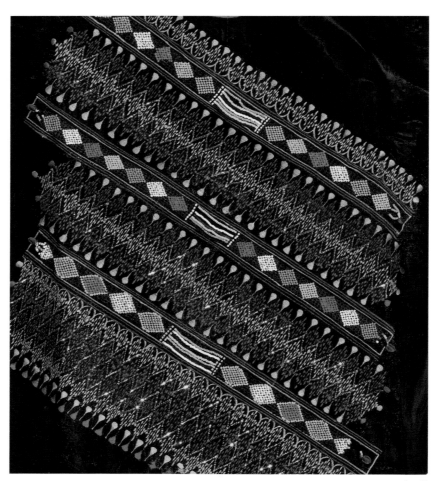

detail

102

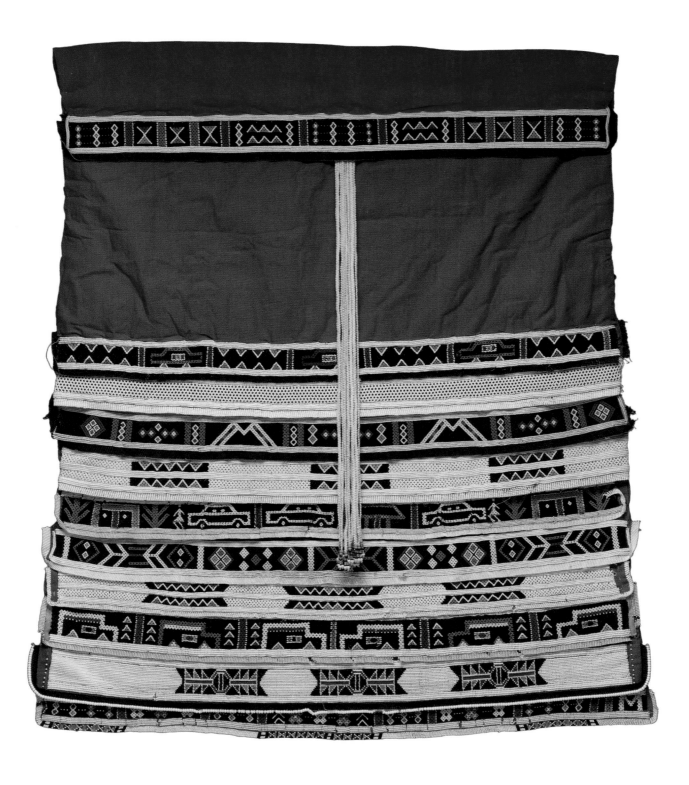

30 (opposite page)
MAIMOUNA DIALLO
Malian
Woman's Tunic
2010
Cotton damask, synthetic dye, glass beads
Tunic: 24.5 x 55.12 in. (62.2 x 140 cm)
Gift of the artist
2010.5

31 (above)
NGWANE PEOPLE (South Africa)
Bridal Cape (*isikoti*)
Mid-20th century (1960s)
Cotton cloth, glass seed-beads
33.25 x 38 x .87 in. (84.5 x 96.5 x 2.2 cm)
Gift of Norma Canelas Roth and William D. Roth
2010.36

32

SEYDOU KEÏTA
Malian, 1923–2001
Untitled #59
1956–57
Gelatin silver print
22 x 15.5 in. (55.9 x 39.4 cm)
Museum purchase with funds provided by the Caroline Julier
and James G. Richardson Acquisition Fund
2002.3.2

33

SKUNDER BOGHOSSIAN
Ethiopian-American, 1937–2003
Time Cycle III
1981
Embossed bark and sand with collage on board
48 x 47.87 x 2.75 in. (121.9 x 121.6 x 7 cm)
Museum purchase with funds provided by the Caroline Julier
and James G. Richardson Acquisition Fund, and the Charles P. and
Caroline Ireland Foundation
2006.3

Susan Cooksey

Bark and Raffia Cloth:

INTERPRETING INDIGENOUS PRESTIGE

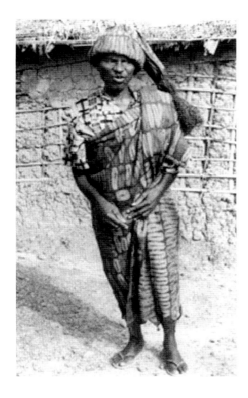

Fig. 1. (above) A Dida man wearing a raffia tie-dyed cap and wrapper. Tiegba village, Divo region, 1988. From Monni Adams and Rose Holdcraft, "Dida Woven Raffia Cloth from Côte d'Ivoire," *African Arts* 25, no. 3 (July 1992): 46, fig. 5. Photograph by Koblan Avoni and Fraternité Matin.

Indigenous plant fibers, including bark and raffia, are the most ancient materials used for cloth production in Africa. In the past, vegetal fibers were widely used to make cloth for everyday wear and for domestic and sacred use. In many regions where these early cloths were used, they were supplanted by cotton that could be grown locally and also by imported cloth. Although generally the production and use of bark and raffia textiles is in decline, for some people indigenous textiles have endured as prestigious symbols of ethnic identity and socio-economic status. For others, they have either been abandoned entirely or have been revived solely for the global market, which capitalizes on the universal appeal of their vibrant designs and rich textures.

Bark cloth derives primarily from a species of fig (*Ficus natalensis*) that grows in the equatorial forest zone of Africa. In West Africa, bark cloth is still produced in Ghana. Formerly, bark cloth was made in Liberia, Togo, and southeastern Nigeria. In Central Africa, production is most prevalent in Democratic Republic of Congo and Uganda, but is also found in Zambia, Malawi, and Madagascar. Raffia-fiber cloth is produced from the raffia palm (*Raphia ruffia, Raphia vinifera*), and is found in a wide zone of West Africa from Liberia to Nigeria; in Central Africa, it is centered in Democratic Republic of Congo but extends to Angola and Gabon. Some

raffia textiles are made in the eastern part of the continent and in Madagascar.

Two examples of raffia cloth from the Dida people of southwestern Côte d'Ivoire are remarkable technically and aesthetically, but also because of their resonance with other textile traditions in West Africa. The two cloths—a hat (*kpako*, Pl. 35) and a woman's loincloth (*vomo* or *yoko*; Pl. 34) on loan from the Garabaghi collection—are seamless, tubular constructions that have been handwoven without use of a loom and then tie-dyed. When the weaving is completed, the threads are cut and over-sewn to secure them. On the opposite end, they are made into a decorative fringe. Longer pieces, such as a loincloth, may have slits cut in the top portion to form an openwork band. The texture can be enhanced by a variety of knots and supplemental wefts. The finished cloth is tie-dyed with red and black dye, made from a root and from a combination of manganese and leaves, respectively. The dyed patterns usually combine yellow (as a ground color) with the brick-red and black to form ovals and circles.

The Garabaghi loincloth (see Pl. 34) has large blocks of knotted decoration dyed dark brown on the upper portion. It is finished at the top end by a short fringe. The bundled weft threads were left intact and have been bundled at the ends into orbs. The tie-dyed motifs are contained in perpendicular squares

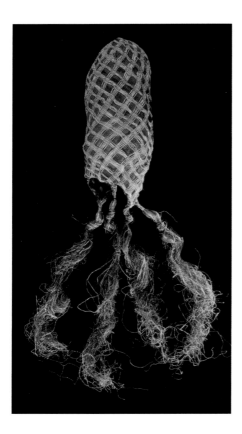

made up of small and large ovals. The dyed areas are exceptionally crisp, and the crinkle texture resulting from the tying is pleasingly juxtaposed with the finely knotted areas. The cap (see Pl. 35) has a dramatic long, dark fringe and high-relief surface from the puckered tie-dyed areas. Both garments would have been striking adornments when worn: the loincloth was looped over a waistband at the back, then drawn between the legs and looped over the band in front, and the cap would have been stretched over the head with the fringe draped over the shoulder (Fig. 1).

The Dida and their neighbors, the Godié, create similar tubular raffia cloths, and they also use similar dyes, but otherwise these garments are unique in Africa (Adams and Holdcraft 1992, 42). Similar diagonally woven raffia bags are made by the Kpelle people of Liberia (Fig. 2), and other Kru-speaking peoples produced raffia caps at least by the early twentieth century. A 1936 account is the first record we have of raffia weaving by Dida women. Thus it is possible that the Dida emulated the Liberian technique to make garments. They may have enhanced them with dyeing and knotting, making them distinctly different from the Liberian bags, which are not tie-dyed and do not have the same ornamenta-

tion. As Renée Boser-Sarivaxévanis has noted (1969, 166), the colors, shapes, and sizes of the tie-dye patterns of the Dida do not match any of the other early tie-dye patterns in West Africa, and she surmises that the use of the earth-toned pigments is probably more ancient than the use of indigo on cotton textiles that was prevalent in the other areas.

However, according to the Dida, production and use of bark cloth and cotton cloth preceded raffia cloth (Adams and Holdcraft 1992, 42). Raffia-cloth garments were once worn during social events such as weddings and celebrations of births and engagements. They were also used for bridewealth and to settle disputes, and either as shrouds or for funerary displays as well. The production and use of raffia textiles have declined among the Dida, but in 1992, Monni Adams and Rose Holdcraft reported that raffia cloth might still be worn at social events. One elder informant commented that raffia was worn to show family wealth because in the past only commoners had worn bark cloth, which required less expertise to make (1992, 45). Jocelyne Etienne-Nugue wrote that raffia cloths were worn in 1985, and were sometimes fashioned into contemporary tailored garments (Etienne-Nugue

Fig. 2. (above) A raffia woven bag from the Kpelle people, Liberia. Collected in 1927. © President and Fellows of Harvard College, Peabody Museum of Archaeology and Ethnology, 27–43–50/B4375 (T1396). From Monni Adams and Rose Holdcraft, "Dida Woven Raffia Cloth from Côte d'Ivoire," *African Arts* 25, no. 3 (July 1992): 49, fig. 12.

Fig. 3. (right) "Women in embroidered skirts dance at the *itul* festival. A chorus of kneeling women, accompanying their chants by pounding calabash rattles, are dressed in deep-red, wraparound garments, Mushenge, Nov. 1974." From Monni Adams, "Kuba Embroidered Cloth," *African Arts* 12, no. 1 (November 1978): 30, fig. 10.

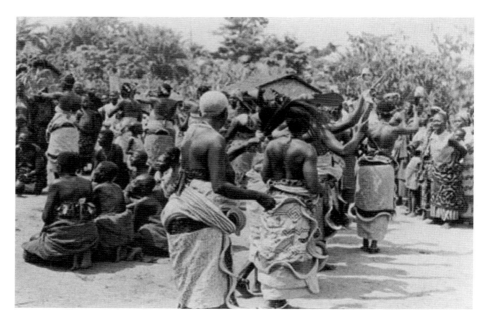

and Laget 1985, 201). In the 1980s, they were considered to be markers of ethnicity and were used in displays of regional traditions at national events.

Of the many peoples of Central Africa who produce raffia textiles, the Kuba are among the most renowned. The name "Kuba" refers both to a kingdom and to a culture group, made up of a number smaller groups organized into chiefdoms that were brought together under the leadership of the Bushoong in the seventeenth century. The Kuba, like the Dida, produce raffia textiles as prestige cloths that are worn or used for displays in ceremonies and funerals. Unlike the Dida, the Kuba have used raffia cloth continually for centuries, and have continued a parallel tradition of using bark cloth. The Kuba mastered many techniques of working with raffia fibers that remain unparalleled, producing very finely woven cloth that can be embroidered, appliquéd, or used as the substrate for a velvet-like cloth, or cut-pile. Cut-pile is associated with the Shoowa, one of the Kuba ethnic groups, who excel at making opulent cut-pile cloth with complex geometric designs. Cloths were also embellished with openwork, beadwork, decorative knots, and bobble fringes. Two examples of Kuba raffia cloth in the Harn collection, a woman's wrapper (Pl. 37) and a woman's dance overskirt (Pl. 36), are typical of Bushoong-style cloths with tightly packed shapes outlined with stitching, and appliquéd areas.

Raffia cloth is woven on a loom by men, and embroidered by women. The embroidery is done by many women in one family; thus many hands and skill levels can be seen in one cloth. The finished cloth is a symbol of the family's wealth and is worn during the *itul* festival, which is performed in the royal capital and has multiple purposes including the display of wealth among families in the community and the reinforcement of royal power. During *itul*, women and men dress in many layers of

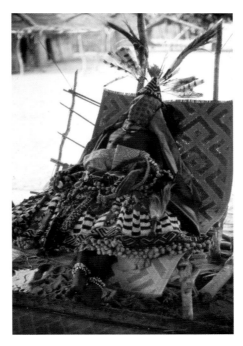

Fig. 4. "The body of a deceased male Bushoong titleholder lying in state." Photograph by Patricia Darish and David Binkley, 1981.

raffia garments produced by their family members (Fig. 3). Raffia cloth is seen even more frequently in funerary rites because the Kuba believe that a deceased person must be dressed in raffia garments carefully selected by her family so that when she passes into the land of the dead, *ilueemy*, she can be recognized there by family and other members of her ethnic group. Although the belief in *ilueemy*, which entails passage through the land of the dead and rebirth in the family in subsequent generations, is not embraced by all Kuba people today, Patricia Darish noted in 1989 that they consider it essential to preserve the practice of honoring and reinforcing their family and ethnic identity through the use of textiles. Another concern is that not dressing the deceased properly will provoke the evil spirits, or *mween*, who will wreak havoc on the lives of the family, causing many types of misfortune (Darish 1989, 135–36).

For the funeral, the deceased is dressed in the most sumptuous garments the family can afford, with the body completely covered with raffia cloth (Fig. 4). Red is a color associated with death, so red is chosen for many of the funerary cloths. Any surplus

cloth is stored by the family for future use (Darish 1989, 131). Several skirts are used for the funerary attire of women: the first is an unembellished red cloth, followed by layers of long, ornate skirts that can be around 30 feet long for men, and 25 feet for women. The less adorned end is affixed closest to the body, and the cloth is then wound around the body many times. For a deceased woman there are two styles included in the ensemble—the *ncak nsueba*, which is undyed cloth embroidered with dark brown thread, and the *ncak mbabla*, which is cloth dyed red after it is embroidered, as in the Harn example (see Pl. 37), which is a deep brick-red. The voluminous wrap skirt is then completed with a much shorter ruffle-edged overskirt (Darish 2004, updated by Darish email, 2/10/11). The ruffle is made by bundling raffia fibers and securing them to the border of the woven cloth. The edge of the skirt bound to the ruffle is accentuated in the Harn example by a dark brown cut-pile strip with small openwork triangles (see Pl. 36). The edging with cut-pile, together with the fine stitching in the appliqué and the embroidery, add beauty and prestige to the cloth.

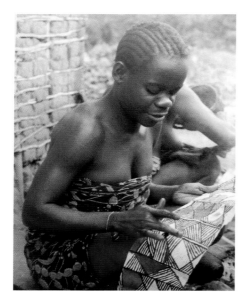

Fig. 5. Left: A Mbuti woman painting designs on a piece of bark cloth. Right: Painted designs on a Mbuti woman's back. Photographs by Robert C. Bailey, 1982.

Fine raffia cloth was produced by other people in the Zaire River region before the Kuba kingdom was founded and before the first Europeans arrived. The Portuguese, who encountered the Kongo in the late fifteenth century, became enamored of their fine raffia textiles and brought examples back to Europe in the late seventeenth century. Missionaries used raffia cloth for liturgical vestments after the Kongo were converted in the sixteenth century. The early Kongo textiles were similar to Kuba cloth in their use of geometric patterning and plush texture. These cloths may have been traded farther inland and thus have influenced the Kuba, who continued to produce cut-pile long after Kongo production ceased. In later centuries, textiles were used as currency with Arab and Swahili traders from the east, and with Europeans, who may have also brought cloth for exchange, prompting theories that Kuba patterns from this time period were influenced by both European and Arabic textiles (Coquet 1993, 90).

By the eighteenth century, flourishing trade in ivory brought the influx of imported cloth, but at a higher cost than the raffia cloth. Because of its cost and the prestige associated with it, only Kuba royals had the right to wear imported cloth, which discour-

aged Kuba merchants from purchasing large quantities of it (Vansina 2010, 15). And because textiles were an important means of demonstrating social and political rank in the Kuba kingdom, any other type of cloth would have been inappropriate (Picton and Mack 1989, 200). This system changed drastically in the twentieth century, but textiles and accoutrements are still used to show social, economic, and political rank. Raffia textiles are still produced for ceremonies such as *itul* and for funerals, but there is a greatly expanded global market for cloth made solely for export. As Monni Adams points out (1978, 27), the production of cut-pile cloth for export was encouraged by missionaries in the 1930s and has accelerated ever since.

For the Kuba, raffia garments are sometimes enhanced with bark cloth, which is revered as one of the most precious of cloths. It is incorporated into prestige wear for men as either solid or polychrome panels fashioned into wrappers. In the central forested regions of Democratic Republic of Congo, and farther east near the border of Uganda and Burundi, the foragers of the Ituri rainforest rely only on bark for cloth production. Ituri textiles are renowned for their graphic, painted adornment. Two bark-cloth examples

in the Harn collection (Pls. 38 and 39), typical of Mbuti-style loincloths, are panels measuring roughly 36 by 15 inches and painted with dark monochromatic lines. Men produce the cloth by stripping the bark and pounding it with wood or ivory mallets until it is pliable. It is dried for days until the surface is free of oils and no longer resists the paint, which is made from gardenia bark. Women fold the cloth in half or in quarters and paint the designs on each folded section, using their hands to make lines and dots, and employing twigs and feathers for finer lines (Fig. 5). There is no concern for matching the designs on the sections, so the unfolded cloth has disrupted lines along the creases.

According to Robert Thompson, the designs reflect the syncopation in Mbuti music and vocalization. He posits that there is a "simultaneous dialectic" at work in the defined and random-seeming structure of the motifs in Mbuti music that is reflected in women's painting (Thompson 1991, 59). The same kind of relationship of forms can be seen in painted body adornment (see Fig. 5). One of the Harn cloths has intersecting cross-hatched bands in the lower portion, and groups of short bundled lines in the upper half, enveloped by vine-like scrolling lines

(see Pl. 38). Together, these disparate motifs function as a visual dialectic. The patterns on this example can also be compared to the neighbors of the Mbuti, the Mangbetu, who apply similar designs both on their bark cloth and on their bodies (Thompson 1991, 96). Mangbetu also adorn figurative sculptures with these designs. A broader connection across cultures is also possible, as Thompson suggests that the art and music of the forest peoples was transposed with the transatlantic slave trade and preserved in African American quilting and in blues and jazz (1991, 97).

Bark and raffia cloth techniques, design, and content have been translated to different media and transformed in different cultural contexts, but they have also been reinterpreted in the works of contemporary artists. In the 1970s, Alexander (Skunder) Boghossian (1937–2003), an Ethiopian expatriate artist living in the United States, traveled to Africa to study art. He visited Uganda, where he learned about the art of bark-cloth production and its purpose and value in Ugandan life (Debela and Nagy 2007, 56). According to Venny Nakazibwe (2005, 295), the Baganda people of Uganda used bark cloth in the pre-colonial era as a marker of social hierarchy in ceremonies for births, at marriages, and in burials, whereas in post-independence Uganda of the 1960s and 1970s, bark cloth was viewed as a cultural artifact and was also fashioned into craft items for the tourist trade. More recently there has been a revival of its use in ceremonies (Fig. 6), and artists and designers have incorporated it into their works (2005, 325 and 370).

Skunder Boghossian returned from Uganda with a large quantity of bark cloth that he began to use in relief constructions. His use of the bark cloth parallels his experimentation with other materials that resonated with non-westernized artistic production in Africa (Achamyeleh Debela, personal communication, 12/2/10). For example, he had worked previously with goatskin, for his series of paintings on recycled parchment strips inscribed with mystical symbols and prayers that have been used for healing in Ethiopia for centuries. He shaped the goatskin by stretching or gathering it and then pigmenting its surface, thus transforming it into earthy, visceral sculpture. Skunder adapted this method to shape bark cloth as a bas-relief form. In his 1981 work *Time Cycle III* (Pl. 33), he soaked the bark in motor oil, and though this may have been merely a means of enhancing its pliability, it also gave the soft, light cloth a darker, more visceral surface. This deeper hue mutes the play of shadows cast by the relief, and seems to embed the fibers more deeply. The effect is a subtle tension between the fine mesh surface of the bark cloth and the bolder relief shapes.

The artist's fascination with the texture of bark cloth may have stemmed from his previous encounter with the Ivorian artist Christian Lattier (b. 1925), who was in Paris in the 1960s when Boghossian was there, and who produced works with metal fiber. Lattier's obsession with dualistic spiritual forces, and with the control they exerted on his art and his life, profoundly affected Skunder (Giorgis 2004, 146), much of whose subsequent work calls these powers into play. For example, Skunder appropriated and abstracted the finely drawn, interlacing motifs that function as amulets on ancient healing scrolls (e.g., "Solomon's Net") and that are thought to act as spiritual force-fields— a kind of web for capturing evil forces. It is possible that Skunder perceived that bark cloth, with its net-like construction, had a similar power. For Skunder, making art was not about spirituality; rather, it was a spiritual act in itself.

It is also likely that Skunder knew of the spiritual power ascribed to bark cloth in Uganda, where it is thought to provide protection for royals and

Fig. 6. (below) "Diana Nnanbogo Mpendo and Ruth Ssampa dressed in bark cloth, 9th coronation anniversary." From Venny Nakazibwe, "Bark-cloth of the Baganda People of Southern Uganda" (Ph.D. dissertation, Middlesex University, 2005), p. 309, Pl. 9.6.

other high-status people during life passages, including funerals (Debela, personal communication, 12/2/10). The theme of transition carries through the symbolism of Skunder's *Time Cycle III*: for example, the circle in the center, which can function as a cosmogram (Harney 2003, 37) or a portal, is encircled by the Amharic and Latin letters that spell out "Welcome"—clearly an invitation to another realm, another state of being (see Pl. 33).

In addition, the lion whose bisected body flanks the circle in *Time Cycle* is both a symbol of the Ethiopian empire and a reference to the Lion of Judah and the lion tamed by Saint Samuel of Waldebba, which is in turn a symbol of the power of spiritual conviction. The lion also symbolizes political power in many African and European nations, both ancient and modern. Acutely aware of the intersection of spiritual and political forces in shaping his identity as an expatriate fleeing political turmoil and as a member of the Ethiopian diaspora, Skunder may have recognized bark cloth as the perfect medium with which to express what he perceived as inherently African forces engaged in a universal symbolic dialogue.

References

Adams, Monni. 1978. "Kuba Embroidered Cloth." *African Arts* 12, no. 1 (November): 24–39, 106–7.

Adams, Monni, and Rose Holdcraft. 1992. "Dida Woven Raffia Cloth from Côte d'Ivoire." *African Arts* 25, no. 3 (July): 42–51, 100–101.

Barbier, Jean. 1990. *Art Pictural des Pygmées*. Geneva: Musée Barbier-Mueller.

Boser-Sarivaxévanis, Renée. 1969. "Apercus sur la teinture à l'indigo en Afrique Occidentale." In Meinhard Schuster and Renée Boser-Sarivaxévanis, *Bericht über das Basler Museum für Völkerkunde und Schweizerische Museum für Volkskunde für das Jahr 1968*, 141–208. Basel: Das Museum.

Cooksey, Susan. 2004. *Sense, Style, Presence: African Arts of Personal Adornment*. Samuel P. Harn Museum of Art. Exhibition catalogue, University of Florida, Gainesville.

Coquet, Michèle. 1993. *Textiles Africains*. Paris: Adam Biro.

Darish, Patricia. 2004. "Kuba Dress and Adornment." In Susan Cooksey, *Sense, Style, Presence: African Arts of Personal Adornment. Samuel P. Harn Museum of Art*, 28–30. Exhibition catalogue, University of Florida, Gainesville.

———. 1989. "Dressing for the Next Life: Raffia Textile Production and Use among the Kuba of Zaire." In Annette B. Weiner and Jane Schneider, eds., *Cloth and Human Experience*. Washington, D.C.: Smithsonian Institution Press.

Debela, Achamyeleh, and Rebecca Nagy. 2007. *Continuity and Change: Three Generations of Ethiopian Artists*. Gainesville: Samuel P. Harn Museum of Art, University of Florida.

Etienne-Nugue, Jocelyne, and Elisabeth Laget. 1985. *Artisanats traditionnels en Afrique Noire: Côte d'Ivoire*. Dakar: Institut Culturel Africain.

Giorgis, Elsabet W. 2004. "Modernist Spirits: The Images of Skunder Boghossian." *Journal of Ethiopian Studies* 37, no. 2 (December): 139–49.

Harney, Elizabeth. 2003. *Ethiopian Passages: Contemporary Art from the Diaspora*. Washington, D.C.: National Museum of African Art.

Nakazibwe, Venny. 2005. "Bark-cloth of the Baganda People of Southern Uganda: A Record of Continuity and Change from the Late Eighteenth Century to the Early Twenty First Century." Ph.D. dissertation, Middlesex University.

Picton, John, and John Mack. 1989. *African Textiles: Looms, Weaving, and Design*. London: British Museum Publications, 2nd ed.

Schmalenbach, Werner. 1990. "Introduction." In Jean Barbier, ed., *Art Pictural des Pygmées*. Geneva: Musée Barbier-Mueller.

Thompson, Robert Farris. 1991. "Naissance du Dessin." In Robert Farris Thompson and Serge Nègre Bahuchet, *Pygmées? Peintures sur écorce battue des Mbuti (Haut-Zaïre)*, 27–114. Paris: Musée Dapper.

Thompson, Robert Farris, and Serge Nègre Bahuchet. *Pygmées? Peintures sur écorce battue des Mbuti (Haut-Zaïre)*. Paris: Musée Dapper.

Vansina, Jan. 2010. *Being Colonized: The Kuba Experience in Rural Congo, 1880–1960*. Madison: University of Wisconsin Press.

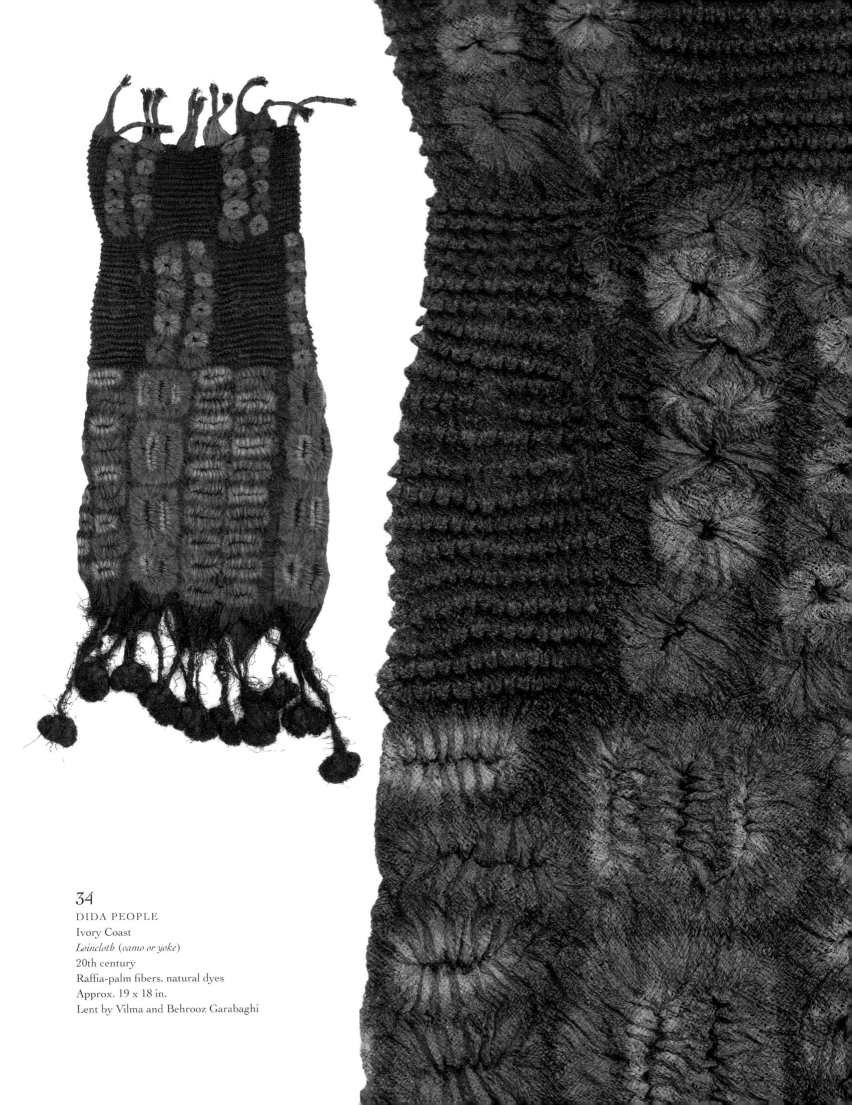

34
DIDA PEOPLE
Ivory Coast
Loincloth (*vamo or yoke*)
20th century
Raffia-palm fibers, natural dyes
Approx. 19 x 18 in.
Lent by Vilma and Behrooz Garabaghi

35 (right)
DIDA PEOPLE
Ivory Coast
Man's Cap (*kpako*)
20th century
Raffia-palm fibers, natural dyes
Approx. 10 x 15 in.
Lent by Vilma Garabaghi

36 (opposite page)
KUBA PEOPLE
Democratic Republic of Congo
Woman's Skirt (*ncaka kot*)
20th century
Raffia fibers, natural dyes
54 x 29 x 5.25 in. (137.2 x 73.7 x 13.3 cm)
Gift of an anonymous donor
2003.18.3

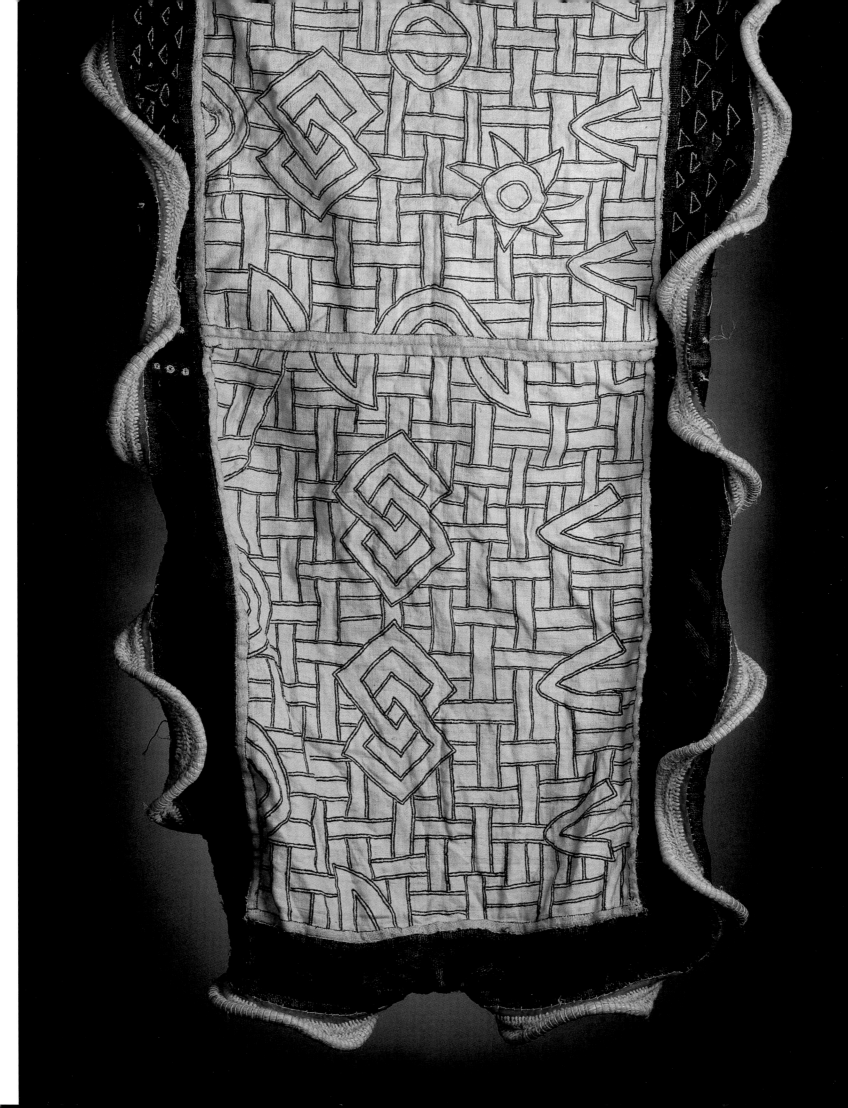

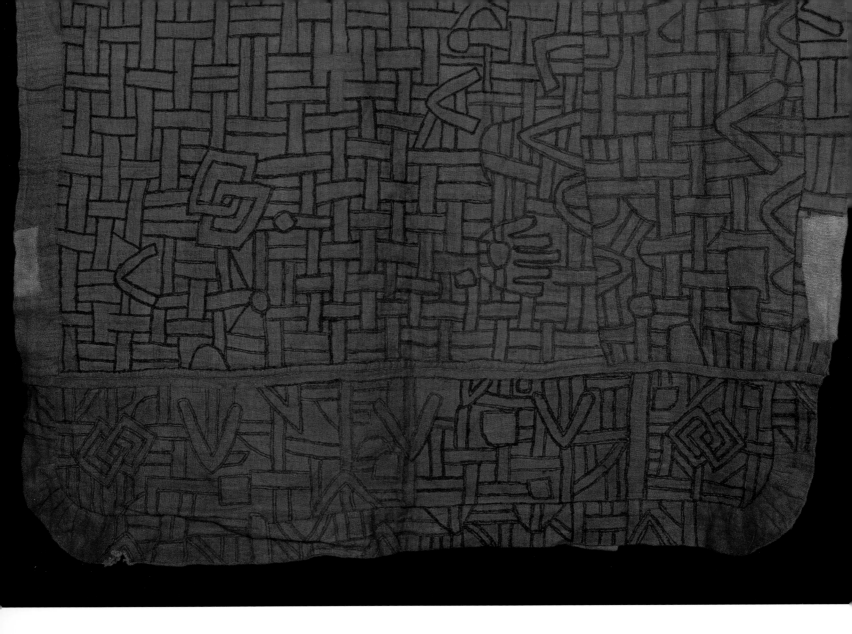

37 (opposite page and above detail)
KUBA PEOPLE
Democratic Republic of Congo
Woman's Skirt (*ncak or ncak mbahla*)
20th century
Raffia, natural dyes
32.5 x 236 in. (82.6 x 599.4 cm)
Gift of Rod McGalliard
2003.40.4

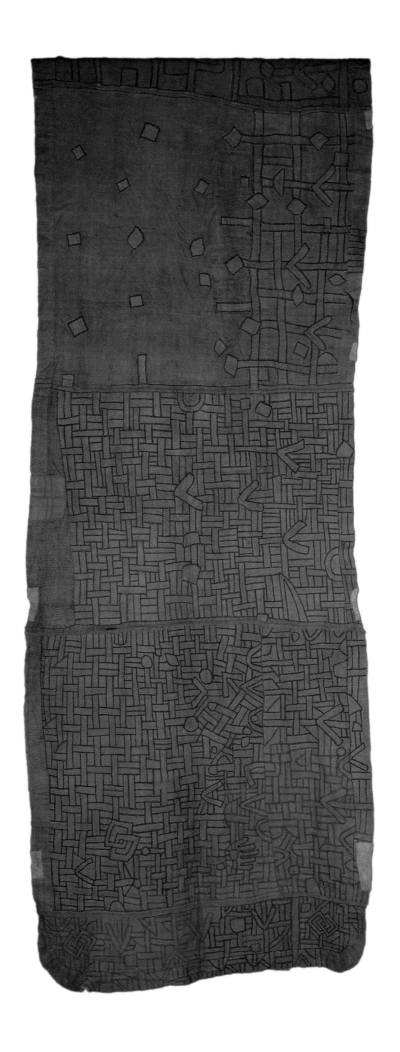

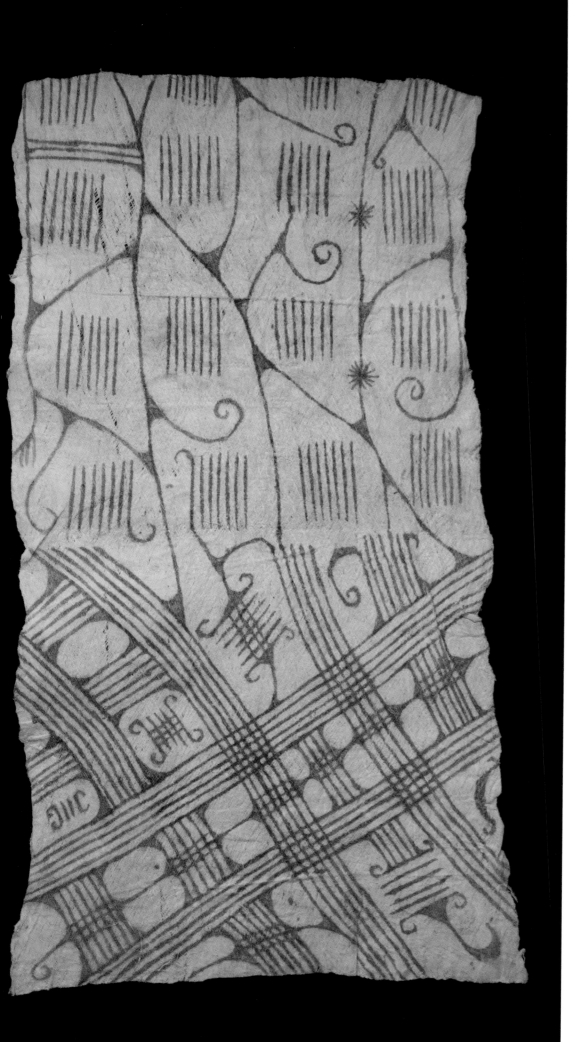

38

39
MBUTI PEOPLE
Democratic Republic of Congo
Woman's Loincloth (*pongo*)
Late 20th century
Bark cloth, natural dyes
35.25 x 15 in. (89.5 x 38.1 cm)
Gift of Richard and
Janice DeVore
2002.38.12

Sarah Fee

Futa Benadir:

A SOMALI TRADITION WITHIN THE FOLDS OF THE WESTERN INDIAN OCEAN

The dawn of the twenty-first century saw academic interest reawaken to global connections, the social and economic relations linking peoples and nations. These, of course, are nearly as ancient as humanity itself. One of the oldest seats for wide-reaching relations is the Indian Ocean, which stretches from East Africa to Indonesia, receiving the waters and maritime traffic of the Red Sea and Persian Gulf. By the first century CE it was an economically integrated trading zone known to the Greeks as the Erythraean Sea. An appreciation of this long, intertwined history is essential for understanding the *futa benadir* textile tradition of southern Somalia, its unique local character and transformations as well as its artistic kinship with this wider Indian Ocean world.

The Benadir Coast, Weaving, and Trade in East African History

The present-day nation of Somalia, which took its modern unified form in the Horn of Africa in 1960, was in ancient times home to autonomous city-states and kingdoms, including the Bible's fabled Land of Punt. The residents of this vast land eventually adopted one of three lifeways, connected by a common language and adherence to Islam. The majority of Somalis, occupying the arid interior, developed a unique nomadic culture based on camel herding. In the fertile inter-riverine zone of

the south, smaller communities combined farming with stock raising. Meanwhile, Somalia's 2,000 miles of coast lining the Red Sea and the Indian Ocean attracted Arab and Persian settlers, giving rise to urban port cities based on trade. Enjoying a strategic position between Europe and Asia, these cities and their seafarers were linchpins in moving spices and aromatics, including local myrrh, toward the Mediterranean, and exotics such as ivory and giraffes eastward. Reaching the peak of their wealth and renown in medieval times, they were visited by Geng Ho's sixth trading fleet from China in 1421–22 (Hersi 1977, 161).

This essay focuses on the Benadir Coast (Fig. 1), the southern littoral of Somalia stretching from the Juba River near the Kenyan border halfway up the tip of "the Horn." With multiple ties to its fertile hinterland and outlying nomadic clans, the area was nonetheless greatly shaped by the Indian Ocean at its doorstep. Indeed, the coast's three major port towns, Mogadishu, Merca, and Brava, were historically the northernmost edge of the Swahili world, which reaches southward along the shore of the Indian Ocean to Mozambique, residents of Brava (and probably formerly Mogadishu) speaking a Swahili dialect (Newitt 1987, 204). With few resources of its own, the Benadir Coast relied on exporting goods from the interior: ivory, aromatics, slaves,

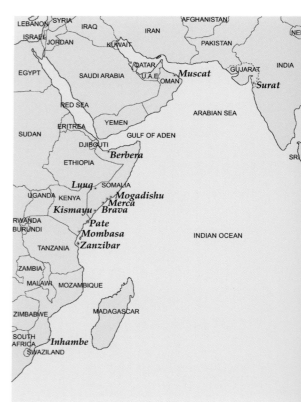

Fig. 1. (above) The Benadir Coast of Somalia. The term "Benadir" derives from the Persian word for harbor. In contemporary usage, however, it refers to all the coast and its hinterland.

Fig. 2. (opposite page left) Women spinning cotton in Mogadishu, c. 1883. The men in the back apply sizing with brushes. From Georges Revoil, "Voyage chez les Benadirs, les Comalis, et les Bayouns en 1882–1883," *Le Tour du Monde* 49 (1885): 37. Courtesy of La Bibliothèque de l'Université Laval.

Fig. 3. (opposite page right) The double-heddle Somali loom, c. 1987. Photograph by Ilene Perlman/*Saudi Aramco World*/SAWDIA.

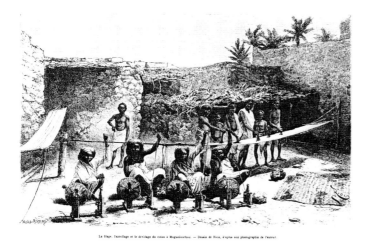

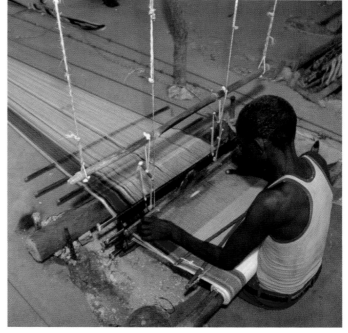

and, later, grain. Yet there was one important exception: cloth. On his visit to Mogadishu in 1331, the Muslim scholar Ibn Battuta observed that residents wove a cloth "unequalled" in quality, which was named for the town and exported as far as Egypt (Gibb 1962, 2:374).

Textiles from the western half of Africa have long dominated the literature, overshadowing the rich history of weaving on the continent's eastern coast. In the sixteenth century, Portuguese explorers found flourishing weaving centers from Mogadishu in the north as far south as Inhambe in Mozambique (Newitt 1987, 204, 207; Prestholdt 1998, 24–26). Specializing in cotton, these centers also worked in raffia and imported silk. In high demand were the sumptuous woven goods of Pate, an island in the Lamu archipelago near the Kenya-Somalia border. Its most celebrated product was made by raveling imported silk Indian textiles and reweaving them into new products consumed by local elites and exported far and wide, along the Zambezi River and into the Zimbabwe plateau.

For many years scholars have debated whether foreign textiles, imported by the millions into Africa and Asia,

destroyed or stimulated local weaving traditions. The most recent compelling arguments, illustrated well by the hybrid wares made in Pate, depict a complex symbiotic relationship wherein the "foreign" and the "local" cannot be easily disaggregated (Kriger 2006; Clarence-Smith n.d.; Prestholdt 1998). Artistic influences and economic stimulation flowed in all directions over time, with consumers and weavers on the "periphery" appropriating, domesticating, and altering imported models, competition often leading to technical and artistic innovation rather than collapse. The handweaving of the Benadir Coast is one of the mightiest examples, periodically reinventing itself to carry a seven-hundred-year legacy into the twenty-first century.

Futa Benadir in the Nineteenth Century: A Unique Configuration of a Regional Style

The textual trail on Benadiri cloth jumps from Ibn Battuta to the mid-nineteenth-century writings of European explorers. They describe a dynamic weaving trade nimbly negotiating changing political and economic circumstances as East Africa as a whole underwent a com-

mercial boom, spurred by increasing trade with the Zanzibari sultanate and European and American merchants. Concentrated in and around the three major port towns of Mogadishu, Brava, and Merca (see Fig. 1), Benadiri weavers were producing an astonishing 50,000 to 360,000 pieces annually (Alpers 1981, 85). In Mogadishu, one of every five citizens was involved in making the cloth, known to traders as *futa benadir* and, locally, as *toob benadir*, *tomonyo*, *benadiri*, or *alindi*. The demand for vast quantities of raw material to fuel this busy industry was met by the Indian Ocean's equally active—and quickly responsive—trade in textile fibers. In the mid-nineteenth century, cotton fluff or yarn was largely imported to the Benadir Coast from India (Christopher 1844, 95). Fifty years later, local cotton production expanded rapidly along the neighboring Shebelle River, the excess now exported to India and Zanzibar (Cassanelli 1982, 168; Schaedler 1987, 18). As a consequence, perhaps, weaving also spread to these inland areas (Revoil 1885a, 35; Luling 2002, 165).[1]

Women had the task of preparing yarn (Fig. 2). At the points of cultivation and in port towns, they processed

bolls with wooden rollers and a fluffing bow, then spun four thicknesses of yarn using a small hand-powered spinning wheel, the first in sub-Saharan Africa to adopt this imported technology (Schaedler 1987, 455; Revoil 1885a, 36; 1885b, 169). Men thereafter took over. Assisted by children, they prepared skeins and warped the loom, applying corn- or sorghum-paste sizing with brushes. Working on a double-heddle pit loom (Fig. 3)—seated at the edge of a hole dug below the heddle—a man could produce one or two cloths a day, depending on the size and quality (Guillain 1856, 1:532). Artisans in Somalia tend to hold marginal social positions, and the makers of *futa benadir* were no exception (Lewis 2008, 7; Luling 2002, 94). It appears that much of the cloth was produced in workshops run on servile labor, particularly in the late nineteenth century, when bondsmen of varied origins made up to 30 percent of port town populations (Cassanelli 1982, 167; Alpers 1983, 451–52). Freemen might work together in family units but were rarely autonomous, engaged in a wage or putting-out system wherein merchants controlled both raw materials and markets (Alpers 1981, 81; Clarence-Smith n.d., 32).

Despite their oppressive circumstances, working as full-time specialized artisans over many generations, Benadiri weavers perfected skills and a range of styles which were in high demand near and far. Finer-quality cloths were sold locally for dress (Guillain 1856, 2:172). Women wore a large piece knotted behind the shoulder and tucked at the waist (*guntino*), and sometimes an additional wrapper over the shoulders (Fig. 4). Men used one piece as a hip-wrap and, means permitting, another attached at the shoulder toga-style (*go*). Up to two-thirds of *futa benadir* were exported by sea: up to northern Somalia, down to Kismayu, Mombasa, and Zanzibar, and out to coastal Arabia (Robecchi Bricchetti 1899, 604n2; Sorrentino 1912, 17; Guillain 1856,

1:532). A great quantity of coarser stuffs moved by caravan to the interior, as far as Luuq and perhaps southeast Ethiopia and Berbera (Casannelli 1982, 152, 180; Sorrentino 1912, 17; Robecchi Bricchetti 1899, 604n2; Alpers 1981, 85). Observed to be "much valued in the interior," *futa benadir* played a critical role in enticing its inhabitants to release the ivory, gums, and grains that foreign traders sought, helping to fuel the region's wider economic boom (Owen 1833, 1:358).

In his admirably detailed study of *futa benadir*, historian Edward Alpers (1981) revealed that until the late nineteenth century, most of the cloth was probably all white. Charles Guillain (1856, 2:532) observed that six qualities were made, and samples collected by European explorers from 1883 to 1910 effectively show a wide range in texture, yarn size, weight, and tightness of weave.[2] Most are subtly aesthetically elaborated, whether through alternating yarn weights to create striation, adding a few lines of colored weft, or through varied fringes. Although Portuguese explorers attributed the white color of East African cloth to a lack of dyes or technical knowledge (Barbosa [1516] 2009, 6), it was more plausibly driven by consumer choice. West Africans favor white for its associations with purity and spirits (Renne 1995). Similarly, on the continent's east coast, Bantu and Islamic cosmologies greatly esteem the color white (Prestholdt 1998, 35n, 153). Some Benadiri leaders chose to dress in white cloth of local manufacture, and all, according to Islamic prescripts, required it for burial (Guillain 1856, 2:506; Christopher 1844, 91).

Beginning in the late nineteenth century, weavers on the Benadir Coast began making colored variants (Alpers 1981, 86). European witnesses of the time linked the shift to increasing competition from American factory-made white fabric, highly prized throughout Africa for its durability and low cost. Challenged to carve out a new niche, Benadiri weavers strategically enlivened

Fig. 4. (above) Woman dressed in *futa benadir* in the *guntino* style, c. 1920. Postcard. Collection of Sarah Fee.

Fig. 5. (opposite page) A multicolored *futa benadir*, collected c. 1910. Courtesy of the Pigorini Museum, Rome, 89638.

their white cloth with color. They resourcefully developed vegetal dyes, valued for their colorfastness (Zoli 1927, 358), although local tastes eventually came to favor the brighter shades of pre-dyed yarns imported from India and Europe, which by 1905 constituted the fifth-greatest import to southern Somalia (Sorrentino 1912; Alpers 1981, 88). What did this colored *futa benadir* look like? Textual sources are vague, speaking only of stripes in yellow, red, and black or navy blue. Closely studying the objects themselves, however, is vital. It shows experimentation with color and design as early as the 1880s. More importantly, it reveals that American cottons are only half of the story. As influential in Benadiri weavers' transition to making colored cloth were textile imports coming from the East, from India and, perhaps above all, southern Arabia. These fabrics provided inspiration for patterning, as well as "product lines" to undercut.

From pre-Islamic times, the economies of the western Indian Ocean rim were inseparably enmeshed. Monsoon winds, as well as political, trade, and religious alliances, favored the flow of peoples and products in all directions. Persian and Omani families settled on the Somali and East African coasts from the ninth century, intermarrying with local groups. Five hundred years later, Gujarati merchants with vessels of 200 to 300 tons came to dominate western Indian Ocean trade (Prestholdt 1998, 17). In the seventeenth century, the Omani ruling household reasserted political and economic influence in East Africa, with the sultan moving his base to Zanzibar in 1840 and placing governors in Benadir port towns. All this while, Swahili and Somali dhows plied the African coastline, the Red Sea, and the Indian Ocean as far as Malacca. Large communities from all these places took up residence in the region's cosmopolitan port towns. One result of the continual mixing was a largely shared material culture. And though this

common artistic heritage has long been recognized for architecture, woodwork, metalwork, and embroidery (Grottanelli 1968; Hirji 2005; Lewis 2008, 10; Johnson 1986, 13), the existence of a western Indian Ocean rim textile aesthetic has been largely overlooked.

Futa benadir beautifully illustrate the main shared characteristics of this nineteenth-century regional style.[3] Fabrics of warp-faced plain weave were generally made in two different weights: heavy and tightly woven, or light and gauze-like. The basic building blocks of ornamentation are warp and weft stripes, with two identical panels joined along the selvage to create a symmetrical composition. Three styles rely primarily on warp stripes. The first features a solid white or blue center with multicolored stripes at the two

selvages, the archetypical Swahili *kikoi* (see Fig. 3). A second variant has a centerfield of very narrow stripes framed by broad selvage stripes, often of red and gold (Pl. 41). The third distributes stripe clusters across the width (see Fig. 4). Another distinctive style, plaid *futa benadir*, displays a wide variety in size and color but usually features small uniform squares (Pl. 42). The final and most complex composition incorporates both checked and striped sections: the middle third of the centerfield is subtly checkered— its horizontal bands created with introduced wefts—and framed on all four sides by stripes (Fig. 5).

Beyond warp striping, several other aesthetic flourishes characterize *futa benadir* and its western Indian Ocean cousins. Cloth ends are often adorned

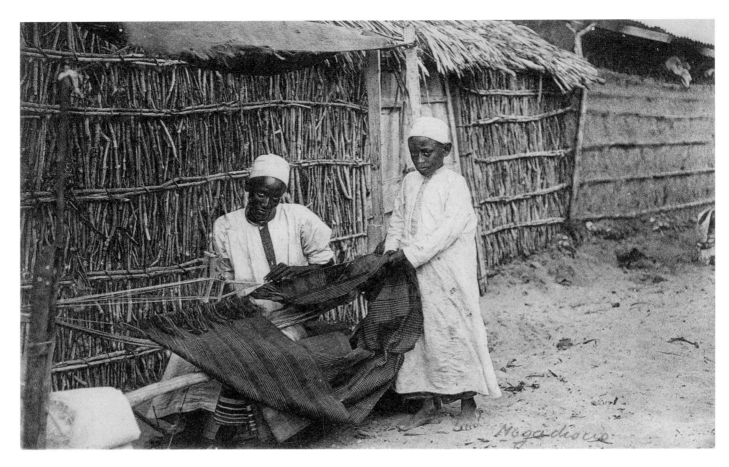

with horizontal weft-wise bands of
varying widths and spacing, sometimes
covering the top and bottom third of
the cloth (see Fig. 5 and Pls. 41, 43).
Discontinuous dark weft yarns might
be inserted to form triangular shapes
inside the centerfield edge, or red stitch-
ing applied to embellish the central
seam where the two panels join (Pl. 43).
Fringes received special elaboration.
The dominant style was long and thin,
tightly plied (or braided) and knotted.
Fine cloths were given a distinctive
finish, an elaborate woven end-band
(*taraza*) running along the top and
bottom of the cloth, typically measur-
ing 1 centimeter wide and striped in
red, yellow, and black (Robecchi Bric-
chetti 1899, 605). Known in technical
terms as a transverse selvedge, this
band greatly enhanced the value and
prestige of a cloth (see Pls. 42, 43).
Probably the work of specialists, it was
formed on a double-heddle "braid"
loom using the loose warp ends of a
cloth as its weft (Fig. 6; Luling 2002,
169). Beyond the Benadir Coast, all

the foregoing core styles and techniques
were common to weavings in Zanzibar,
parts of Madagascar, the Zambezi
River region, and, to this day, Oman
and Yemen (Prestholdt 1998, 7; Muller
and Snelleman 1893; Maurières et al.
2003; Richardson and Dorr 2003;
Schaedler 1987, 426).[4]

Disentangling the direction of
influences is challenging (and perhaps
pointless) in this dynamic, hybrid
regional art form, with its centuries
of transshipping, "outsourcing," and
"pirating," with numerous sites producing
and distributing nearly identical styles.
The dominant role of India has long
been demonstrated. Millions of South
Asian textiles poured into East Africa
before the nineteenth century, and at
least one Benadiri striping style was
derived from an Indian prototype
(Alpers 1981, 90n42). The double-
heddle pit loom, spinning wheel, and,
perhaps, cotton may have passed to
the Benadir Coast from India, either
directly or via the Red Sea or Gulf of
Aden (Schaedler 1987, 447, 450; Alpers

1981, 80). The etymology of *alindi*, the current local term for Benadiri-style cloth, further points to this nation (Lewis 2008, 10). Significantly, however, the terms *futa* and *toob* are of Arabic origin, as is *taraza*, which denotes the iconic woven end-band. Fashion tends to emanate from dominant political and economic centers, and in the nineteenth-century western Indian Ocean, the regional powerhouse was the southern Arabian nation of Oman. Curiously, scholars have overlooked the voluminous trade in Omani handwoven cloth to East Africa. On the Benadir Coast, as throughout the region, this so-called Muscat cloth ranked among the greatest imports (Museo della Garesa 1934, 42; Christopher 1844, 87; Robecchi Bricchetti 1899, 203; Guillain 1856, 2:535). Striped and checked varieties, such as the *subahid* (*soba'iyyah*) and *deboani*, probably exerted the single greatest stylistic influence on the nineteenth-century western Indian Ocean textile aesthetic (Fee 2010).

As astutely noted on a Somali diaspora internet chat thread devoted pointedly to foreign influences, identity, and dress, "What is important is how the . . . Somalis . . . have adapted it [clothing]."[5] Within Somalia, weavers interpreted and transformed imported styles for regional tastes. Merca, for instance, was known for a green shade not used elsewhere (Alpers 1981, 90), while the Abgal peoples had a singular preference for cloths of narrow blue and white stripes (Revoil 1885a, 47). Further imbuing cloth with a local imprimateur, striping styles were given Somali names such as "goats in the sand dunes" and "teeth" (Gould 1989, 9). So, too, Benadiri weavers created new styles over time, independent of developments elsewhere. Nineteenth-century observers tended to attribute *futa benadir*'s continued success to the low cost of cotton or labor. Yet price alone has never influenced African fashion. It is probable that, as along the Swahili Coast described by Prestholdt (1998), the

skill of Benadiri weavers and their intimate knowledge of local markets enabled them to better anticipate quickly changing fashion trends. With Omani and Yemeni weavers producing for the Benadiri market, it is likely, too, that their repertoires were ultimately influenced by Benadiri tastes, contributing to the blended regional style.

Futa Benadir (*Alindi*) in the Twentieth Century and Beyond

Over the twentieth century, world events and local ingenuity continued to shape the fortunes of *futa benadir*. Five colonial powers carved up Somalia, the Benadir Coast falling to Italy in 1895 but remaining in open rebellion for years after. With age-old trade patterns severely disrupted, Brava stopped producing cloth, while exports from Mogadishu and Merca[6] reportedly dropped to a mere 3,700 pieces in 1909–10 (Revoil 1888, 390; Alpers 1981, 91). The shortages of World War I reversed this downslide, spurring increased production of *futa benadir* well into the 1930s, during a time of regional economic prosperity. In the 1960s, following independence, *futa benadir* were still being exported in impressive numbers to neighboring countries (Alpers 1981, 93). Patterns of local consumption meanwhile came to resemble those found more broadly in Africa. Benadiris largely stopped using *futa benadir* as daily clothing, reserving it for ceremonial dress, notably at weddings and religious events (Gould 1989, 9). Following Somalia's unification and political independence in 1960, *futa benadir* gained new meanings and increased visibility, elevated as a symbol of national identity and pride throughout the nascent country, including its northern provinces. Representing another force for change, American Peace Corps volunteers in the late 1960s encouraged weavers to vary their striping styles, leading to the creation of a popular variant named "3–5" in honor of a British cigarette brand (John W.

Johnson, personal communication). In the 1980s, the cloth was further adapted to appeal to modern, urban tastes and lifestyles, being tailored into cushion covers or, more dramatically, transformed into sophisticated apparel by local fashion designers such as Amena Egal (Gould 1989, 11).

Although their wares received widening acclaim, weavers themselves remained poorly rewarded. Into the 1970s they were largely beholden to the merchants who paid their wages and advanced them yarn at inflated costs. Working conditions had improved little from those described in the nineteenth century: weavers labored in the back alleys of the old town, their pits filling with water in the rainy season. And yet, weaving represented survival and "dignity" to vulnerable populations; perhaps a first stop for slaves freed in the late nineteenth century, in the twentieth weaving served to absorb new immigrants and the urban poor, still employing some 2,000 people in the 1960s (Pantano 1910, 27–28; Alpers 1981, 78n5, 97). Hoping to alleviate their plight, the Somali government set up weaving cooperatives. By 1976, six cooperatives in Mogadishu were providing 800 members with weatherproof building facilities, yarn at wholesale prices, and points of sale for completed works, contributing to an annual production of some 1.5 millions yards (Alpers 1981, 96; Ali 1980, 10–11).

Despite these modern modifications, the techniques and styles of handwoven *futa benadir* remained surprisingly faithful to earlier antecedents, safeguarding many of the hallmarks of the western Indian Ocean rim textile style. Illustrative are the pieces collected in the 1970s by John and Katheryne Loughran. Most retain the iconic aesthetic flourishes of the nineteenth century—namely, wide selvage striping, narrow internal stripes (Pl. 41, 43), checks (Pl. 42), finely plied fringes, and even the red seam and woven end-band (Pls. 42, 43).

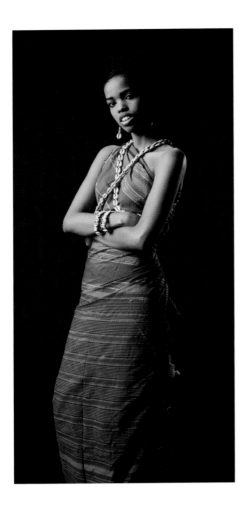

Fig. 7. (above) Somali woman of the U.S. diaspora wearing *alindi*. Photograph by Tariq Tarey, 2011.

Where innovation had come was again in the realm of color. Weavers had widened their palette to include bright aniline shades of pink, purple, and turquoise. In doing so they were again no doubt taking their cue from local fashion trends, which now favored brightly colored imported synthetic cloths from Korea and Japan. Even with the creation of a Somali state-run textile factory, some 1,500 Benadiri weavers were holding their own in 1989 (Gould 1989, 9). But drastic changes were on the horizon.

The Somali civil wars of 1991–92 and their aftermath brought unspeakable death and destruction to the Benadir Coast. Its unarmed urban citizens of mixed origins—perceived as wealthy and "foreign" by nomadic clan-based militias—were targeted for violent intimidation and death, their property seized. Over 70 percent of residents fled the country, contributing to the creation of large Somali diasporas in Kenya, Europe, and North America. Showing its most miraculous resiliency yet, *alindi* handweaving continues to this day in Merca and Mogadishu.[7] In addition to supplying markets in Somalia, the cloth occasionally makes its way to cities such as Copenhagen, London, and Toronto. Less expensive and more readily available in both the diaspora and homeland are industrial imitations. A modern spin on age-old Indian Ocean patterns, these are fabricated in Bombay factories. But still they must please Somali consumers. The most popular style references nineteenth-century *futa benadir* basics, with a color scheme of red, black, and yellow, and a clever imitation of the woven band. Women may use the cloth for wedding dress, while cultural performers and social activists don the vibrant colors in public spaces to assert Somali origin and pride (Fig. 7). The stalwart *alindi*—in all its guises—remains a forceful marker of Somali identity in the transnational community, purposefully chosen, as with other forms of dress, to keep "memories and dreams alive and to shape the future of a new Somali nation" (Akou 2004, 50). ◆

Acknowledgments

For their generous help in the research for this essay, I thank Heather Akou, Edward Alpers, Nur Bahal, Wayne Barton, Susan Cooksey, Egidio Corsi, Silvia Forni, Bryna Freyer, John W. Johnson, Hélène Joubert, Edward Keall, Edgar Krebs, Rossella Martin, Maimuna Mohamud, Sharif Abow, Christian Webersik, and Helen Wolfe.

References

Akou, Heather. 2004. "Nationalism without a Nation: Understanding the Dress of Somali Women in Minnesota." In Jean Allman, ed., *Fashioning Africa. Power and the Politics of Dress*, 50–63. Bloomington: Indiana University Press.

Ali, Syed Shafqat. 1980. "A Sectoral Study of Textiles Industry in Somalia." Report prepared in two parts for the Ministry of Industry Government. Project DP/SOM/72/007.

Alpers, Edward A. 1983. "Muqdisho in the Nineteenth Century: A Regional Perspective." *Journal of African History* 24, no. 4: 441–59.

———. 1981. "Futa Benaadir: Continuity and Change in the Traditional Cotton Textile Industry of Southern Somalia, c. 1840–1980." In Ernest Pépin, Catherine Coquery-Vidrovtich, and Alain Forest, eds., *Actes du Colloque Entreprises et Entrepreneurs en Afrique (XIXe et XXe siecles)*, 1: 77–98. Paris: L'Harmattan.

Barbosa, Duarte. (1516) 2009. *Description of the Coasts of East Africa and Malabar*. Cambridge: Cambridge University Press. Reprint of the 1866 Hakluyt Society edition.

Cassanelli, Lee V. 1982. *The Shaping of Somali Society. Reconstructing the History of a Pastoral People, 1600–1900*. Philadelphia: University of Pennsylvania Press.

Christopher, W. 1844. "Extract from a Journal by Lieutenant W. Christopher." *Journal of the Royal Geographical Society* 14: 76–103.

Clarence-Smith, William Gervase. n.d. "Cotton Textiles on the Indian Ocean Periphery, c. 1500–1850." Unpublished manuscript.

Fee, Sarah. 2010. "Beyond Indian Cottons: The Trade in Omani Cloth and Fibers in the Western Indian Ocean, 1750–1900."

Paper read at the Pasold Research Foundation/CHORD conference "Textile Distribution Networks, 1700–1945." University of Wolverhampton, U.K., September 8–9, 2010.

Gibb, H. A. R. 1962. *The Travels of Ibn Battuta*. 3 vols. Cambridge: Cambridge University Press.

Gould, Lark Ellen. 1989. "The Weaver's Song." *Saudi Aramco World* 40, no. 5 (September/October): 8–11.

Grottanelli, Vinigi L. 1968. "Somali Wood Engraving." *African Arts* 1, no. 3: 8–13, 72–73, 96.

Guillain, Charles. 1856. *Documents sur l'Histoire, la Géographie et le Commerce de l'Afrique Orientale*. 3 vols. Paris: Imprimerie de Mr. Bouchard-Duzard, Arthus Bertrand.

Hersi, Ali Abdirahman. 1977. "The Arab Factor in Somali History." Ph.D. dissertation, University of California at Los Angeles.

Hirji, Zulfikar. 2005. "The *kofia* tradition of Zanzibar: the implicit and explicit discourses of men's head-dress in an Indian Ocean." In Ruth Barnes ed., *Textiles in Indian Ocean Societies*. London: Routledge, 62–80.

Johnson, John William. 1986. "Introduction: Word and Image in the Horn of Africa." In Katheryne S. Loughran, ed., *Somalia in Word and Image*, 11–15. Washington, D.C.: Foundation for Cross Cultural Understanding.

Kriger, Colleen E. 2006. *Cloth in West African History*. Lanham, Md.: AltaMira Press.

Lewis, Ioan M. 2008. *Understanding Somalia and Somaliland: Culture, History, Society*. New York: Columbia University Press.

Luling, Virginia. 2002. *Somali Sultanate: The Geledi City-State over 150 Years*. London: Haan.

Maurières, Arnaud, Philippe Chambon, and Eric Ossart. 2003. *Reines de Saba. Itinéraires textiles au Yemen*. Aix-en-Provence: Edisud.

Muller, H. P. N., and J. F. Snelleman. 1893. *Industrie des Cafres du sud-est de l'Afrique*. Leiden.

Museo della Garesa. 1934. *Museo della Garesa Catalogo*. Mogadishu: Regio Governo della Somalia.

Newitt, M. D. D. 1987. "East Africa and Indian Ocean Trade: 1500–1800." In Ashin das Gupta and Michael Pearson, eds., *India and the Indian Ocean, 1500–1800*, 201–23. New York: Oxford University Press.

Owen, W. F. W. 1833. *Narrative of Voyages to explore the Shores of Africa, Arabia, and Madagascar*. Vol. 1. New York : J. & J. Harper.

Pantano, Gherardo. 1910. *Nel Benadir: La Citta di Merca e la Regione Bimal*. Liverno: S. Belforte.

Prestholdt, Jeremy. 1998. "As Artistry Permits and Custom May Ordain: The Social Fabric of Material Consumption in the Swahili World, circa 1450 to 1600." PAS Working Paper, No. 3. Evanston, Ill.: Northwestern University.

Renne, Elisha. 1995. *Cloth That Does Not Die*. Seattle: University of Washington Press.

Revoil, Georges. 1888. "Voyage chez les Benadirs, les Comalis, et les Bayouns en 1882–1883." *Le Tour du Monde* 66: 385–416.

———. 1885a. "Voyage chez les Benadirs, les Comalis, et les Bayouns en 1882–1883." *Le Tour du Monde* 49: 1–80.

———. 1885b. "Voyage chez les Benadirs, les Comalis, et les Bayouns en 1882–1883." *Le Tour du Monde* 50: 129–208.

Richardson, Neil, and Marcia Dorr. 2003. *The Craft Heritage of Oman*. 2 vols. Dubai: Motivate Publishing.

Robecchi Bricchetti, Luigi. 1899. *Somalia e Benadir*. Milano: Carlo Aliprandi.

Schaedler, Karl-Ferdinand. 1987. *Weaving in Africa South of the Sahara*. Munich: Panterra.

Sorrentino, G. 1912. *Ricordi del Benadir*. Naples: Tipografia Angelo Trani.

Zoli, Corrado. 1927. *Oltre Giuba: Notizie Raccolte a cura del Commissariato Generale nel Primo Anno do occupazione Italiano (1925–1926)*. Rome: Syndicato Italiano Arti Grafiche.

Notes

1. The history of weaving in the Benadir hinterland and its relations to port town weaving is poorly documented. Luling (2002, 165, 169–71) indicates it was an important activity in Afgoye-Geledi. Geledi pieces from the 1880s held at the Musée du Quai Branly display telltale western Indian Ocean aesthetics.
2. Among others, the Musée du Quai Branly and Rome's Pigorini Museum hold early Benadiri collections.
3. Shared textile aesthetics may have existed from Northern Kenya to the Quirimba islands of Mozambique as early as the sixteenth century (Prestholdt 1998, 30).
4. The history and distribution of the transverse selvage, made as well in some areas of Southeast Asia, has yet to be fully studied.
5. Posted by Ngonge December 11, 2006 on the Camel Milk Threads, Camel Milk Debate: Does Somalia Have a Culture? http://www.somaliaonline.com.
6. By the late nineteenth century, production had largely shifted from the town of Merca to the outlying village of Jelib-Merca.
7. Information on contemporary *alindi* is based on discussions with Nur Bahal, Maimuna Mohamud, and Sharif Abow of Toronto, Heather Akou, John W. Johnson, and Christian Webersik.

40
Tanzania
Cloth (*kanga*)
2010
Factory-printed cotton
44 x 61.75 in. (111.8 x 156.8 cm)
On loan from James and MacKenzie Ryan

MacKenzie Moon Ryan

The Emergence of the *Kanga*:

A DISTINCTLY EAST AFRICAN TEXTILE

Kanga are colorful, mass-produced, industrially printed textiles worn widely by women in many parts of East Africa (Fig. 1), and occasionally by men in domestic settings. These rectangular-shaped textiles measure about 66 by 44 inches. Most often worn as wrap garments, one *kanga* is worn around the body and the second is used as a head or shoulder covering, and thus they are sold in pairs. The design of each adheres to a basic structure: a central motif surrounded by a wide, continuous graphic border. *Kanga* most often display a proverb or phrase in Swahili, framed just below the central motif. Generally *kanga* feature bright colors of ink printed on white, factory-produced cotton cloth (Fig. 2).

Kanga central motifs and border designs vary considerably, but generally speaking, they all possess a striking graphic sensibility (Pl. 40). Bold colors and outlines are favored; careful shading or gradual tonal variances are almost never present. Aside from the Swahili proverb or phrase, typical *kanga* are quadratically symmetrical. Everyday items such as plants, animals, and other domestic objects are regularly featured on *kanga*. Some *kanga* are also commemorative in theme, while others display abstract geometric patterns, which at times resemble floral or paisley-like prints, or common designs found on local mats, baskets, and doors.[1] Aspirational images are also frequently seen on *kanga*, such as diamond rings, airplanes, and buildings.

The *kanga* featured in the exhibition (Pl. 40) was purchased by the author while on research in Dar es Salaam, Tanzania, in November 2010. This example features a purple, black, and yellow floral design printed on white, factory-produced cotton cloth. Its accompanying Swahili phrase "Mungu hana likizo" translates to "God doesn't have holidays" and provides a pointed reminder that complaining about one's hardships will not make them disappear.

The history of this textile involves many actors and a series of textile precursors. The emergence of *kanga* can be traced to a distinctly local and particular series of events, triggered by international factors but maneuvered

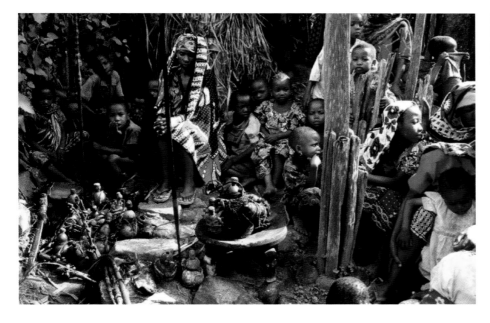

Fig. 1. (left) Healer wearing a *kanga* over her head, surrounded by children from the village. Near Mlalo, Usambara Mountains, Tanzania, 1997/98. Photograph by Barbara Thompson.

129

by local players. Textiles have long been luxury goods on the Swahili Coast, and with the intensification of the slave trade around 1800, cotton fabric began to be imported in large quantities from India, North America, and Europe. These imports were in turn traded along the caravan routes from the coast to the interior of East Africa, and "cotton cloth became the most important commodity for the exchange of slaves, ivory, rubber, beeswax and food."[2] Cotton cloth was associated with the elite throughout East Africa—the Swahili, the Arabs, and chiefs of the hinterland. To participate in the new moneyed economy, men had to work for wages, which could then be used to buy cloth.[3] Trade in increasingly affordable machine-produced textiles set the stage for the development of *kanga*.

Around 1850, most inexpensive industrially produced cotton cloth was imported from Salem, Massachusetts.[4] This white cloth came to be known as *merikani*, the Swahili word for "America" used in Tanzania. However, between 1861 and 1865 the American Civil War disrupted the productivity of the United States and their flowing trade in cotton.

The gap in the market was quickly filled by merchants from British India who peddled lesser-quality Indian cotton. This Indian cotton was greyer in color than the naturally white American cotton. To mask the inferior color and quality of Indian cotton imports, slave women began dyeing their Indian "*merikani*" with locally produced indigo.[5] The process changed the cloth from a dingy white to a deep blue or black, from imposter *merikani* to what came to be called *kaniki*.

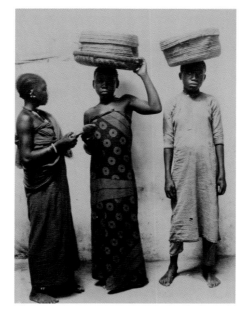

Meanwhile, another innovation would lead to the emergence of the *kanga*. By all accounts, the *kanga* developed out of an innovation using *lenço*, printed handkerchiefs the Portuguese first traded to East Africa in the sixteenth century. By the latter half of the nineteenth century, *leso*, as the handkerchiefs came to be known in Swahili, were being printed in England, the Netherlands, and Switzerland.[6] Around 1860, Swahili women from either Mombasa or Zanzibar first sewed together six *leso* (three by two) to make a wrap garment that displayed printed designs.[7] By 1863, when missionary Charles New visited Mombasa, the new *leso ya kushona*, or "sewn *leso*" garment, was considered highly fashionable. New describes Swahili women's manner of dress in his travelogue:

> *Visuto* square coloured cloths, and *kaniki*, indigo-dyed stuffs, are common articles of dress; but *leso*, large coloured cotton handkerchiefs, are much affected. Six of the latter cut into two parts of three each, are sewn together so as to make one square cloth and the dress is complete. This is drawn round the body under the arms, and is secured by gathering the ends together and rolling them into a ball at the chest. A similar article is worn over the shoulders, or is hung from the head like a veil. . . . Dressed in this style, particularly when the material is new and the colours are bright, the Mswahili woman is in her glory, and appears to admire herself prodigiously.[8]

Fig. 2. (above) A *kanga* shop, located on Uhuru Street in Dar es Salaam, Tanzania. Uhuru Street is the principal area for textiles sales in the city, and this photo shows one of many shops and market stalls. Photograph by MacKenzie Moon Ryan, November 2010.

Fig. 3. (left) Three Swahili women wearing different types of cloth; from left to right: *kaniki*, Indian cotton cloth dyed with indigo; *leso ya kushona*, European printed cotton handkerchiefs; *merikani*, white factory-produced cotton cloth. Image courtesy of the Winterton Collection of East African Photographs, Melville J. Herskovits Library of African Studies, Northwestern University.

European traders attempted to import new designs of sewn *leso* by 1877, but the odd size and unceasing demand for innovative designs at first put off European manufacturers.[9] By 1888, European manufacturers had seized upon this newly expanding market of Swahili women's fashions and imported sewn *leso* textiles.[10] Figure 3 shows three young women from the Swahili Coast wearing these forbearers of *kanga*; *merikani*, *kaniki*, and *leso ya kushona*. For a time, all three styles co-existed, as this photo depicts (Fig. 3). Soon after, local Indian merchants, inspired by the sewn *leso*, had begun to hand-stamp woodblock print designs onto imported *merikani* cloth, cut roughly to the size of the sewn *leso* garments.[11] These textiles became known as *kanga*. European traders quickly seized on this newly expanding market, and machine-printed *kanga* were imported from Europe within a few years of the *kanga*'s invention.[12]

As its popularity increased, European firms began mass-producing *kanga*. According to East Africanist historian Laura Fair, the first mention of imported *kanga* appeared in British trade reports from 1897, the same year that slavery was abolished. However, the new market of freed slaves did not come without its challenges; advocates for British commercial expansion warned potential investors that "nothing but an intimate knowledge of the local market can determine what designs are most likely to meet the popular taste."[13] Therefore, the German, Dutch, and French firms that dominated *kanga* manufacturing at the turn of the twentieth century went through a lengthy process to ensure the production of successful *kanga*.[14] They first produced samples of *kanga*, with bright colors and crisply printed designs, imitating those of hand-stamped woodblock prints. These samples were then sent to Zanzibar for approval or modification to ensure successful sale on the Swahili Coast.

This new garment spread freely, and by 1900, British Captain J. E. E. Craster wrote in his report on neighboring island Pemba, "Zanzibar is the Paris of East Africa, and the Zanzibar belles are admittedly the glass of fashion. To keep up their reputation for smart dressing involves the frequent purchase of new *kangas*, of which, I understand, a Zanzibar girl will possess as many as two to three dozen sets at one time."[15] The final addition of the Swahili phrase, first printed in Arabic script and later in Roman script, completed the *kanga*'s evolution in the early twentieth century. Today, a standard *kanga* design can immediately be perceived, though innovation in motif, color combinations, and Swahili phrases continues to flourish.

The early development of *kanga* included the interaction of many disparate groups—Swahili women, local Indian merchants, European, American, and British Indian traders, and manufacturers the world over. Despite its roots in global affairs, *kanga* has emerged as a distinctly local phenomenon. Evolved from the lineage of *merikani*, *kaniki*, and *leso ya kushona*, the *kanga* developed as, and continues to be, a distinctly East African textile. ◆

References

Abdullah, Fatma Shaaban. 1984. "Reflection on a Symbol." *Africa Now* (February): 49–51.

Fair, Laura. 2001. *Pastimes and Politics: Culture, Community, and Identity in Post-Abolition Zanzibar, 1890–1945*. Athens: Ohio University Press.

Linnebuhr, Elisabeth. 1997. "*Kanga*: Popular Cloths with Messages." In Karin Barber, ed., *Readings in African Popular Culture*, 138–41. Bloomington: Indiana University Press.

New, Charles. 1874. *Life, wanderings, and labours in eastern Africa: with an account of the first successful ascent of the equatorial snow mountain, Kilima Njaro, and remarks upon east African slavery*. London: Hodder and Stoughton.

Prestholdt, Jeremy. 2008. *Domesticating the World: African Consumerism and the Genealogies of Globalization*. Berkeley: University of California Press.

Schmidt, Karl Wilhelm. 1888. *Sansibar: Ein ostafrikanisches Culturbild*. Leipzig: F. A. Brockhaus.

Spring, Christopher. 2009. *Angaza Afrika: African Art Now*. London: The British Museum Press.

———. 2006. "Printed Cloth (*Kanga*)." In Kiprop Lagat and Julie Hudson, eds., *Hazina: Traditions, Trade and Transitions in Eastern Africa*, 31–33. Nairobi: National Museums of Kenya.

———. 2005. "Not Really African? *Kanga* and Swahili Culture." In Hassan Arero and Zachary Kingdon, eds., *East African Contours: Reviewing Creativity and Visual Culture*, 73–84. London: Horniman Museum.

Zawawi, Sharifa. 2005. *Kanga: The Cloth that Speaks*. Bronx, N.Y.: Azaniya Hills.

Notes

1 Zawawi 2005, 19; Abdullah 1984, 49.
2 Linnebuhr 1997, 139.
3 Ibid.
4 Prestholdt 2008, 74–75.
5 Fair 2001, 67.
6 Spring 2009, 13; Spring 2005, 74.
7 Fair, by contrast, cites Linnebuhr's date of the late 1870s for the creation of *leso ya kushona*. See Fair 2001, 79–80.
8 New 1874, 60.
9 Linnebuhr 1997, 140.
10 Schmidt 1888, 144.
11 Spring 2005, 75.
12 Spring 2006, 31.
13 Department of Overseas Trade, *Report on Trade*, 1897, 14, as cited in Fair 2001.
14 Fair 2001, 80.
15 J. E. E. Craster, *Pemba: Report for the Year 1900*, 15, as cited in Fair 2001.

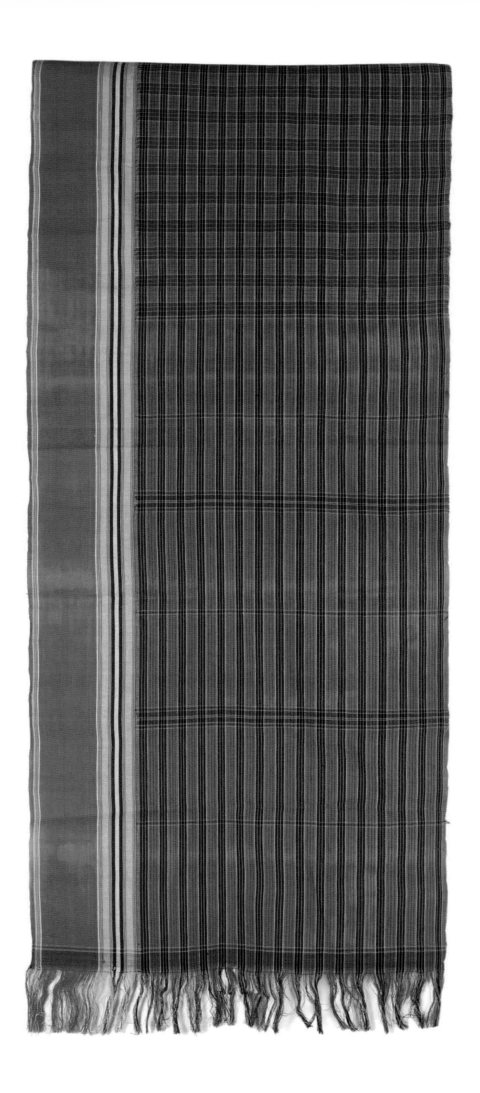

41 (left)
SOMALI PEOPLE
Benadir, Somalia
20th century
Woven Textile (*futa benadir*)
Cotton and lace
143.25 x 26 in (363.9 x 66 cm)
Gift of Katheryne Loughran and
John Loughran, President of the
Foundation for Cross
Cultural Understanding
2005.28.81

42 (opposite page)
SOMALI PEOPLE
Benadir, Somalia
Woven Textile (*futa benadir*)
20th century
Cotton
dimensions
Gift of Katheryne Loughran and
John Loughran, President of the
Foundation for Cross
Cultural Understanding
2005.28.77

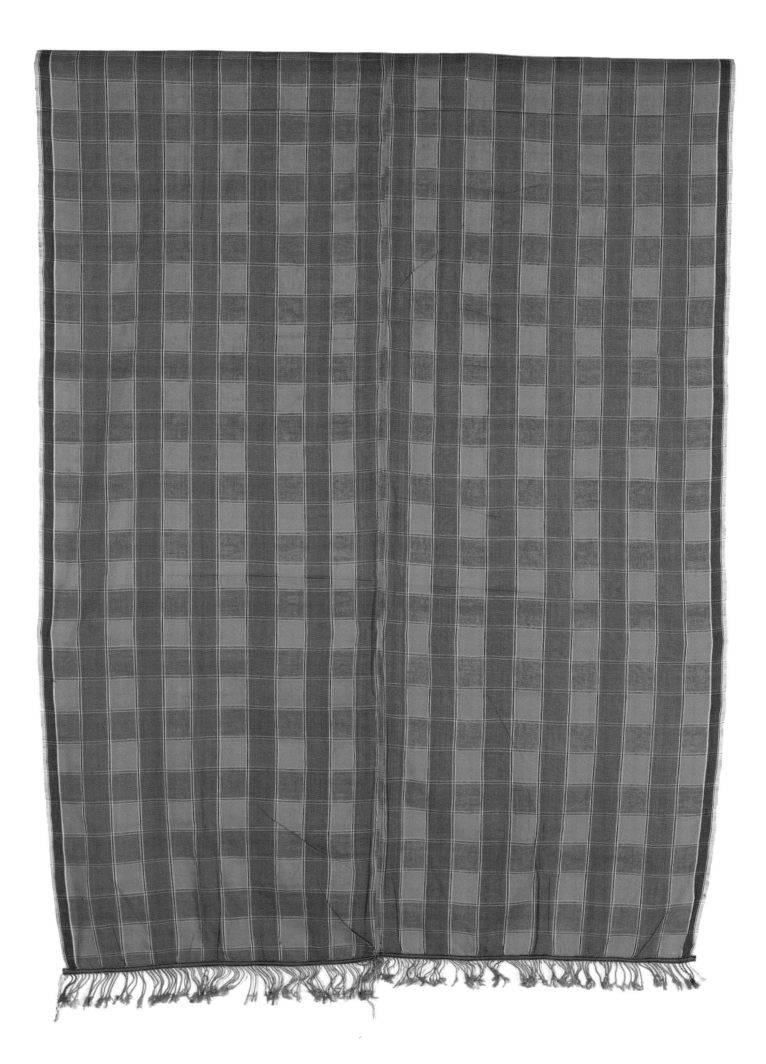

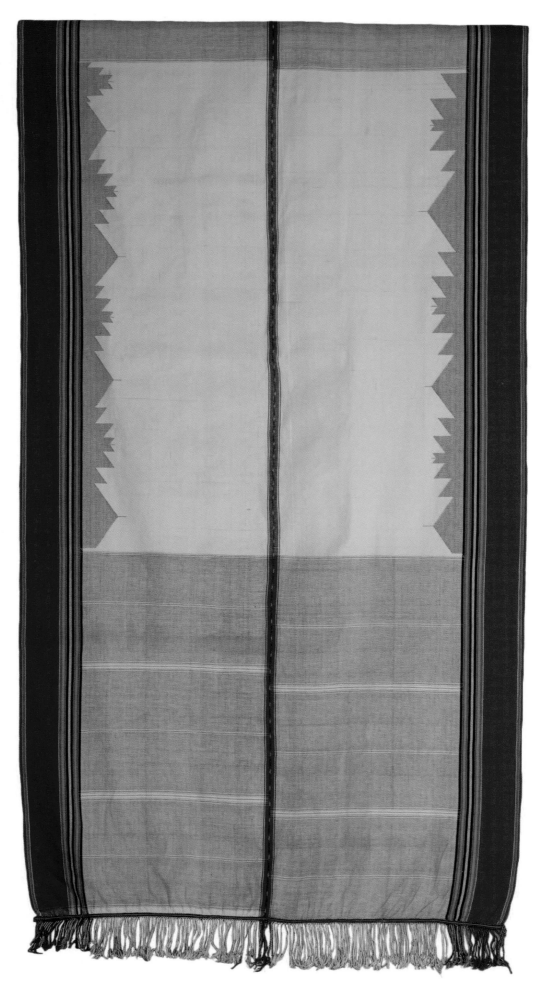

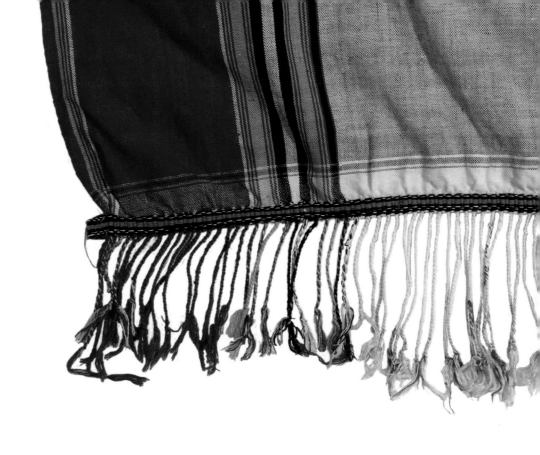

43 (opposite page, detail above)
SOMALI PEOPLE
Benadir, Somalia
Woven Textile (*futa benadir*)
Cotton
135 x 50.5 in. (342.9 x 128.3 cm)
Gift of Katheryne Loughran and John Loughran, President of the
Foundation for Cross Cultural Understanding
2005.28.79

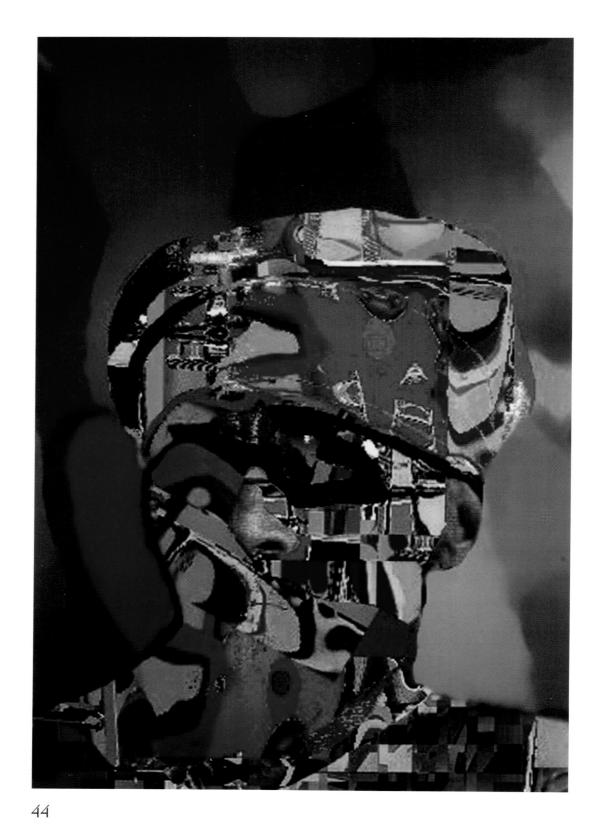

44
ACHAMYELEH DEBELA
American, b. Ethiopia, 1947
The Priest
1990–91
Chromogenic color print
16 x 20 in. (40.6 x 50.8 cm)
Museum purchase with funds provided by the
Ruth Pruitt Phillips Endowment
2009.8

Susan Cooksey

Cloth and Performance:

THE WORK OF VIYÉ DIBA AND ACHAMYELEH DEBELA

Clothing conceals and protects the body, but also extends the physical dimension and aesthetic presence of the body. The works of two artists represented in the exhibition, *Traces* by Viyé Diba (Pl. 45) and *The Priest* by Achamyeleh Debela (Pl. 44), both relate these functions of cloth to performance.

Viyé Diba: *Traces*

Viyé Diba (b. 1954), a Senegalese artist, has always been interested in the relationship of humans to their environment. From his art-student days in Senegal, where conventional art materials of paint and canvas were scarce, he became intrigued with the use of both natural and human-made found materials that had been used and discarded. For Diba, these materials, including pieces of cloth, "carried with . . . [them] some form of human signature, a trace of human action" (Harney 2004, 193). Later, in 1983, he began using these materials along with paint and canvas. His 2007 work *Traces* (see Pl. 45) reflects this later stage, which he calls his "third generation" of work, and which combines found and conventional Western fine-art materials, including canvas and oil paint, with the manufactured cloth known as *pagne* and locally produced cotton strip-woven cloth.

By the 1990s, Diba was investigating the notions of African authenticity, balancing the ideas of Leopold Senghor

(1906–2001), who spoke of *l'âme nègre*, and those of contemporary theorists. He examined African objects in museums and fixated on two elements— proportion and rhythm—which, according to Senghor, inform and authenticate African visual arts and dance. In *Traces* and other "third-generation" works, Diba relies on the repeated forms of vertical strips of cloth to suggest the compositional strategies of traditional African sculpture and the rhythms of African dance. He counterbalances the vertical thrust of the light, expansive upper portion of the canvas with a smaller, darker field in the lower portion. The visual weighting of this lower section stabilizes the composition formally but also conceptually, and is Diba's nod to the use of proportion in African sculpture. But the compact, earthy field is also connected to African dance, which "is a humble procession that draws attention to our status as terrestrial beings, and through its steps we sense our spirituality" (Viyé Diba, email communication, 10/21/10, as translated by Susan Cooksey).

Diba's canvases are sometimes more akin to sculpture than to paintings, embedded as they are with fabric pouches or with pieces of wood wrapped in fabric or cord. The act of binding these materials seems to parallel the practice of containing and concealing powerful substances by African religious practitioners, including healers

and diviners (Cooksey 2004, 108; Roberts and Roberts 1996, 206). The artist insists that his incorporation of the textiles and other materials that expose the structure of the canvas "allows a primary relation to the material, . . . it is more participatory" (Diba, 10/21/10 email). For Diba, the canvas and *pagne* are both structural, and are his medium.

Diba's exploration of the interrelationship of structure with surface seems generated by his attention to textiles, and specifically to the clothed human form. He has voiced his admiration of Senegalese women, who use their dress as a form of painting, "thanks to a judicious use of colors" (Harney, 2004, 192). Diba's use of color to control form by the application of many layers of hues is not unlike the layering of clothing to conceal or extend the body, or express ideas of self. In *Traces*, for example, a fine layering of tertiary colors forms a cloud-like field that has small patches of saturated color breaking through (see Pl. 45). The subtly animated surface can also be compared to the patination of antique African sculpture so admired by Western collectors. The use of this subtle palette has been interpreted as Diba's mockery of this imposed aesthetic (Harney 2004, 197). Diba is reinforcing the idea that oil and acrylic paint, substances originating in the Western art world, are superficial applications that are

not integral to the structure of the work. This is his method of directing attention to the primacy of cloth as both a substrate and an inherently African material.

The substrate is the site of a confrontation with the medium that is aggressive and combative. Diba places multiple layers of materials, including canvas, *pagne*, and found objects, on the ground to provide more resistance to his attacks on them, which involve ripping and pulling the fabric (Fig. 1). The energy from this resistance allows him to "move beyond the poetic language of painting" and allow a productive dialogue between artist and materials (Harney 2004, 190). Although many of his finished works show signs of this confrontational approach, with shredded, twisted, or dangling parts, these pieces have been carefully bound and synthesized into the composition. The level of Diba's combativeness varies, and each work is a document of the character and progression of his dialogue. As an example, *Traces* shows few signs of the aggressive performance, only some open stitching on its inner seams, and some highly gestural marks and abrasions. While its surface is intensively treated and highly activated, the overall effect is somber and subdued. Thus although it remains evident that the fabric has been ripped and resewn yet is still straining at the seams, it has also resisted concealment by the painted surface. It is the subtlety of this tension—the result of diverse treatments of the fabric—that is most compelling to the viewer. As Diba explains: "The most important thing to know about the work is the nature of the collaboration of many interventions, by hand sewing, machine sewing, and its contact with the material, and the profound structure of the material" (Diba, 10/21/10 email, as translated by Susan Cooksey).

Fig. 1. (above) Viyé Diba at work in his courtyard studio, 1994. In Elizabeth Harney, *In Senghor's Shadow: Art, Politics and the Avant-garde in Senegal, 1960–1995* (Durham and London: Duke University Press, 2004), p. 198. Photograph by Elizabeth Harney.

Fig. 2. (opposite page) Priests of the Ethiopian Orthodox Church gather for a ceremony during the annual Festival of Maryam Zion in Aksum, Ethiopia, 2001. Photograph by Rebecca Martin Nagy.

Achamyeleh Debela: *The Priest*

The Priest (1990–91), a digitally generated chromogenic color print by Achamyeleh Debela (b. 1947), is based on the artist's memories of Ethiopian Christian Orthodox liturgical performances. The central image, the holy man's head, is completely wrapped in a brilliantly patterned cloth; only his nose and an ear are exposed to allow us to recognize him as human (see Pl. 44). Debela explains the work as one that is a "collage of images from the Ethiopian Orthodox church celebrations" that he recalls from his childhood in Addis Ababa (Debela, personal communication, 12/2/10). Debela's image expresses the joy and exuberance he felt as a boy when he saw the Orthodox processions wending their way through his hometown toward sacred sites. He was most impressed by Timkat, the celebration of Epiphany in which the Ark of the Covenant is carried in a solemn procession, and by baptisms, which he remembers as joyful events attended by throngs of people. In these ceremonies, he recalls that a multitude of priests appeared, lavishly adorned from head to toe in hues that corresponded to their rank (Fig. 2).

Rather than represent the monochromatic vestment of a single cleric, Debela's image of the priest's head is covered by a fantastic polychromatic cloth, condensing the full spectrum of his experience into a single vision (see Pl. 44). While the image may be the embodiment of an aesthetic experience, Debela focuses on the head to emphasize the intellectual aspects of Orthodox religion. The life-sized image also evokes Debela's memory of the priests' one-on-one contact with those they reached out to bless with their processional crosses. In some ceremonies the priest's head is partially concealed by a turban, and Debela remembers the sense of elated anticipation he felt as the priest directed his gaze on him as a sign of blessing. By obscuring the eyes in his *Priest*, however, Debela blocks the figure's gaze. Despite this obfuscation of the priestly gaze, the image reflects the Christian Orthodox iconic style of Christ and the saints facing forward and confronting the viewer. *The Priest* retains its iconic power by virtue of its frontality and life-sized proportions, but its countenance has been replaced by a swath of colorful patchwork abstracted from the scans of Debela's drawings, paintings, and found or electronically generated images (Debela, personal communication, 12/2/10; Harney 2003, 92). These are presented as the kaleidoscopic projections of the artist's memories, and it is through them that he transforms an icon into a mirror of his own experience.

References

Cooksey, Susan. 2004. "Iron Staffs in the Crossroads: Art and Divination in Toussiana, A Southwestern Burkina Faso Community." Ph.D. dissertation, University of Iowa.

Harney, Elizabeth. 2004. *In Senghor's Shadow: Art, Politics and the Avant-garde in Senegal, 1960–1995*. Durham and London: Duke University Press.

———. 2003. *Ethiopian Passages: Contemporary Art from the Diaspora*. Washington, D.C.: National Museum of African Art.

Roberts, Allen F., and Mary Nooter Roberts. 1996. *Memory: Luba Art and the Making of History*. Munich: Prestel.

45
VIYÉ DIBA
Senegalese, b. 1954
Traces
2007
Mixed media
55 x 51 in. (197.3 x 129.5 cm)
Museum purchase, gift of
Mrs. Ruth Pruitt Phillips
2009.44

Courtnay Micots

Griffins, Crocodiles, and the British Ensign:

KWEKU KAKANU'S *ASAFO* FLAGS AND FOLLOWERS

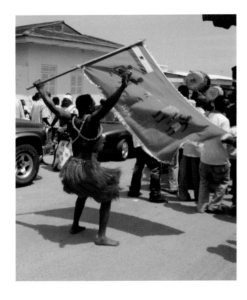

Prior to warfare and during rituals, Fante flags, or *mfrankaa* (*frankaa*, singular), were danced or carried by a specially trained member, the *frankakitanyi*, of an *asafo* company (Fig. 1). Although once serving as the military arm of the Fante, today's *asafo* serve three critical roles in the Fante community: political, in that they give the common man a voice in governmental issues; social, in that they act as a cooperative group to provide labor for public works and as the local unit called upon in cases of emergency; and religious, in that they play an important role in member funerals and state ceremonies. Fante *asafo* expanded their roles in response to the growing economy and urbanization experienced on the Ghanaian coast during the pre-colonial period.

Though one report mentions the use of a painted flag in 1693,[1] it was not until the mid-nineteenth century that Fante *asafo* groups widely adopted the use of flags. Throughout the nineteenth century, the Asante, a rival Akan group, attacked the Fante along trade routes and in port cities to gain direct access to the coast and greater profits. Constant attacks weakened the Fante's hold over the region and increased their reliance on the British, who for decades operated as mediators between the two Akan groups. The British interest was commercial; they did not want trade routes to be severed, denying access to Asante gold mines in the north. The coast

unofficially became a British colony with the Bond of 1844. When the Asante attacked the Elmina fort in 1873, the British retaliated and defeated the Asante in March of 1874. By July, Britain had formally established the British Crown Colony of the Gold Coast.

During this period, flag-makers began to include a small British ensign in the upper corner of *asafo* company flags as a mark of allegiance with the British, who were quickly becoming the major source of military power on the coast. This served to remind those viewing the flag of the strength of the Fante company, often acting as reinforcements for British troops. However, Fante attitudes toward the British may have changed by the turn of the century, for the British administration imposed strict regulations on *asafo* companies and their arts.

Fante tailors continued to incorporate the British national symbol and sometimes chose different colors or placed stripes in varied compositions. By harnessing another nation's symbol and altering it, the Fante may have been visually neutralizing British power by making it part of their own without upsetting the British administration. Though they may have simply misunderstood the actual design, greater variations in the British ensign generally appear in Fante flags sewn later in the colonial period.[2] The British ensign was replaced with the Ghanaian flag when Ghana gained its independence in 1957.

Fig. 1. (above) Kyirem No. 6 *asafo* company *frankakitanyi*, Okyir Festival. Anomabo, Ghana, October 10, 2009. Photograph by Courtnay Micots.

Fig. 2. (below) Kweku Kakanu (seated). Ghana, 1980. Photograph by Doran H. Ross.

Fig. 3. (right) Patterns used by Kweku Kakanu, 1978. Photograph by Doran H. Ross.

Asafo flags measure approximately 3 by 5 feet, with some companies possessing display banners up to 300 feet long. Brightly colored swatches of fabric depicting animals, objects, and humans are sewn to a typically monochromatic cotton background. Details may be added with embroidery. The cloth is imported, as are many of the motifs, most of which allude to important chiefs and warriors, proverbs, or symbols of strength and courage.

In the first Fante flag in the Harn exhibition (Pl. 46), two grasscutters, or large rodents, are hunted by a black animal with wings and a hawk-like beak. This composite animal, probably a griffin, holds a duiker, or small antelope, in its beak. The cloth on the duiker

has since worn away, so only the remains of the original stitching are visible. Griffins were borrowed from English mythical imagery and transformed by the Fante artists into their local construct. The griffin became a symbol attached to the proverb "Will you fly or will you vanish? Either way you can't escape us." Currently the Fante prefer a multiheaded dragon in place of the griffin in many of their arts. According to Doran H. Ross, an authority on Akan arts and former director of the Fowler Museum at UCLA, this flag was originally sewn by Fante artist Kweku Kakanu (b. 1910; Fig. 2), who worked in Saltpond (personal communication with Ross in early 2010).

In the second flag (Pl. 47), a crocodile watches over a small pond filled with fish. Frogs and birds are nearby. This popular motif is associated with the proverb "Fish grow fat for the benefit of the crocodile." Although this flag is similar to many flags produced by Kweku Kakanu, the outlines of the crocodile and fish do not match patterns used by Kakanu (Fig. 3). His fish usually have curved tails, and his crocodiles have a large round bump at the end of the snout. The border is also dissimilar to those on flags he created. This can be seen when these two flags are compared. Thus, two explanations are possible. Either an apprentice in Kakanu's workshop was learning from him, or contemporary tailors copied

Kakanu's work from images available in publications such as *Asafo! African Flags of the Fante* by Peter Adler and Nicholas Barnard (1992). The latter explanation seems most likely because the border is a bright, unaged white fabric.

Symbols utilized in *asafo* flags and banners stem from a long history of pictorial references to proverbs and ideas. The presence of a crocodile, a fierce reptile common to West African waterways, conveys the idea that the enemy is doomed. Using a composite perspective, the body is depicted from an aerial view while the head is shown in profile.

As noted by Ross (2010), contemporary production of *asafo* flags in southern Ghana has been taking place in record numbers since the mid-1990s for sale to tourists, collectors, and international dealers who purchase these items mostly from dealers, or middlemen, in Accra, Ghana's capital city. Ross has identified eight workshops, including two in the Kormantine/Saltpond area. Not only are new flags created with the British ensign to mimic pre-independence flags, but also old flags are recycled for international sale. An older flag in poor condition may be patched. The Kakanu flag with the griffin has two odd white patches—a star near the top and a rectangle underneath the griffin—both seemingly added by a local dealer to ready the flag for sale. Both flags were collected

143

in Accra in 1993. The flag with the crocodile likely originated from one of these contemporary workshops. ◆

References

Adler, Peter, and Nicholas Barnard. 1992. *Asafo! African Flags of the Fante*. London: Thames and Hudson.

Aronson, Lisa. 2007. *Threads of Time: African Textiles from the Traditional to the Contemporary*. Brookville, N.Y.: Hillwood Art Museum.

Cole, Herbert M., and Doran H. Ross. 1977. *The Arts of Ghana*. Los Angeles: Museum of Cultural History, University of California.

Fynn, John Kofi. 1971. *Asante and Its Neighbors 1700–1807*. London: William Clowes.

Kea, Ray A. 1982. *Settlements, Trade, and Politics in the Seventeenth-Century Gold Coast*. Baltimore and London: Johns Hopkins University Press.

Kent, Kate P. 1971. *Introducing West African Cloth*. Denver, Colo.: Denver Museum of Natural History.

Philips, Thomas. 1752. "Journal of a Voyage Made in the Hannibal of London." In Awnsham Churchill, ed., *A Collection of Voyages and Travels*. London: Messieurs Churchill for Thomas Osborne.

Ross, Doran H. 2010. "First Word: True Colours, Faux Flags, and Tattered Sales." *African Arts* 43, no. 2 (Summer): 1–7.

———. 1979. *Fighting with Art: Appliquéd Flags of the Fante Asafo*. Los Angeles: University of California.

Notes

1 Phillips 1752, 228.
2 Flags sewn by Kweku Kakanu and his workshop are an exception. These flags represent the British ensign more accurately. Doran Ross, personal communication, 5/23/10.

46 (opposite, top)
KWEKU KAKANU
Ghanaian, b. 1910
Asafo Company Flag with Griffin (frankaa)
c. 1940s
Cotton
39 x 63.5 in. (99.1 x 161.3 cm)
Loan from the Honorable Kenneth and Bonnie Brown

47 (opposite, bottom)
AFTER KWEKU KAKANU
Ghana
Asafo Company Flag with Crocodile (frankaa)
After 1950
Cotton
37.5 x 65 in. (95.3 x 165.1 cm)
Loan from the Honorable Kenneth and Bonnie Brown

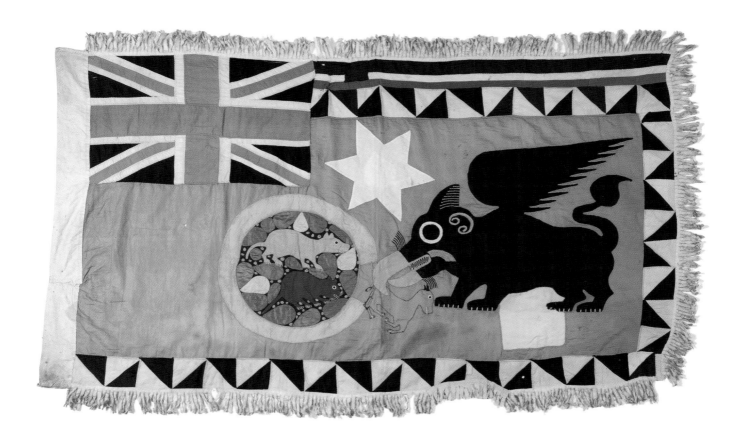

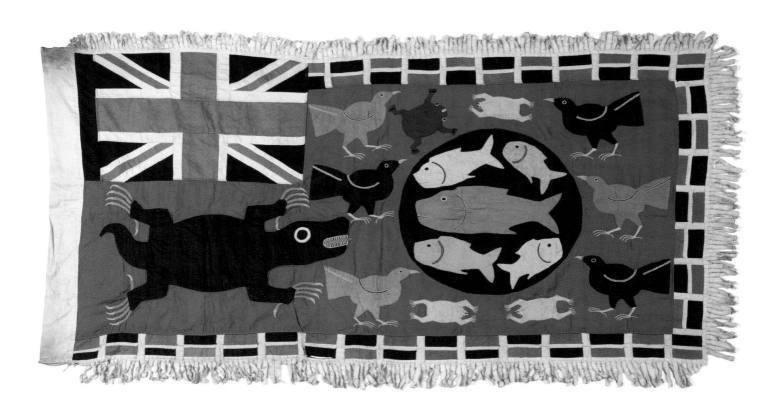

Jordan A. Fenton

Displaying the Ostentatious:

CONTEMPORARY CHIEFTAINCY DRESS AND THE EBONKO COSTUME FROM CALABAR, NIGERIA

On a Saturday afternoon in December 2009, the streets of a section of Calabar, the capital of Cross River State, Nigeria, seemed to explode with excitement as elegantly dressed Ekpe chiefs and colorful, dynamic masquerades displayed their finery, while Ekpe members sang and rejoiced. A new title-holder was installed in a local shrine. The procession (Fig. 1) publicizes the honoree's new position as he is outfitted in ceremonial dress: an imported English top hat; a beaded velvet collar resting on a white cotton T-shirt with a plastic beaded, baldric-like form fitted across his chest; and a loosely cascading scarf (*okpomkpom*) made of the same imported indigo-resist cotton wrapper that is tied around his waist.[1] A majestic blue umbrella calls attention to his central position, as fellow Ekpe chiefs accompany him in support, equally "dressed to impress" in the latest chieftaincy fashions: local and imported caps and walking sticks, damask and *nkisi* wrappers,[2] and long shirts of colorful eyelet embroidery. Behind the chiefs, members of lower ranks wear white long shirts of rayon and cotton with wax-print wrappers neatly tied around their waists. Despite the dry-season heat, chiefs and members dress in layers, not for comfort but because an ostentatious display is required to intensify the performance.

Prancing in all directions, a variety of masquerades employ both local and global materials. While other maskers[3]

forcefully dart through the streets, one masquerade, the Ebonko, moves majestically and calmly, staying close to the chiefs. Its lavishly beautiful costume, made of imported cloth, contrasts with the aggressive nature of the raffia fibers of the others (see Fig. 1). All of these things are integrated into a multilayered performance that addresses flamboyance and status, and thus attests to the many regional and global influences across time and space.

The Harn's Ekpe chief ensemble (Pl. 50) provides a glimpse into the eclectic styles manifested in chiefly dress in Calabar today. The velvet hat, created by Emmanuel Edem Effiom, features a stylized peacock of beadwork embroidery. Other motifs—such as the crown, draft board, anchor, canoe, and fleur-de-lis and other floral designs—are common today, many imported in the early days of contact.

The white eyelet-embroidery chieftaincy shirt is a garment made of factory-woven fabric locally known as "lace." The eyelet-embroidery textile became popular in Calabar during the early 1990s, replacing white rayon, linen, cotton, and multicolored velvet shirts. Multicolored velvet shirts were a popularly sought-after style in Calabar two decades ago, influenced by the tastes of neighboring Igbos.

The *okpomkpom* is worn like a scarf, but in a more dramatic manner. It loosely hangs from the neck and is tied to create

the effect of cascading loops, often featuring bows. Chiefs carefully select this article because it serves as an accent to unite the ensemble. The *okpomkpom* in the Harn exhibition (see Pl. 50) consists of cream and blue colors, iridescent rayon and linen fabrics, decorated with sections of factory-woven alternating horizontal lines.

Chiefs carefully consider their ensembles as compositions. The choice of the color blue for the *okpomkpom* connects the vibrant white eyelet shirt to the deep indigo wrapper. The cotton wrapper is known as *ukara* and is the primary symbol of membership into the Ekpe society. Only members may wear this textile. The distinctive white motifs are of *nsibidi*—an imaged and pantomimic language that symbolizes the grades of initiation, esoteric lore, and history of Ekpe. *Ukara* is manufactured by neighboring Igbo peoples and imported into Calabar.

The walking stick in the Harn ensemble was made locally from cane in Calabar, and its *nsibidi* iconography was produced with black pigment. Chiefs today normally favor the imported, commercially produced adjustable canes. The walking stick serves as the staff of office for a titled chief and is thus considered to be an important part of his ensemble.

Local artisans create shoes of imported velvet fabric on rubber soles. The elaborate beadwork embroidery

Fig. 1. Ekpe street performance following the installation of a chief. The Ebonko masquerade, located on the right, is made of cloth and contrasts with the raffia Ekpe masquerades on the left. The honoree's ceremonial dress and that of his fellow Ekpe chiefs are typical chieftaincy ensembles. Members of lower ranks are behind the chiefs and masquerades. Calabar, Nigeria, 2009. Photograph by Jordan A. Fenton.

decorates the surfaces of the shoes and completes the ensemble, visually linking the chief's footwear to his headwear. The peacock iconography on the shoes in the Harn ensemble (see Pl. 50) matches that on the hat. In fact, chiefs often commission matching motifs for their coordinated outfits. The peacock, which originated in India, was most likely brought to Calabar before or during the slave and oil trade. The peacock came to symbolize a specific level of initiation in the Ekpe society.[4] The popularity of Calabar beadwork demonstrates an older fashion still thriving today.

The Ebonko costume from the Harn collection by the master artist Ekpenyong Bassey Nsa (Pl. 49) provides another example of artistic innovation through the use of imported materials. In the past, damask fabrics were used to create the cloth body suit, the "mane" around the chest, and the arm and leg tufts, as well as a covering attached to the conical head structure. Today, a polyester fabric called "sample cloth" or "decorative cloth," manufactured with floral and circular metallic sequined motifs, is preferred. Typically the Ebonko costume is enhanced with handwoven yarn trimming attached to the borders of the mane and tufts. Sequin trim, mirrors, and small bells add further beauty—and in past years, tremendous numbers of beads were threaded onto the costume.

Long before Western contact, the cultures of the Cross River region of southeastern Nigeria and west Cameroon seem to have interacted, a dialogue taking place among the peoples of these areas and those of neighboring regions.[5] As early as the beginning of the sixteenth century, European contact introduced new dealings and interaction. For the next five hundred years, Calabar actively gained wealth, fresh ideas, and materials, first through the transatlantic slave traffic and then through the oil trade. Imports included metals, cloths of Indian, English, and Javanese origins, beads, mirrors, and bells.[6] These items turned into prestigious objects for the elite, all members of Ekpe.[7] Perhaps as a result of the slave trade, the Efik modified their version of Mgbe (known as Ekpe) so that it not only functioned as a means of governmental agency but also regulated trade and enforced the collection of debts.[8] Social prominence belonged to Ekpe and was reflected through extravagant presentations of wealth.

The contemporary dress of chiefs and the Ebonko costume demonstrate how art forms are temporal repositories that reveal influences from West and Central Africa, the Americas, Europe, and Asia. These ensembles suggest the level of sophistication with which individuals actively choose from an assortment of local and imported ideas and materials, incorporating them into local notions of aesthetics, use, and meaning. ◆

References

Fenton, Jordan A. 2008–10. Doctoral research fieldnotes.

National Commission for Museums and Monuments. 1986. *The Story of Old Calabar: A Guide to the National Museum at the Old Residency, Calabar*. Lagos: National Commission for Museums and Monuments.

Nicklin, Keith. 1983. "No Condition Is Permanent: Cultural Dialogue in the Cross River Region." *The Nigerian Field* 48: 66–79.

Northrup, David. 1978. *Trade without Rulers: Pre-Colonial Economic Development in South-Eastern Nigeria*. Oxford: Clarendon Press.

Picton, John. 1995. *The Art of African Textiles: Technology, Tradition, and Lurex*. London: Barbican Art Gallery.

Notes

1 The ensemble described here is typical of Ekpe and honorary chieftaincy ceremonial installation regalia, and also of the groom's outfit during "traditional" marriages in Calabar. Another common feature of this ceremonial dress is wristlets and armlets adorned with yarn and beads. By the end of the nineteenth century, Calabar styles of dress were possibly influenced by Victorian fashions (National Commission for Museums and Monuments 1986).

2 Locally, *nkisi* refers to a finer quality damask in terms of pattern and design, and is generally understood to be less cumbersome.

3 These maskers are commonly known as Ekpe, Atad Ekpe, and Idem Ikwo among the Efik and Efut, while the Qua-Ejagham refer to this variety as *abon ogbe*.

4 A peacock feather is placed into a white band of cloth tied around the neophyte's head during his initiation into the Nkanda grade.

5 See Nicklin 1983.

6 For more, see Northrup 1978.

7 By the time Europeans arrived in Calabar, it was already home to the Efik, Efut, and Qua-Ejagham peoples. The Efiks inhabited the coastal area of Calabar and developed into the trading middlemen who dominated European trading relations. The past population of Calabar was always a conglomerate of different peoples. Today, the population of Calabar is estimated at about three million people, many of multiethnic origins.

8 Prior to European intervention, Mgbe served as a regulating society, essentially the government for the Ejagham peoples even into the colonial era. Mgbe/Ekpe are commonly referred to in literature as leopard societies. However, the notion of the leopard is also conceptualized as the lion. Further, the leopard/lion attribution only scratches the surface when defining Mgbe and Ekpe holistically.

Susan Cooksey

Transfigured Textiles:
MASQUERADES AND IMPORTED CLOTH

In the last century, the use of textiles in masquerades has included a variety of locally produced and imported materials, although imported factory-made cloth has now almost entirely eclipsed the use of domestic material. Nowhere has the transition from local to imported usage become more apparent than in Nigeria, as illustrated by three examples from the Harn collection: an Igbo Agbogho mmuo (maiden-spirit) mask (Pl. 51), a Northern Edo Okakagbe mask (Pl. 52), and a Yoruba Egungun mask (Pl. 48). The first two demonstrate a remarkable instance of how an individual artist transformed a regional masking style through his introduction of imported fabric and appliqué. The Egungun masquerade represents a literal layering of local and imported textiles.

Colorful appliqué masquerades, locally known as Okakagbe, of a southern Nigerian culture group, the Northern Edo, were most likely inspired by the masks of peoples to the east of the Niger River, particularly the Igbo (Borgatti 1979, 4). The link between Okakagbe masks and Igbo maiden-spirit masks is immediately obvious because both are made of brightly colored imported cotton textiles that are pieced together, and appliquéd and couched to create complex patterns. Igbo maiden-spirit masquerades may have been adopted by peoples as far north as Nsukka, where residents claim that the maiden-spirit mask was brought there

from the Agulieri, who are just east of the Northern Edo (Aniakor and Cole 1984, 137). Both masquerades have groups of performers similarly garbed, including a leading matriarchal figure. In the Northern Edo tradition, she is called "Ancient Mother," and in the Igbo tradition she is known as "the Mother of Spirits" (*Nne mmuo*). *Nne mmuo*'s eldest daughter is *Idu*, or "Headload," for she bears an enormous headdress. Ancient Mother is also identified by her astounding headdress, with numerous figures on the top who represent her many children. She is also accompanied by a child in a similar costume but without the headdress, and by another major female figure, "Respected One" (*Otugo*). The Igbo troupe (Agbogho mmuo) representation of female spirit-beings includes a mother and her daughters. The dance of the women in both groups, Igbo and Northern Edo, idealizes femininity, which is characterized by attributes of beauty: light coloring, and delicacy of movement and physical features.

In addition to the main female characters, the Northern Edo masquerade includes male characters who play minor roles. The Harn Okakagbe mask (see Pl. 52) represents one of two male characters whose name varies depending on each dance troupe. The male masks are differentiated by the absence of breasts and, most often, a pattern other than the intricate star

patterning on the chest that is the mark of the two main female characters. The repertoire of appliqué designs is clearly adapted from the Agbogho mmuo patterns (Borgatti, email communication, 12/14/10), which are partly derived from young Igbo women's painted body adornment, or *uli* (Aniakor and Cole 1984, 121). Despite the clear visual link in the appliqué designs of Agbogho mmuo and Okakagbe, they do not seem to both be inspired by body adornment. Jean Borgatti notes that the Northern Edo have a tradition of body painting but have never mentioned its connection to the appliqué patterning of Okakagbe (Borgatti email, 12/14/10). The Harn Agbogho mmuo body-covering is adorned with appliquéd motifs of circles filled with checkerboard patterns, alternating with rows of arcs, and a grid pattern on the chest (see Pl. 51).

The male character's headdress (see Pl. 52) consists of a series of cloth-covered arcs festooned with yarn tassels. The headdress design seems to have carried over from the Agbogho mmuo, as seen in a photograph by G. I. Jones from the 1930s (Fig. 1). The Okakagbe masquerade was first introduced into Etsako, the central region of the Northern Edo area. The roots of the masquerade can be traced to a single individual, Okeleke, an artist from the borderland

of the Igbo and Igala people. Okeleke brought the masquerade to Etsako sometime near the 1920s, and it quickly supplanted local masquerades made of leaves, grass, and handmade cloth. Okakagbe's main function is to honor ancestors, and the early version using local materials was deemed too drab and outmoded to properly pay homage to the spirits of the deceased, when locals compared it to the vibrant patterns of the appliquéd costumes introduced by Okeleke. It shortly became well established in the local repertoire of masquerades and has persisted until today (Borgatti 1979, 4).

The Harn Okakagbe mask was made by Lawrence Ajanaku, an appliqué specialist and carver born in 1926 in Ogiriga (Fig. 2). Though Okeleke clearly left his mark on the appliqué artists of Estafo, including Ajanaku, the latter's style is distinguished by its elegant and economic use of line and form. Ajanaku worked in various Estafo communities beginning sometime in the late 1940s or early 1950s, and remained active at least until 2003, when this mask was made. His work has received much acclaim locally, nationally, and abroad, and commissioned works have been collected by

the National Museum in Lagos and shown in European and American exhibitions. Jean Borgatti reported that Okakagbe was still performed in 2003, with only subtle changes (Borgatti email, 12/14/2010). The only slight variations may be in the cloth and yarns, which are subject to what is available in local markets, and some appliquéd costumes are made with machine stitching.

Egungun masquerades appear in many areas of the Yoruba world, and many employ textile body-coverings. Egungun means both "masquerade" and "power concealed," a necessary condition for the ancestral spirits they embody (Abiodun, Beier, and Pemberton 2004, 33). One of the most spectacular forms of the masquerade is composed of layers of textile strips, attached to the headpiece and flaring out at the feet of the dancer (Fig. 3). The concealment of the body with cloth layers adds to the drama of the revelation of the ancestral presence: as the dancer whirls around and the cloth splays out, inner layers of different colors and patterns are exposed. The masquerade expresses the ancestor's ability to suddenly and dramatically transform his- or herself. The effect of

Fig. 1. (above) Maiden-spirit maskers, Agbogho mmuo. Near Awka, Nigeria. Image courtesy of the Fowler Museum at UCLA. Photograph by G. I. Jones, 1930s.

Fig. 2. (right) Okakagbe dance troupe, wearing costumes made by Lawrence Ajanaku, who is seated, second from the right. Ancient Mother is on the far left, and Respected One is on the far right, with the two minor male masks and one female mask in the center. Uzairue, 1973. Photograph by Jean Borgatti.

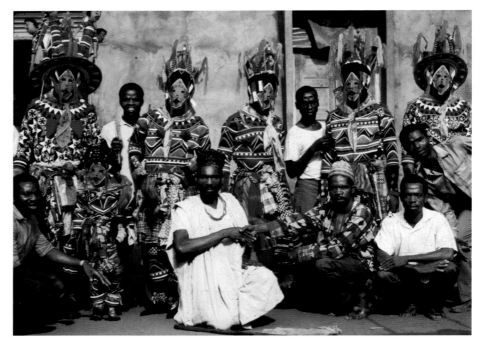

the cloth is in fact a means of mediating the spiritual presence between the visible world of humans and the unseen spirit world. But as Rowland Abiodun notes, cloth can outlast its owners, and thus the Yoruba consider it to be immortal, and symbolic of the continued life of the ancestors beyond death (Abiodun, Beier, and Pemberton 2004, 40). The layers of cloth are carefully chosen from old handwoven indigenous cloths, forming the innermost layers, to factory-made imported cloth, attached successively as the mask is periodically renovated. The accumulation of the cloths reveals the age of the mask and the duration of the homage paid to the ancestor by his or her descendants. The mask is at once a shrine for contact and veneration of the desceased and an embodiment of the prestige and power of the ancestors. Ancestral authority is narrated by the textiles that enshroud them, and is encoded in the colors, patterns, and textures of those materials.

The Harn Egungun masquerade has at its core a layer of men's strip-woven cloth made of indigo-dyed cotton yarns (see Pl. 48). The dense middle layers are made up of a variety of imported European factory-print cloth, including a type that appears to be a wax print that imitates Javanese batik. Wax prints were among the most popular imports to West Africa beginning in the late nineteenth century. Ghanaian mercenaries who served the Dutch in their colonies developed a taste in Indonesia for batiks, which they brought back to Ghana in 1872. The Dutch Haarlem Cotton Company introduced machine-made imitations of wax prints in West Africa, and the strong market there spurred their manufacture in Manchester, England. Wax prints made in Holland are still some of the most desired of all textiles in Africa, although imitations from other parts of Europe, and from Asia and Africa, are less costly and more widely consumed (Fig. 4).

In the early days of wax-print production, the printed patterns were derived from Indonesian textile designs, but eventually African-inspired patterns were developed. The Harn Egungun includes panels that appear to have Indonesian designs, with dark-blue and brown foliate patterning, as well as European-style patterns that were popular imports during the colonial era, in the early to mid-twentieth century. The outermost layers include burgundy-colored velvet and red wool panels. The color red is associated with the heat of the ancestors, which warms their onlookers and also warns them of the spirits' potential to harm them if not properly venerated. According to Rowland Abiodun, these colors and fabrics are among those most valued by the Yoruba, who say that velvet is "the epitome of good taste in cloth" (*Aran, tii pari aṣo*) and that the red panels are "the doyen of all cloths" (*Alaari, baba aṣo*); their prestige is derived from that fact that they were originally imported products of Europe and North Africa (Abiodun, Beier, and Pemberton 2004, 39).

In the context of Egungun masquerades, cloth is a medium for honoring the ancestors, and imported cloth plays an important role in elevating the status of ancestors. The contributions made to the Egungun of contemporary imported cloths not only show the ancestors' relevance to the living but also, in such huge displays of diverse materials from multiple sources, prove their life force, or *àṣe*, which is linked to the ancestors' power to adapt and transform themselves (Abiodun, Beier, and Pemberton 2004, 40). Imported cloth is perceived as a metaphor for change, as an empowering force. The greater implications are that, through its empowerment, the Egungun serves to bind the living to their deceased relatives, and thus enforces a sense of family history and identity.

In contrast to this notion of textiles being appropriated from another source

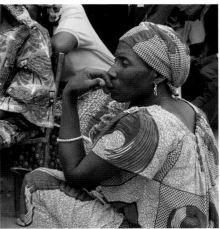

Fig. 3. (top) A Yoruba Egungun dancer in Ijebu area, Nigeria. Photograph by John Pemberton III, 1986.

Fig. 4. (bottom) Women wearing wax-print and other imported cloth. Toussiana, Burkina Faso, 2006. Photograph by Susan Cooksey.

but used to reinforce or authenticate cultural or group identity, the work of the artist Yinka Shonibare (b. 1962) uses wax-print cloth to engage the viewer in a dialogue about the personal and the collective, global process of identity-construction. Shonibare's 1999 *Victorian Couple* (Pl. 53) features two headless mannequins dressed in Victorian-era tailored garments made of boldly patterned wax-print cloth purchased in the Brixton market, not in Africa as one would expect. The artist presents the viewer with a number of discordant elements that are carefully assembled here: the headless and unarticulated figures, thus with no identity, wearing cloth strongly but erroneously associated exclusively with African culture, in a style (Victorian era) known to be associated with the period of African colonization, the slave trade, and the obliteration of African identity. Further investigation of these associations forces the viewer to consider what constitutes history, who narrates history, and what is at stake in constructing such histories. There is also the question of how such narration affects the perception of identities. Shonibare shows us that the association of wax prints with Africanity is as false a construction as the assumption that would, for example, associate race, nationality, or other factors as single signifiers of identity. ◆

References

Abiodun, Rowland, Ulli Beier, and John Pemberton. 2004. *Cloth Only Wears to Shreds: Yoruba Textiles and Photographs from the Beier Collection*. Amherst, Mass.: Mead Art Museum, Amherst College.

Aniakor, Chike C., and Herbert M. Cole. 1984. *Igbo Arts: Community and Cosmos*. Los Angeles: Museum of Cultural History.

Borgatti, Jean. 1979. *From the Hands of Lawrence Ajanaku*. UCLA Museum of Cultural History Pamphlet Series, Vol. 1, No. 6. Los Angeles: Regents of the University of California.

Picton, John. 1995. *The Art of African Textiles: Technology, Tradition, and Lurex*. London: Barbican Art Gallery.

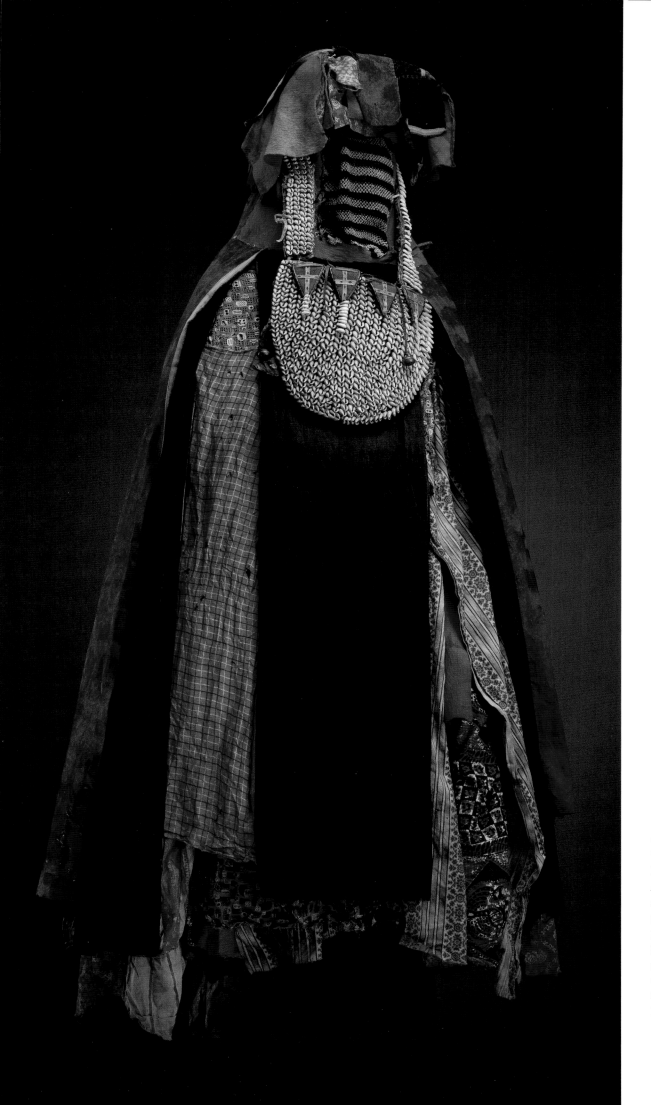

48

YORUBA PEOPLE
Nigeria
*Ancestor Spirit Masquerade
Costume (Egungun)*
20th century
Imported fabric, local fabric,
leather, cowrie shells, metal
60.25 x 24.5 x 16.75 in.
(153 x 77.52 x 55.9 cm)
Gift of Rod McGalliard
1993.12.6

153

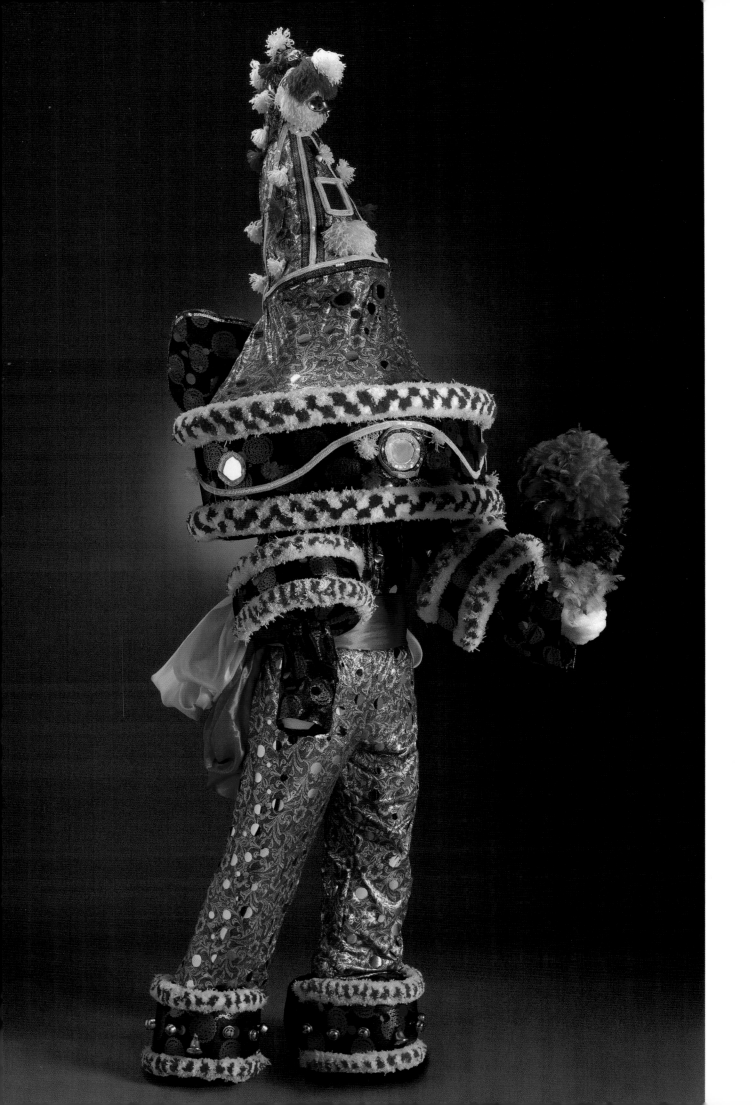

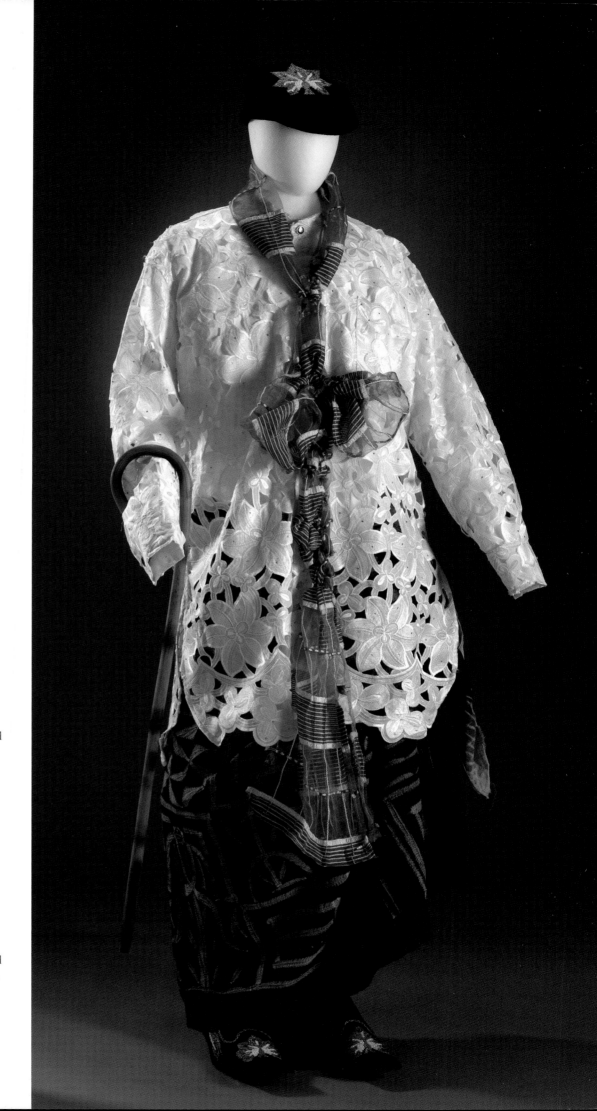

49 (opposite page)
EKPENYONG BASSEY NSA
Nigerian, b. 1973
Ebonko Masquerade Ensemble
2010
Mixed media
63 x 29 in. (160.02 x 73.66 cm)
Museum purchase with funds provided
by the Caroline Julier and James G.
Richardson Acquisition Fund
2010.68.1

50 (right)
CALABAR
Nigeria
Ekpe Chief's Attire
2010
Mixed media: dyed cotton cloth,
silk/nylon, beads, sequins, velvet
66 x 28 in. (167.64 x 71.12 cm)
Museum purchase with funds provided
by the Caroline Julier and James G.
Richardson Acquisition Fund
2010.68.2

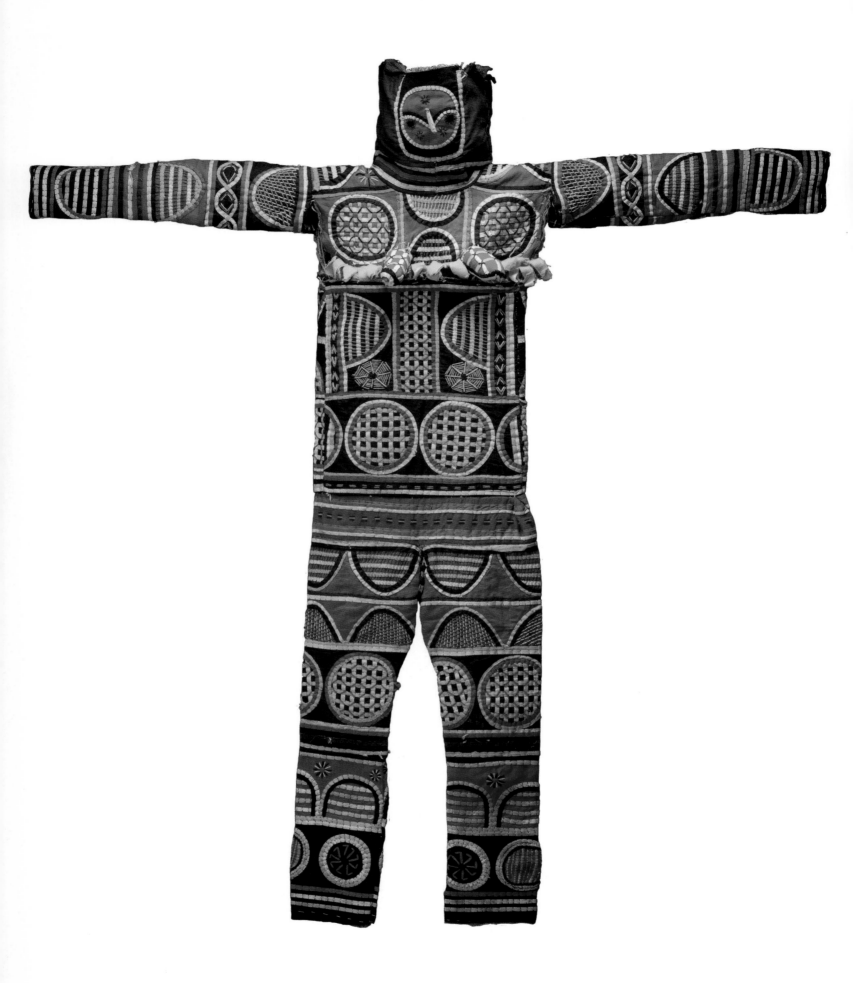

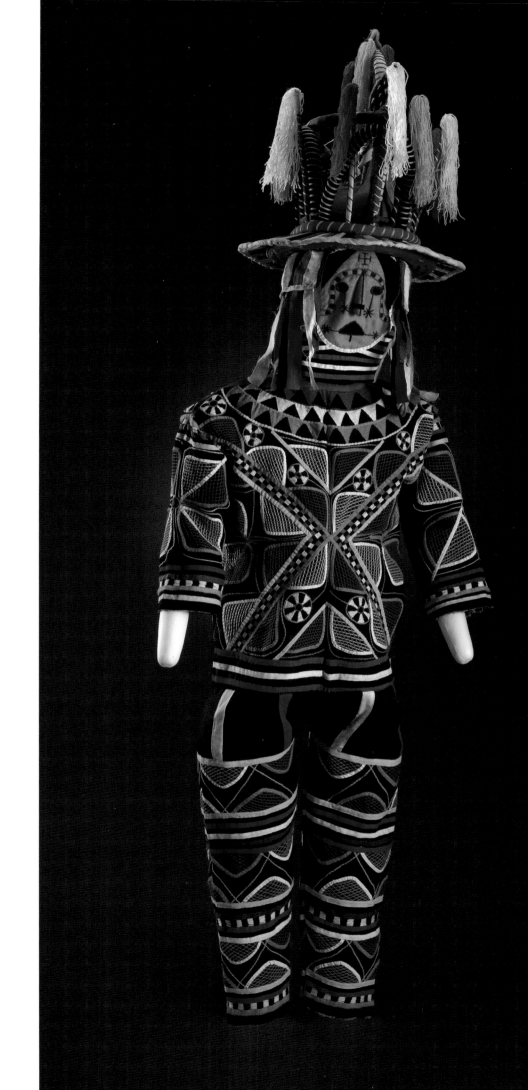

51 (opposite page)
IGBO PEOPLE
Nigeria
Maiden-Spirit Costume (Agbogho mmuo)
Late 20th century
Imported fabric, yarn
67 x 58 in. (170.2 x 147.3 cm)
Gift of Rod McGalliard
1990.14.37

52 (right)
LAWRENCE AJANAKU
Nigerian, b. 1926
Okakagbe Masquerade Costume
2003
Cotton
90 x 50 in. (228.6 x 127 cm)
Museum purchase with funds provided
by the Caroline Julier and James G.
Richardson Acquisition Fund
2010.4

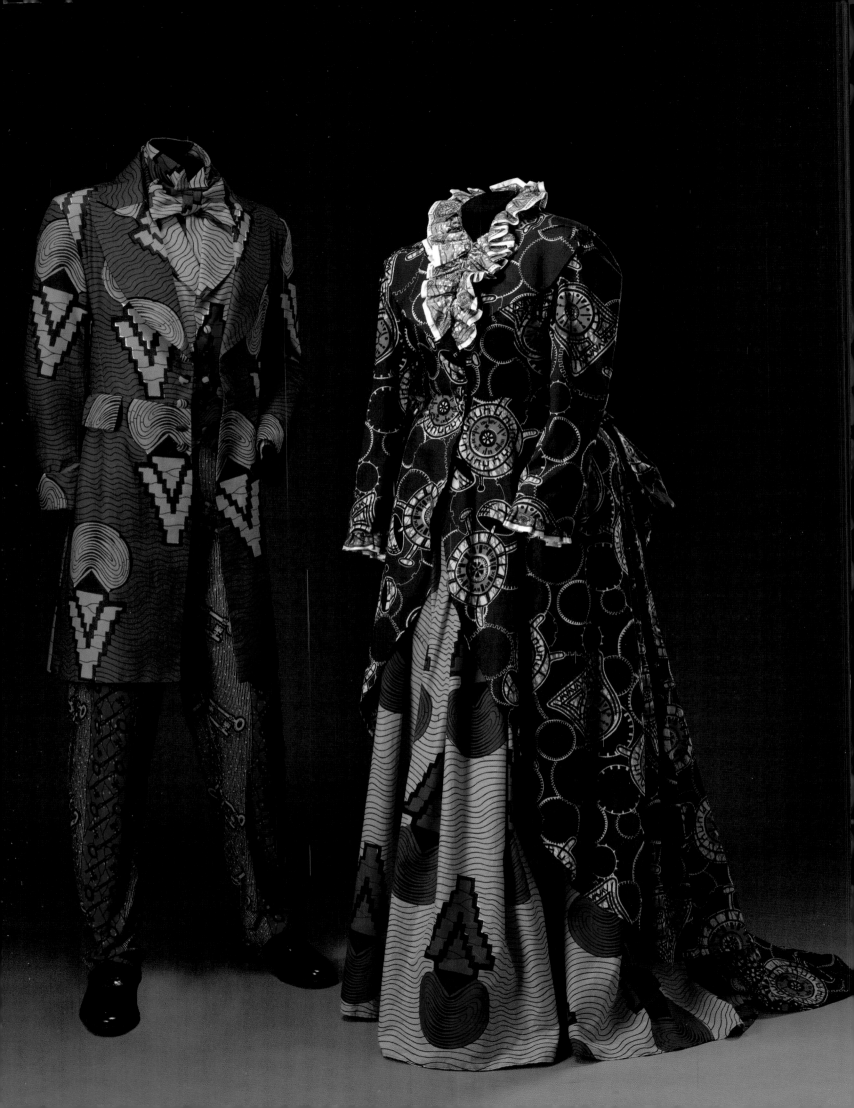

Contributor Biographies

Dr. Cynthia Becker is Associate Professor of Art History at Boston University and specializes in the arts of the Imazighen (Berbers) in northwestern Africa, specifically Morocco, Algeria, and Niger. She is the author of *Amazigh Arts in Morocco: Women Shaping Berber Identity* (University of Texas Press, 2006). Her current research concentrates on the history of the trans-Saharan slave trade and its implications and its effects on material culture in northern Africa.

Dr. Susan Cooksey is Curator of African Art at the Samuel P. Harn Museum of Art, University of Florida. She has curated numerous exhibitions on African art and is the curator of the current exhibition, *Africa Interweave: Textile Diasporas*. Her research has focused on arts related to divination in southwestern Burkina Faso. Publications include studies of masquerades for the spirit Do, and images of twins in Win culture.

Dr. Sarah Fee is Associate Curator in the Department of World Cultures, Royal Ontario Museum, Toronto. Her research and publications have focused on women, weaving, and ceremonial exchange among the Tandroy of southern Madagascar and, most recently, on the historic connections between trade and cloth production along the western Indian Ocean rim.

Jordan A. Fenton is a Ph.D. candidate in African art history at the University of Florida. He is preparing a dissertation on performed and imaged *nsibidi* (a secret pictographic and pantomimic language) and the masquerades of the Ekpe/Mgbe society in Calabar, Cross River State, Nigeria.

Dr. Suzanne Gott is Assistant Professor in the Department of Critical Studies at the University of British Columbia, Okanagan. Recent publications include "The Ghanaian *Kaba*: Fashion That Sustains Culture," in Suzanne Gott and Kristyne Loughran, eds., *Contemporary African Fashion* (Indiana University Press, 2010); and "Asante *High-timers* and the Fashionable Display of Women's Wealth in Contemporary Ghana," *Fashion Theory* 13, no. 2 (June 2009).

Dr. Courtnay Micots received her Ph.D. in art history from the University of Florida in 2010. Her research interests include the coastal arts of Ghana, West Africa, and contacts between African and Western artistic traditions. She has taught at Florida Southern College, the University of Florida, the University of Illinois at Champaign-Urbana, and most recently at the University of South Florida.

Dr. Rebecca Martin Nagy is Director of the Samuel P. Harn Museum of Art, University of Florida. Throughout her career she has curated exhibitions and published articles and exhibition catalogues about medieval, contemporary, and African art. Most recently she co-organized the exhibition *Continuity and Change: Three Generations of Ethiopian Artists* (2007) with Achamyeleh Debela and produced the accompanying catalogue. Prior to her appointment as director of the Harn, she spent 17 years at the North Carolina Museum of Art in Raleigh, where she concluded her tenure as associate director of education while also serving as curator of African art.

Dr. Robin Poynor teaches the arts of Africa and of Oceania as Professor in the School of Art and Art History at the University of Florida. His 1970s fieldwork in Nigeria as a Fulbright Hays Fellow examined the arts of the Owo Yoruba Kingdom. His dissertation at Indiana University, "The Ancestral Arts of Owo," addressed the arts associated with death and dying and ancestral veneration among the Owo Yoruba. *A History of African Art* (Abrams, 2000), written with Monica Blackmun Visona and Herbert M. Cole, was among the Library Journal's Best Books of 2000 and received Honorable Mention in the Arnold Rubin Outstanding Book Awards. The 2008 edition was released by Pearson Education and Prentice Hall.

Christopher Richards is a Ph.D. candidate in African art history at the University of Florida. He recently published "There's No Place like Africa: An Exploration of African and African-inspired European Fashion," in the Indian journal *Art Etc.*

Dr. Victoria L. Rovine is Associate Professor of Art History and African Studies at the University of Florida. Her Ph.D. is from Indiana University. She has conducted research on textiles, fashion, and contemporary art in Mali, South Africa, and elsewhere in Africa. Her book *Bogolan: Shaping Culture through Cloth in Contemporary Mali* (Indiana University Press, 2008) analyzes the contemporary manifestations of a local textile. She has published numerous book chapters and articles on African fashion design and African influences on Western fashion design.

MacKenzie Moon Ryan is a Ph.D. candidate in African art history at the University of Florida. She received her M.A. from Florida in 2008 and B.A. from Hamline University in 2006. While pursuing her degrees, she also spent two years at the University of London's School of Oriental and African Studies. Her dissertation research is focused on the *kanga*, a colorful and graphic mass-produced, industrially printed textile worn by women as wrap garments throughout East Africa and beyond. She is interested in the *kanga's* communicative and cultural role within society, as well as its contemporary uses and transformations as the product of local tastes and international ties.

53 (opposite page)
YINKA SHONIBARE
British/Nigerian, b. 1962
Victorian Couple
1999
Fiberglass, leather, Dutch wax cloth, and metal
Male figure: 65 x 21 x 12 in. (165.1 x 53.34 x 30.48 cm)
Female figure: 61.5 x 19.5 x 18 in. (156.21 x 49.53 x 45.72 cm)
Overall: 66 x 50 x 22 in. (167.64 x 127 x 77.41 cm)
On loan from the Norton Museum of Art, Purchase acquired through the generosity of the Contemporary and Modern Art Council and the R. H. Norton Trust, 2006.10

Africa Interweave: Textile Diasporas
February 8 — May 8, 2011
Samuel P. Harn Museum of Art
University of Florida, Gainesville

This publication is made possible by the John Early Publications Endowment,
the 1923 Fund, Richard and Mary Ann Green, Bob and Joelen Merkel, Storter
Childs Printing Company, Inc., the Harn Program Endowment, and the Harn
20th Anniversary Fund.

Editing: Victoria R. M. Scott
Design and composition: Ron Shore, Shore Design
Plate photography: Randy Batista
Coordination and production: Tami M. Wroath

Printed in Canada

Library of Congress Cataloging-in-Publication Data

Cooksey, Susan.
 Africa interweave : textile diasporas / Susan Cooksey ; with essays by
Cynthia Becker ... [et al.].
 p. cm.
 Catalog of an exhibition held at the Samuel P. Harn Museum of Art,
University of Florida, Gainesville, Feb. 8-May 8, 2011.
 Includes bibliographical references.
 ISBN 978-0-9833085-0-8
 1. Textile design--Africa--Exhibitions. 2. Textile fabrics--Africa--Exhibitions.
I. Becker, Cynthia J., 1965- II. Samuel P. Harn Museum of Art. III. Title. IV.
Title: Textile diasporas.
 NK8887.C66 2011
 746.096'07475979--dc22
 2011007064

Published by the Samuel P. Harn Museum of Art
University of Florida
SW 34th Street and Hull Road
Gainesville, Florida 32611-2700
www.harn.ufl.edu